Charlie Clark is a terrifically talented teller of the treasury of tantalizing, true tales of times gone by in Arlington!
—*Tom Dickinson, former president, Arlington Historical Society*

Clark captures the county's pride in its history, its tradition of civic activism, its famous citizens and its quirkiness. Readers will find that these lively vignettes entertain and inform, making clear why Arlington is such a great place to live.
—*Rob Smith, associate professor at George Mason University and former superintendent (1997–2009) of Arlington Public Schools*

Much has been written nationally about Arlington County's planning and transit-oriented development decisions. Charlie Clark's essays bring to life the people who've made Arlington's places "home"—both before and after Arlington was transformed by the coming of Metro. The flavor of our neighborhoods, the inherent funkiness of generational community transformation and the comfort of family life are all revealed in these deft reflections.
—*Mary Hynes, longtime Arlington resident and school and county board member*

Published by The History Press
Charleston, SC 29403
www.historypress.net

First published 2014

Manufactured in the United States

ISBN 978.1.62619.505.9

Library of Congress CIP data applied for.

ARLINGTON COUNTY
Chronicles

CHARLIE CLARK

INTRODUCTION BY ALAN EHRENHALT, FOREWORD BY NICHOLAS F. BENTON

THE
History
PRESS

To local scribes everywhere

CONTENTS

CONTENTS

CONTENTS

CONTENTS

FOREWORD

This compilation of the best of Charlie Clark's more recent "Our Man in Arlington" columns, reprinted from the *Falls Church News-Press*, is exemplary of what his columns, as published in the *News-Press* each week from December 2010 to the time of this writing, have come to mean for Arlington County and all of Northern Virginia.

One does not have to be from Arlington to appreciate the rich fabric of community that his columns have come to represent. His love for his community radiates through his cumulative work and, as represented in this volume, symbolizes a quality of human connection through community with which today's society seems to be losing touch.

The remarkable mix of local history with human interest and contemporary local political battles weaves a fabric of a self-conscious sense of belonging and connecting for everyone buying into Charlie Clark's Arlington community, which could be anyone's community where it is sought out, defined and cultivated in a similar way.

Charlie Clark came to me in October 2010 with the proposal to revive what I had begun earlier as an "Our Man in Arlington" weekly report as part of my effort to interest readers in a wider area around the tiny city of Falls Church in conjunction with my efforts to expand the circulation of the *News-Press*.

FOREWORD

I founded the *News-Press* in 1991 to serve the thirteen thousand residents of Falls Church and quickly discovered how a good community newspaper contributes to a heightened self-realization of community. Augmenting the weekly coverage of local high school sports, drama clubs, small business hopes and wrangles at city hall, I soon recruited as regular contributors our congressman and representatives in the state legislature. But by 1997, I was ready to expand the newspaper's reach and therefore needed community-based content that spoke to the interests of Falls Church's nearest neighbors.

I first went to Supervisor Penny Gross, representing the Mason District area adjacent Falls Church in the mammoth, one-million-strong Fairfax County. She complied with a weekly report called "A Penny for Your Thoughts," which she has continued to pen personally every week since.

Then looking to Arlington, the formidable jurisdiction of more than 200,000 on another side of Falls Church, I was assisted by then-senator Mary Margaret Whipple in finding Richard Barton, a prominent local political figure who'd semi-retired. He was more than up for doing a fine job, but after eight years, he decided he'd had enough. That's when Charlie Clark, after some hiatus, stepped into the picture.

Although not retired and gainfully employed as a journalist, Charlie nonetheless was eager to take on the challenge of the revival of the "Our Man in Arlington" weekly column. Well plugged into the Arlington community and an accomplished and talented writer with a passion for his hometown, Charlie hardly needed to be coaxed. He has provided a stream of colorful content—varied as it has been, from history to culture to curious oddities to politics—that has made editions of the *News-Press* in Arlington veritably fly out of their boxes each Thursday, while causing our website to light up as well.

It soon became obvious that a compilation of his weekly columns in a single volume such as this would be an imperative, and so now we have it. It is the first one, but we all hope it won't be the last.

A final point: Charlie Clark's columns and my newspaper exemplify the importance of good journalism to a sense of community that I don't believe the Internet, alone, will ever be able to achieve. There is something about shared geographical space—the natural way that human beings, with the limits of physicality, organize themselves into communities—and the physical presence of the heady whiff of newsprint mixed with printer's ink bringing an array of news and opinions of a community to its members

FOREWORD

that is essential for people, even when they strongly disagree, to find ways to resolve differences and move forward. Better equipped to empathize, they even learn to genuinely like one another.

NICHOLAS F. BENTON
Founder, owner and editor of *Falls Church News-Press*
Falls Church, Virginia
January 19, 2014

ACKNOWLEDGEMENTS

I would like to highlight the fine help I received from Nicholas F. Benton, editor and publisher of the *Falls Church News-Press*, who gave me the gig; Susannah Clark for helping shape the manuscript; Elizabeth Clark McKenzie for keeping the production materials organized; photo editor extraordinaire Jane Martin for vivid picture research; Becky Eason for visual consults; Tony Awad of Photoscope for image processing; Diana Sun, Mary Curtius, Helen Duong and all the others for speaking to me on behalf of Arlington County government; Judy Knudsen and her team at the Arlington Public Library for helping me tap the Center for Local History; and, last but first, my wife, Ellen, who reads me best.

Introduction

Arlington, Virginia, isn't a community one instantly associates with history. Outsiders tend to think of it as a D.C. suburb that acquired an identity only in the postwar years, as the growth of the federal government swelled its population. Unlike nearby Georgetown or Alexandria, Arlington possesses no quaint nineteenth-century shopping streets and no roster of colonial mansions for tourists to traipse through.

But whether the public knows it or not, Arlington is a historic place. Its catalogue of historical lore goes back to the early nineteenth century, when the original copy of the Declaration of Independence was hidden away in an Arlington gristmill to prevent the British from seizing it in the War of 1812. It was a player in the Civil War, when Robert E. Lee's sprawling estate on the banks of the Potomac was seized by the U.S. government to provide a resting place for fallen Union soldiers. Those are events that deserve to be remembered by those who compose the county's population of more than 200,000 in the early twenty-first century.

So are the changes that came over Arlington in the past half century, as it steadily evolved from a conservative bedroom community for military families to an entry point for Latin American immigrants to a trendy entertainment mecca for affluent young people from all over the Washington area. Someone should be telling that story as well.

To Arlington's great good fortune, someone has come along to do it. Charlie Clark grew up in Arlington in the 1950s and '60s and developed a curiosity about its past and present that maintained itself even as he settled

there as an adult to raise his family. There were stories about Arlington, Charlie sensed, that nobody else was telling. Three years ago, the *Falls Church News-Press* gave him the opportunity to tell them in a new column titled "Our Man in Arlington." Since then, week after week, Charlie has provided to his readers a chronicle of his community's history, politics and culture that reaches back two centuries and stretches out to take in the simmering current disputes over issues such as development of a new streetcar system, the impact of high-rise development and the decision to move thousands of defense-related jobs out of the community.

This book offers the best of Charlie Clark's writing about Arlington over the past several years. And his best is very good indeed.

If you are interested in the Civil War, you will learn from Charlie that Arlington was the only Virginia county to vote against secession in 1861 and that it did so despite the fact that Robert E. Lee was its most prominent citizen. You will find out that future president Rutherford B. Hayes commanded Ohio's Twenty-third Union Regiment from the neighborhood of Upton Hills.

It also turns out that the two berms that still sit at the intersection of Old Glebe and Military Roads started out as fortifications placed there to discourage Southern troops from attacking Union forces in Arlington over Chain Bridge. And that General John Mosby, the Confederate "Gray Ghost" who conducted guerrilla raids against Union forces during the war, ended up living quietly in Arlington decades after hostilities ended.

You may have guessed that Arlington, situated as it is on the border of Washington, D.C., has its share of tales to tell about major characters in American political history. But you may not have known that Henry Clay, then secretary of state, and John Randolph, then a senator, actually fought a duel in Arlington near the corner of Glebe Road and Randolph Street in 1827. Neither man was hurt, although Clay's shot managed to pierce Randolph's coat. "You owe me a coat, Mr. Clay," Randolph said when the brief encounter was over.

If you live in Arlington, or nearby, you have probably driven past the Washington Golf and Country Club or perhaps visited the grounds. But it's unlikely you were aware that that land was a favorite horseback riding retreat for President Theodore Roosevelt.

There are dozens of other nuggets like that in this book, reminders that if Arlington wasn't at the center of many dramatic events in American history, it somehow has a piece of lots of them.

But anecdotes from the distant past are only a part of what makes "Our Man in Arlington" so interesting. Equally prominent are stories from more

recent times, especially those that have to do with the author's Arlington childhood. The book is replete with accounts of what Arlington was like in the 1950s and '60s, especially the local commerce and social institutions that defined the county in those years but have faded away in the decades since.

In one column, an old card table with ads along its sides gets Charlie to thinking about the businesses that have vanished in Arlington since his youth—"the bygone haberdasheries, entertainment venues and hardware emporiums that now exist only in our collective memory." He locates a few that have survived through the decades, notably a shoe store, a shoe-repair shop and a monument maker. In another column, a visit to an old movie theater piques his curiosity about the movie houses that existed in Arlington in the 1950s, and he proceeds to identify them one by one, along with some memories of the role they played in the lives of his contemporaries.

One very funny column takes on cotillion, the dreaded Saturday afternoon ballroom dancing event that forced pre-teen youth to dress up in uncomfortable clothing and practice their manners, keeping them from the basketball courts where they really wanted to be. There is a nostalgic column about the day camps where children of that era spent lazy summer afternoons, playing games in an easygoing, unstructured fashion that has long since yielded to much more formal regimes of activity.

In the final section of the book, Charlie advances to the present, reporting on the controversies that define politics in Arlington today. He jumps into almost all the juiciest ones: the debate about whether to build a streetcar system, the art center that has failed to live up to expectations, the likelihood that development will take place along a new Metro line, the high-rise construction in Ballston that has altered the appearance and character of a neighborhood he remembers fondly and the noise control regulations that county government has promulgated but rarely bothers to enforce.

Sometimes you can tell where Charlie stands on an issue. It's clear that he considers Ballston overdeveloped and that he thinks the federal government has erred in moving thousands of defense-related jobs to distant suburbs. More often, however, he gives both sides a fair shot and leaves it to his readers to make up their own minds.

On the question of whether Arlington County should invest in a streetcar system, for example, one gets to the end of Charlie's essay without having a clear idea what he really thinks. Part of that may be his sense that he is bound by norms of journalistic balance and that he is ultimately a reporter, not a commentator. But part of it seems to be a genuine ambivalence on complex political questions—Charlie is blessed

(or cursed) with the ability to see both sides of the issue, and his columns on public controversy reflect that.

"I'm a reasonable man about Arlington," he writes in one column. And so he is. But he is more than that—he's a priceless source of information and insight, and when you get to the end of this book, you will understand the community in a way you never have before.

ALAN EHRENHALT

Chapter 1

AN ARLINGTON SAMPLER

What's in Our Name?

August 24, 2011

The latest permutation for the noble name of Arlington is a warship.

In June 2011, the U.S. Navy agreed to a commissioning in Norfolk in autumn 2012 for the USS *Arlington*, the newest in the navy's fleet of San Antonio–class LPD amphibious assault ships.

The vessel named to commemorate 9/11 is actually the navy's third to bear the Arlington name, as there was one during World War II and another during Vietnam.

The ship is under construction in Pascagoula, Mississippi, where, at a christening ceremony, Arlington fire chief James Schwartz spoke movingly of first-responder cooperation and the ship's coat of arms' message of "strength, honor and fortitude. I intend to place a copy of this important symbol in each fire station in Arlington as a constant reminder of the direct connection between what we do domestically and what the *Arlington* does globally," he said.

It's a fine cause. My only concern is that folks around the world know that the ship is named for the real Arlington and not one of many pretenders.

In this area, we all know Arlington is more than a cemetery. The name, as black-belt county history buffs recall, goes back to our English heritage. In the early nineteenth century, George Washington Parke Custis built

Arlington House (later the home of Robert E. Lee) and named it for the family's ancestral home in Northampton County on Virginia's Eastern Shore.

That place, in turn, had been named for an early English patron of a Custis colonist, but here the facts are disputed. Many assume this patron to be the seventeenth-century Henry Bennet, Earl of Arlington, who hailed from Middlesex, outside London. But the late Arlington historian C.B. Rose Jr. notes in her book that the timing of the year in which he got his title doesn't fit. The Brit for whom the Custis Virginia estate was named may have been a locality called Arlington in Bibury Parish in Gloucestershire.

Either way, it is our county where the name Arlington gathered steam. Eventually, it spread over these United States to twenty-one entities, if you count towns and villages. There are Arlingtons in Arizona, Georgia, Illinois, Iowa, Kansas, Kentucky, Massachusetts, Minnesota, Nebraska, New York, North Carolina, Ohio, Oregon, South Dakota, Tennessee, Texas, Vermont, Washington and Wisconsin. Plus there's the unincorporated community in Northampton, Virginia. You even find an Arlington Road (also the title of a 1999 movie) in Bethesda.

I've been prejudiced against Arlington, Texas, ever since the Washington Senators moved there in 1971. I have warmer feelings for Arlington, Massachusetts, where a friend who grew up in Arlington, Virginia, took me one summer to chill out with her grandmother.

But opportunities for confusion are ample. Even for your man in Arlington.

I recently went online to book a tent for an upcoming party in Clarendon. After inquiring at "Arlington Tent Rental" via an e-mail address and a cellphone area code with no geographical familiarity, I received this polite reply: "Although I do travel statewide, I have only one or two tents up in that direction. Truthfully, it will be much cheaper to use a company out of Amarillo or somewhere closer. Clarendon is about 300 miles from me, and truly the mileage charges would cost more than the tent."

We wouldn't want those folks around the world who encounter the USS *Arlington* to give the credit to Texas.

Roots at Arlington Hall

April 30, 2013

Whenever I drive past Arlington Hall, I'm reminded that if it did not exist, neither would I.

It was there, at the intersection of Arlington Boulevard and George Mason Drive, that my parents met during World War II.

Today, the one-hundred-acre complex is a fenced-off home to the Army National Guard Readiness Center and the George P. Shultz National Foreign Affairs Training Center. But this prime location has a more intriguing history, encompassing debutantes and spies of both local and global import.

Arlington Hall began as the county's sole private school, built in 1927 as a junior college for women. Its handsome yellow-brick colonial structure with six columns housed a high school, classrooms, a gym and indoor and outdoor equestrian arenas for two hundred students. Instruction for females of the smart set included music, art, drama, home economics, secretarial skills and physical education, according to Nan and Ross Netherton's pictorial history of Arlington.

But its horses were the main attraction, according to Smithsonian American History Museum director John Gray, whose mother studied there in the mid-1930s. "We grew up with great photographs of her on the fiercest horses, jumping in the ring, and a few pictures of the students, dressed to

In the 1930s, Arlington Hall was a private girls' school. *Library of Congress.*

the nines for their dinners," he told me. "Mother continued to ride with the riding instructor from Arlington Hall on the circuit."

Though the Great Depression forced the school into bankruptcy, it survived under nonprofit trusteeship until 1942. That's when the federal government took over and set up the U.S. Army Signal Corps' Signals Intelligence Service, tasked with breaking the Japanese code. Renamed Arlington Hall Station, the site hosted many young intelligence officers and linguists who'd been summoned to Washington for the war effort. Among them were a Yale history major newly commissioned as an army lieutenant (my father) and a Newcomb (Tulane University) language major (my mother).

The project was so secret, my dad wrote in a letter recently unearthed by my sister, that when he asked recruiters to describe the "actual work, they couldn't tell us." Mom described the difficulty of code-breaking on camera in the 2007 WETA-produced documentary *Homefront: World War II in Washington*, in which she declared crash-course learning of Japanese "a tall order."

Both my future parents used their time at Arlington Hall to meet people from unfamiliar backgrounds and to enjoy nightlife with eligible singles. Just a couple years ago, I tracked down their first apartment, walking distance at Fillmore Gardens. I carried a black-and-white snapshot of the couple from 1944 and invited a befuddled current resident to gawk at the photo of my folks taken half a century earlier on his front stoop.

When the war ended, Arlington Hall continued as a national security hub—the drama of a Soviet spy named Bill Weisband at the site was not exposed until the 1990s. It served as headquarters for the National Security Agency, U.S. Army and Air Force security organizations and, later, parts of the Defense Intelligence Agency.

Today, the beautiful Arlington Hall main building—on the National Register of Historic Places—is run by the State Department for its Foreign Service Institute. Each year, it offers six hundred courses, in seventy languages, to some 100,000 enrollees from more than forty agencies.

For security reasons, my request for a tour was denied. But I still contentedly drive by.

We're All Exceptional

September 27, 2011

Is there such a thing as Arlington exceptionalism?

In September 2011, Bloomberg's *Business Week* named us the second-best "city" in America (the editors knew we're actually a county, so we'll waive that point).

And the exceptionalism vibe was in full flower during a stimulating talk given on September 14 by Terry Holzheimer, the director of Arlington Economic Development, who made no bones about us being hot stuff in his talk to a receptive crowd of banqueters at the Committee of 100.

The key boasts seem to be that two-thirds of Arlington's population of 216,000 holds a college degree, that our median income level is a hefty $93,806 and that we have phenomenally low unemployment (4.2 percent as of July) and relatively few home foreclosures.

"Arlington is the epicenter of scientific research for the defense and homeland security industries," the county website states matter-of-factly.

Our well-educated hiring pool, said Holzheimer as he pointed to convincing charts on a screen, is the reason major employers such as the Corporate Executive Board and the Defense Advanced Research Projects Agency (DARPA) pitched their tents here. (DARPA's new building on Randolph Street, he added, is among the first urban government buildings to be built in full compliance with current security specifications.)

In the office construction and rental sweepstakes, "we beat the pants off everyone in the region, and we ate Fairfax County's lunch," Holzheimer said. "Ninety-six percent of Northern Virginia office construction is taking place in Arlington."

In retail space, Arlington delivers 300,000 new square feet for shopkeepers every year, the equivalent of a new shopping center annually.

The Great Recession, to be sure, imposed a soft market in housing. "But Arlington will do fine," he said. "Our median home prices are up there with New York, San Francisco and Los Angeles." The condo market, despite the wishes of some young aspiring owners awaiting fire-sale prices, has not crashed.

Environmentalists can point with pride to the claim that Arlington has double the green buildings of any other county in the region.

The massive federal workforce moves now taking place under the Base Realignment and Closure Commission have been "serious but manageable,"

he says. They caused nowhere near the expected disruption in Rosslyn and Crystal City, both of which are on their way to renovations and promising new tenants.

Arlington has completed 70 percent of its thirty-year plan to steer commercial and transport development along its Rosslyn-Ballston corridor.

In schools, the arts and general livability, goes Holzheimer's spiel, "we've outperformed everyone in the region, probably everyone in the country."

The future, of course, carries risks. Holzheimer mentions the fact that Arlington could be a terrorist target (the Pentagon on 9/11); that the extension of Metro to Tysons Corner will rejigger commercial competition; that the county is dependent on the feds for contracts and tenants; that our mobile population is changing demographically (youth! minorities!); and that affordable housing is threatened.

But Arlington can adapt. Its marketing strategy, Holzheimer says, spurns the "dogs by the lake" homey images many jurisdictions hoke up in their self-promoting videos. Instead, Arlington accentuates "brainpower."

With perhaps a touch of insolence, I asked Arlington's economic development guru if his counterparts in Falls Church, Fairfax and Alexandria would agree with his "We're No. 1!" assertions. (Is there talk of Falls Church exceptionalism? I was wondering.)

"I've got the data," Holzheimer said. "Research firms don't lie."

Arlington's a Fair

August 6, 2013

Herewith is a fair-to-midway prescription for enjoying the Arlington County Fair.

Carefully plan your visit as you dress up in your best finery. (Kidding!) Ponder both the traditional treats—the funnel cakes, the display of community booths—and the new enhancements for the event set for August 7–11 at Thomas Jefferson Community Center.

Added in 2013 to the cotton candy confab that attracts fifty thousand (billed as "one of the largest" freebies on the East Coast) is a sponsored 5K walk/run on Sunday. There was a digital-age County Fair Idol Contest, in which high school kids competed via Facebook "likes" for a chance to perform at the fair's Thursday night opening ceremonies.

Arlingtonians let their hair down at the annual county fair. *Arlington County Government.*

There's also a fresh agenda of good deeds for the green-minded. "Our fair was one of two county fairs in the country that won a $10,000 recycling grant from Keep America Beautiful and Alcoa," I was told by fair chairperson Tiffany Kudravetz. "We're doing a lot more in recycling—more bins, better signage—and in informing the community via educational presentations and on-site volunteers to facilitate the increased recycling efforts. And we're doing some composting as well."

I advise bringing your patience if you're willing to arrive by shuttle bus from the I-66 and Quincy Street parking garage or other sites. Stubbornly committed drivers can find anarchistic parking in nearby residential backstreets (but I'm not betraying my secrets).

If you want to catch the piglet races, you should check the schedule. (Our porcine performers need a rest, too.) Same for the Harlem Wizards hoopsters, who at least are in the spotlight voluntarily.

If you're like me, you'll gauge your interest in the local musical talent based on cleverness of the band names. Atoms Apart? Good Brotha Clyde featuring Satellite Society? Burn the Ballroom? I'm sold.

Do plan on at least one on-site meal that throws calorie counting to the winds. Arlington's rich stew of easy ethnic experimentation makes it tough to make up your mind. I suggest you walk alongside the T.J. gym

and promenade by the full array of vendor sights and smells. Then let your spouse or date decide.

Those who are too sober-minded or chronologically advanced for the pony rides and tilt-a-whirls, note that you will find no sign reading, "You must be this eccentric to enjoy this ride." So I'd steer you instead to the cavernous cool indoor exhibition hall, where every interest group in the greater Arlington family is waiting to vie for your attention.

Between shows by grinning cloggers and the Arlingtones barbershop boys, you can deepen your understanding of why it takes all kinds to make a county.

I counted 165 groups on the roster—everyone from Americans for Prosperity and the Arlington Green Party to Aid Our Veterans, *Northern Virginia Magazine*, the Beekeepers Association of Northern Virginia and Massaging Insoles. The ever-dedicated Washington-Lee High School alumni again shame their absent Yorktown and Wakefield counterparts.

On the scene in person are luminaries from every local political organization, nearly every religious denomination and many country offices. There's a slew of professional associations and entrepreneurial contractors and retailers.

There will be a caucus of candidates and bumper sticker suppliers for whom every month is November.

The fair is also a chance to vent your spleen to everyone from the county treasurer to the USS *Arlington* Commissioning Committee.

Allow two to three hours. I guarantee you'll bump into friends.

Chapter 2

OUR RICH HISTORY

Swaddling the Founding Documents
November 22, 2011

Now we learn that the Declaration of Independence once made a pit stop in Arlington.

On November 15, 2011, a dozen history buffs assembled on the Virginia side of Chain Bridge (braving scant parking and the noise of the GW Parkway) to dedicate the county's latest official marker celebrating our local-cum-national legacy.

This tale's hero is a nineteenth-century State Department clerk named Stephen Pleasonton. Two years into the War of 1812, he had the foresight to perceive that, with hostile British troops at the gates of the capital, some precious historic documents needed safeguarding.

On instructions from Secretary of State James Monroe, he defied direct superiors and grabbed the original copies of the Declaration of Independence, various laws, the secret journals of the Continental Congress and some correspondence of George Washington. He put them in linen sacks and transported them by horse cart over Chain Bridge, where they were secreted in an abandoned Lee family gristmill off Pimmit Run. Fearing discovery, Pleasonton the next day moved the documents farther out to Leesburg.

"I never learned about this in school," said Steve Dryden, a local history activist who was instrumental in the research that nailed down the likely

Beside the entrance to Chain Bridge lies the founding document's marker. *Anne McCall.*

site. "I have a feeling it was not commemorated because it wasn't exactly a glorious moment in American history. But it was glorious for this gentleman," who went on to become top auditor at the Treasury Department and head of U.S. lighthouse operations.

The humble unveiling was attended by officials from the American Foreign Service Association as well as Potomac Heritage Trail enthusiasts (mostly invaders from Fairfax) glad to see hikers get another outdoor attraction.

County board member Jay Fisette presided over the ceremony held on land shared by the county, state and federal governments. He called it another sign of Arlington's historical role as a "pass-through" linking North and South. He recited a litany of Arlington's historical firsts, from being the only Virginia county not to vote for the 1861 secession to being home to the first Federal Housing Administration–financed apartments in the 1930s.

Looking on with satisfaction was Arlington historic preservation coordinator Michael Leventhal. It was his team that wrote the text for the marker and added it to the new wave of educational signage enriching our suburban setting.

Other recent markers include one crediting creation of the Internet to the Defense Advanced Research Projects Agency and another labeling the

parking garage where *Washington Post* reporter Watergate Bob Woodward met in secret with the source inelegantly named "Deep Throat."

In May 2011, Leventhal was given an award by U.S. Interior secretary Ken Salazar for his work over the past decade recognizing thousands of historic properties during nominations to the National Register of Historic Places and for helping some two hundred property owners earn historic rehabilitation tax credits.

Arlington is "not as rich, colorful and well known as other places," he told me. "We don't have dozens of house museums. But we're pragmatic as we move through time—we're a real working type of community."

The story told by the new marker near Chain Bridge is "iconic in that it was a government bureaucrat who came to save the documents on account of his job."

Arlington has been "in the thick of history," Leventhal said, but we don't have major events to mark. "We do it in snippets."

A Lee Family Scandal?

October 15, 2013

Do the lesser-known annals of Arlington history offer evidence of an early nineteenth-century sex scandal? A family secret involving marquee names like Lee, Custis and Febrey?

I've done my darndest to bring the tale alive.

The rumor passed down for generations of a child's suppressed illegitimacy revolves around the Febreys. The patriarch Nicholas Febrey (1800–1868) became one of Arlington's wealthiest landowners when, in 1837, he bought perhaps 600 acres at a bargain among the 1,200 acres known as Washington Forest. They were owned by his pal George Washington Parke Custis, builder of Arlington House. (For the location, think today's Swanson Middle School, Dominion Hills, Glencarlyn, Upton Hill, BJ's Wholesale Club.)

Nicholas married into the famous Ball family (twice, due to widowerhood) and produced three sons, two of whose stately homes remain today at Wilson Boulevard and North McKinley and on Powhatan Street. (A fascinating lawsuit brought in 1887 by John Febrey against the federal government sought reimbursement for livestock confiscated by Union soldiers during the Civil War, a conflict that split the Febrey brothers.)

A rare 1844 photo of George Washington Parke Custis, who built Arlington's namesake home. *Library of Congress.*

The racy rumor came to me from Sara Collins, a serious Arlington Historical Society researcher drawn to the Febreys. In 2003, she interviewed Febrey descendant John Gott (since deceased), a longtime librarian at Langley High School, as oral history.

Gott recalled his elderly great-aunt recounting the tale of a minister in Arlington whose daughter got pregnant, possibly by a member of the Lee family, and took the newborn to Custis, saying (illogically), "Here's your bastard, you raise it." Allegedly, the boy was born on Christmas Day, so they named him Nicholas. And he arrived at Arlington House in February, so they abbreviated that as Febrey.

The claim was repeated in conversation with the late Falls Church city historian Melvin Lee Steadman Jr., and I found another Febrey descendant, Jim Miller, posting it on Ancestry.com.

Working in the story's favor is the fact that Nicholas Febrey's parentage is a blank page (indeed, an Internet search of French historical surnames

shows the name is extremely uncommon). Plus his friendship with the well-connected Custis may explain him getting a good land deal. The dramatic reluctance of Gott's great-aunt to discuss what would have been a shameful family secret at the time adds authenticity, and there's even talk of a resemblance in photographs between Nicholas's son Henry Febrey and Robert E. Lee.

But the dates don't quite work. Febrey's birth is recorded as October 3, 1800. A peek at Arlington House histories shows that Custis didn't move from Mount Vernon onto the property he inherited from George Washington until Martha Washington's death in 1802. Work on what would become the Custis-Lee Mansion didn't start until 1802 (and took sixteen years). Custis married Mary Lee Fitzhugh in 1804 and had four daughters, only one of whom survived: Mary Anna Randolph Custis, the future wife of Robert E. Lee.

Though Custis was famed for his warm hospitality (see his daughter's memoir), and his wife was a fervent Episcopalian, what are the odds he would take in a foundling before embarking on those major undertakings that shaped his life for the next half century?

If there were sexual shenanigans by Lee boys (who were as visible as dogwoods in post-colonial Virginia), what are the chances of their being discoverable in 2013?

Perhaps a DNA test for Lees and Febreys?

The Local Clay-Randolph Duel

March 6, 2013

On the mercifully few occasions when I engaged in boyhood fisticuffs, I had no inkling that my drama was unfolding on soil with a notable history of one-on-one violence.

A few steps from my Arlington childhood home, off North Glebe Road just up from Chain Bridge, lies the probable location of an infamous dueling ground of the early nineteenth century.

If you pull your car over, you can read the historic sign erected by the Virginia Department of Historic Resources in 2000. Here on April 8, 1826, witnesses watched the famous duel between two American political luminaries: Henry Clay of Kentucky and John Randolph of Virginia.

35

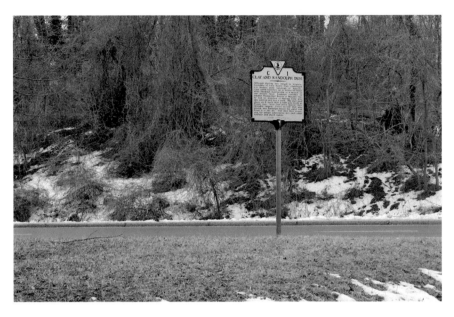

Historians' best guess for the site of the big 1826 quest for satisfaction. *Samantha Hunter.*

Clay, of course, would become known in Congress as the "Great Compromiser." But the two men that day were hardly in a compromising mood.

The clash—like many in the era that accepted dueling as a way to defend one's honor—erupted over personal insults. Clay, forty-nine, a southerner, had just become secretary of state for President John Quincy Adams—whom Senator Randolph of Roanoke, fifty-three, loathed for his abolitionism.

Clay's political horse-trading offended Randolph, who stood in the Senate and called Clay, among other quaint epithets, a "blackleg," which meant an unsavory gambler. Such calumnies on the chamber floor raised a host of political stakes and legalisms. So Clay challenged the acid-tongued Randolph to give him satisfaction.

"No one had the right to demand an explanation for remarks in the Senate, least of all a member of the executive branch," wrote Clay biographers David S. Heidler and Jeanne T. Heidler.

Randolph wanted to duel across the Potomac on his native soil, even though the tradition was illegal. The completion of the Little Falls Bridge (a Chain Bridge predecessor) had opened a new dueling ground a convenient carriage ride from Georgetown.

The site at what is now Randolph Street and Glebe Road inspired a fascinating review of the geography by Ruth M. Ward in the 1981 *Arlington*

Historical Magazine. Massaging a variety of sources, she places the dueling ground fifty to seventy-five feet south of Fort Marcy (off GW Parkway), on the back of Pimmit Hill Palisades.

On that snowy-rainy Saturday at around 4:00 p.m., Clay and Randolph arrived with their "seconds," military officers and politicos. Friends had sought desperately to dissuade the two from going through with the duel, for which Randolph had chosen pistols at ten paces. During the run-up, Randolph recklessly promised to receive Clay's shot passively and avoid making his wife a widow, as recounted in Michael Lee Pope's book *The Hidden History of Alexandria, D.C.* "If I see the devil in Clay's eye," Randolph told friends, "I may change my mind."

Clay stood before a small stump, Randolph by a low, gravelly embankment. The two saluted.

After an accidental premature shot by Randolph, each fired once, Randolph hitting the stump and Clay's ball ricocheting off the gravel. After their seconds reloaded the weapons, Clay fired and hit the gravel again, but a projectile pierced Randolph's billowing coat.

Randolph shot in the air. "I do not fire at you, Mister Clay," he proclaimed. "You owe me a coat, Mister Clay," said Randolph.

"I'm glad the debt is no greater," replied Clay. They shook hands.

The outcomes of my own boyhood "duels" are lost to history. But my recollection is that they ended with a similar gained wisdom.

Arlington in the Civil War

March 22, 2011

"I'm 167 years old," intoned George Dodge, whom I know as an Arlington attorney, history buff and mild-mannered Rolling Stones fan.

But on March 17, Dodge was displaying his chops as a learned impersonator of a local historic figure: Private Alexander Hunter, a Confederate soldier from the Seventeenth Virginia Infantry who grew up on the slave plantation called Abingdon, on the grounds of what today is Reagan National Airport.

Dodge's convincing evening presentation at Central Library was part of the Arlington Historical Society's series commemorating the 150th anniversary of the Civil War. It elicited drama from the fact that one of his questioners was black history activist Craig Syphax, a descendant of Arlington slaves.

To bone up on your local Civil War heritage, you should start with Margaret Leech's masterful *Reveille in Washington: 1860–1865*, published in 1941. It has myriad Arlington and Falls Church references. There's fine detail on the Lee family saga on Arlington Heights and nifty lesser-known factoids such as Colonel Rutherford B. Hayes commanding the Ohio Twenty-third Regiment in what today is the Upton Hill Regional Park, from which he could see the Capitol dome.

Arlington is especially rich in remnants of the War Between the States. It sited several of President Lincoln's famous forts ringing Washington, among them Fort C.F. Smith (now a wonderful park near Spout Run) and Fort Ethan Allen, at the Madison Community Center. (If you doubt that the spirit of the Old South lives on, check out the plaque in the yard of a private home on nearby Stafford Street decrying "the War of Northern Aggression.")

The never-quite-ended debate over the role of slavery in the war was central to Dodge's portrayal of "gentleman" soldier Alexander Hunter. The well-born Arlingtonian who enlisted at seventeen learned to shoot in the woods by the Potomac. (We know because he published three volumes of memoirs of his exploits, including escapes after being captured five times.)

Dodge said Hunter would have followed the political and legislative events that led to the war and that slavery was at their core. "Most soldiers looked for adventure, and there was a fear of an invasion by federal troops, which politicians played up," his character said. "Some people saw slavery as an underpinning of the war, but that wasn't emphasized by those in the South."

Hunter's father owned fifty slaves, "a valuable commodity that his heritage depended on," Dodge said. Slaves were 11 percent of the population, and Virginia was the biggest slave state. "We saw it has a paternal system and considered them workers central to our economic order," his character said. "But we knew there had to be emancipation at some point."

Syphax asked "Hunter" if, while in Union prisons, he had to take orders from "negroes."

Yes, but he resented it. Hunter would not, however, have tolerated physical abuse of slaves, saying abusers should get capital punishment. "I'm not here to apologize for the system," said Dodge/Hunter. "But it's hard to judge a person for the era in which they grew up."

Many in the audience asked about Dodge's period equipment—his belt buckle, canteen and cartridge box. His clean gray uniform, made by a modern reenactor sutler, wasn't representative, Dodge said. "You should have seen the dirty rags we wore after Antietam."

He went on for more than an hour, seldom breaking character.

Mosby Memories

October 3, 2012

Who knew the Gray Ghost was an Arlingtonian?

The legendary Confederate raider John S. Mosby has been on my mind during the current Civil War commemorations, and a recent drive through Mosby Heritage Country resurrected my hazy memory of his Arlington connection.

Colonel John Singleton Mosby, the "Gray Ghost," had a postwar place in Arlington. *Library of Congress.*

Warrenton, Virginia, is where you must start if you wish to grasp the meaning of Mosby, the Southern states' champion of Swamp Fox–inspired guerrilla warfare who, with ultimately only 1,900 raiders, was able to pin down as many as 14,000 Union troops across the Shenandoah Valley.

Mosby was a colorful figure who spooked the enemy, once hiding high in a tree for eight hours while Yankees searched a safe house just a few feet away. In one famous episode in March 1863, he and twenty-nine followers near Fairfax Court House barged into a home on Little River Turnpike where Union general Edwin H. Stoughton lay asleep. Mosby smacked the general's naked behind as he rustled him out of bed to arrest him. He asked the Northerner whether he knew the name Mosby. Then he smilingly identified himself.

A visit to the Warrenton visitors' center allows you to see the home Colonel Mosby occupied after the war and visit his grave. You get oriented for the various driving tours that spoke out along the stretch of Route 50 called the John Singleton Mosby Highway and on to such storied Virginia haunts as Millwood, Upperville, Middleburg and Aldie.

But I found no acknowledgement of Arlington, not from the tourism official or the local librarian, nor the Mosby memoirs and biographies I consulted.

For that I had to rely on the Arlington historian Kathryn Holt Springston, who weaves Mosby into her Smithsonian bus tours of Civil War history in Arlington.

The trick, she explained, is to remember that Arlington was part of Alexandria County during Mosby's life (1833–1916). Also, Mosby's time as an Arlington resident came during the post–Civil War decades, in which the celebrity held federal jobs but depended financially on the hospitality of his fellow retired cavalrymen.

"Mosby was always one of my favorite characters, an incredibly complex man who has been varnished by many so-called historians with too broad a brush," she says. To the chagrin of Confederate sympathizers, Mosby after the war befriended one-time foe Ulysses S. Grant, who, by then president, appointed Mosby, an attorney, consul to Hong Kong. Later, during the McKinley and Theodore Roosevelt administrations, Mosby held jobs in the Interior and Justice Departments, living with relatives downtown on K Street and at various Alexandria County addresses.

In Arlington, from about 1897 to 1902, "Mosby lived in a large old house where Fillmore Gardens apartments now stand—it was the home of one of his men," Springston says. During the 1910s, he wrote his memoirs at a house on Columbia Pike owned by ex-ranger Sanford Bradbury.

Former rangers such as Stuart Thomson and Fountain Beattie were his connections to the area, and he shows up in one Arlington census, Springston says. We know this through Mosby's letters, many of them held at the National Archives.

There's a cottage industry of Mosby enthusiasts, Springston notes, among them Walton Owen of Fort Ward Park, Kim Holien of the U.S. Army at Henderson Hall and others in Fairfax.

The gray one will always be among the historical ghosts that linger in Arlington.

The Mystery Mansion

July 5, 2011

When Nevada Republican senator John Ensign resigned in 2011 a step ahead of the ethics police, few commentators noted the Arlington connection. Admittedly a bank shot, it nonetheless brings out an intriguing slice of local history.

The maritally troubled Ensign was a receiver of spiritual counseling at the famous C Street Townhouse downtown. This veritable dorm for lawmakers in the news for the wrong reasons (recall South Carolina governor Mark Sanford) is owned by the Fellowship Foundation, which for decades has run the nonpartisan National Prayer Breakfast.

Lo, that group's headquarters is a mysterious mansion overlooking the Potomac alongside Fort C.F. Smith, off Spout Run in the Woodmont neighborhood of Arlington.

The white colonnaded manse known as "The Cedars" is marked as private property (though I recently wangled permission to stroll the grounds). Led by Pastor Doug Coe, the foundation's denizens avoid limelight, as goings-on there are colorful.

In her memoir, Hillary Clinton wrote of an uplifting lunch in the mansion as a new first lady in 1993; singer Michael Jackson borrowed its rooms soon after the 9/11 attacks; conscience-troubled Republican strategist Lee Atwater and disgraced United Way chairman William Aramony took refuge on its bucolic grounds; so did Supreme Court justice Clarence Thomas during his Anita Hill ordeal.

The home's interior was described by investigative author Jeff Sharlet as "a room appointed with statues of bald eagles and photos" of Presidents

The late nineteenth-century Doubleday Mansion is home to a mysterious foundation. *Arlington County Public Library Center for Local History.*

Carter and Nixon. Oddly, a *New Yorker* article last year called the property "a Revolutionary War–era mansion." My Arlington histories tell it differently.

Long known as the Doubleday Mansion, the home, according to Eleanor Lee Templeman's *Arlington Heritage*, was named for Colonel William Doubleday. He and his wife built the bulk of the modern house after moving there in 1898, adding to a structure probably from the mid-nineteenth century. Naming the house "The Cedars" for the surrounding trees, the couple used it to entertain Fort Myer officers and other VIPs.

In 1916, the Doubledays sold their home to Harry Wardman, builder of the hotel that became the Sheraton-Park. In 1919, he sold the house to railroad builder Richard Harlow, who renamed it Hockley, after his Maryland ancestral home. Harlow's daughter Caroline in 1923 moved with her husband, an admiral who would die at the end of World War II, leaving the home to daughter Ann Wilkinson.

The 1930s and '40s brought celebrities to the mansion. It was leased to the sister of military air power pioneer Billy Mitchell, its digs enjoyed by men in President Franklin Roosevelt's brain trust. In 1946, Trans-World Airlines took over on a ten-year lease. TWA president Jack Frye remodeled the interior before leasing it to Howard Hughes. In 1948, Pan-American

Airways founder G. Grant Mason Jr. moved in with a wife and six kids. They renamed it Peakleigh, a combination of their mothers' names.

When the foundation purchased the home in 1978, it restored the name "The Cedars," according to Nan and Ross Netherton's *Arlington County in Virginia: A Pictorial History*.

Before the political sex scandals broke in 2009, the only peep most Arlingtonians heard about The Cedars came in 2004, when the county board responded to complaints from nearby homeowners about the foundation's use of dormitories for its programs for disadvantaged youth. Because the seven-acre property is zoned as a worship and teaching center, the board deemed such use proper.

Teddy Roosevelt's Rides

July 2, 2013

Teddy Roosevelt continues to blow the fourth-inning presidents' race at Nationals Park. But in real life, of course, T.R. was anything but a slowpoke; in fact, the old Rough Rider was an ace horseman who rode many hours through woods here in Arlington.

I ponder this when I bike from my home on, ahem, Roosevelt Street and pass the Birchwood cabin, perhaps the most tangible Arlington site where the nation's twenty-sixth president made pit stops.

At the intersection of North Wakefield and Twenty-sixth Streets, a stone's throw from the fenced-off Washington Golf and Country Club, lies the modernized restoration of the cabin built in 1839 by Caleb Birch.

The Teddy connection grew out of his friendship with Admiral Presley M. Rixey, the White House physician (under McKinley) and navy surgeon general who bought hundreds of acres of Arlington farmland as a summer home in 1888. (He went on to buy hundreds more in Falls Church and farther out.)

Rixey is best known in Arlington for having sold, in 1908, seventy-five acres that became the country club, its clubhouse on "Rixey Mountain," next door to Rixey's Mansion (which became Marymount University), on a fancy trolley stop known as Rixey's Station in "Cherrydale, Va." (Today, Rixey's name adorns town homes across Glebe Road.)

Rixey's memoir reveals that farming his properties in a "30 mile radius" was as important as medicine. "Many happy hours I passed in company with

T.R. dragged his less-energetic associates on horseback through Arlington. *Library of Congress.*

the dearest friends in every walk of life," the doctor wrote, "among them President and Mrs. Roosevelt and their children, on horseback, or strolling among my cattle making plan after plan for the future."

Most famously in wintertime 1909, Rixey accompanied Roosevelt on an exhausting one-hundred-mile ride to Warrenton.

Teddy was highly prescriptive in horsemanship requirements. Rixey cited "the danger to the president on horseback from the crowds who would frequently join the party and almost ride over him." Hence a list of rules was distributed stipulating that the president notify the rider he wishes to accompany him, who stays on his left with the companion's right stirrup to the back of the president's left stirrup. Others kept ten yards back, and no one accompanied Teddy when he was riding with Mrs. Roosevelt. Anyone not able to control his

mount withdrew to the rear. "He was a hard rider," Rixey wrote, and the rules "added much to the president's comfort and to my peace of mind."

Roosevelt gave Rixey a saddle and bridle that had been gifts from citizens in Cheyenne, Wyoming, artifacts Rixey later donated to the New York Historical Society.

After Rixey helped get the country club running, he declared in 1923 that "these beautiful playgrounds will be one of the most attractive homes for lovers of the outdoor life in Arlington County (the future Arlington City) or any other locality in the world."

The Birchwood cabin, meanwhile, drew visits from Roosevelt until his death in 1919, according to recollections of one Richard Wallace. Wallace was an African American White House chauffer whom Rixey hired to clear land for the golf course and who also prepared ice cream for T.R. Wallace eventually moved into the cabin, planting apple trees. According to local histories, Rixey relocated the tenth green to protect the structure before deeding it to Wallace.

Teddy Roosevelt's haunt is today a private home.

An Anniversary for Rock Spring Church

April 16, 2012

Many steeples dot the Arlington landscape, but few embody our hometown's activist style of religion like Rock Spring Congregational United Church of Christ.

On May 18–20, 2012, Rock Spring marked its 100th anniversary with a litany of events ranging from a reunion of old pastors to a strawberry festival to a special service for the congregation of five hundred. Their contributions give them much cause for celebration—countywide.

There's Arlington's first community lending library, its first Boy Scout troop and its first cooperative preschool. A roster of prominent Rock Springers includes the late county board stars Ellen Bozman and Jim Hunter and legendary state delegate Mary Marshall.

Fingerprints of other members can be found on the cornerstones of such institutions as Hospice of Northern Virginia, local Meals on Wheels, the Arlington Food Assistance Center, Arlingtonians Meeting Emergency Needs (AMEN) and the Arlington Housing Corp.

My own relationship with the handsome campus on Little Falls Road consists of having performed, as a twelve-year-old in 1965, in a well-meaning rock band on the stage of its Neighborhood House. But I know some contemporary members.

Sara Fitzgerald, a parishioner who married her husband there in 1975, sees the place as "extended family" for many transplanted Washingtonians. "Over the course of its history, Rock Spring seems to have always attracted people who were thoughtful, curious and committed," she told me. "The key issues have changed over the past one hundred years, but we continue to strive to make the world a better place for all of God's children. We don't always agree, but we respect each other's opinions. And we find ways to have fun in the process."

I asked the current senior pastor, the Reverend Kathryn Nystrand Dwyer, how she addresses political sensitivities from the altar of nonpartisanship. Rock Spring "honors the individual thought process of every person and has long encouraged putting faith into action through service," she said. "We have a tradition of encouraging respectful and informed conversation and dialogue about current and controversial issues that affect people from all walks of life. We embrace advocacy towards dialogue, bridge-building and understanding. Through sermons, forums and educational programs, we try to provide a theological rather than political grounding for these efforts."

The historical record offers an even rarer legacy—one of outward-looking, pragmatic citizens prone to avant-garde action. The congregation's first gift to the community was bestowed just three years after its founding as Vanderwerken Congregational Church (named for the nearby trolley stop along what today is Old Dominion Drive).

What became the Carrie M. Rohrer Memorial Library began in 1915 when a church committee sought to honor a young mother recently deceased. As Eleanor Lee Templeman wrote in her history of Arlington, "They all knew the tedium of reading the same few stories over and over, yet books were expensive for people on government salaries and the nearest public library was Seventh and K Streets in Washington."

That children's library, like the cooperative preschool set up at Rock Spring during World War II by WETA founder Elizabeth Campbell and others, still serves the church mission.

In January 2012, the Virginia General Assembly adopted a resolution honoring Rock Spring's clergy and members for their "constant commitment to democratic decision-making and consensus-building." The Arlington County Board approved a similar proclamation, congratulating the church for a "vision that looks beyond its immediate neighborhood."

The Old Saegmuller School

December 29, 2010

Taking the proverbial walk by the old school this Christmas, I was pleased to notice that Arlington County had installed a new metal historic sign.

Marking what in my youth was James Madison Elementary School (now the Madison senior citizens center on Old Glebe Road) stands a plaque noting the site of what, in the early decades of the twentieth century, was the Saegmuller School.

It was named for its benefactor, George Saegmuller (1847–1934), the wealthy German-born inventor who, in America, became an early officer of the Bausch & Lomb Optical Co. His Nuremberg castle–inspired mansion ended up as home to the Arlington chapter of the Knights of Columbus.

I'd long thought it odd that the name of Saegmuller, an education luminary who chaired Arlington's nineteenth-century board of supervisors, would be removed from the school and replaced, just five years after the man died, with an all-American nod to a founding father.

The long-ago-demolished Saegmuller School on the site of today's Madison Center.
Arlington County Public Library Center for Local History.

Then one day it hit me. Arlington's James Madison Elementary was so named in 1939. That's when Hitler was threatening the world and German names in this country were anything but fashionable.

It's a fine example of how the names that guide us around our community reflect our politics, culture and commerce.

This month, the Arlington Historical Society published, for the first time in book form, its collection *Why Do We Call It...?: Thumbnail Histories of Arlington County Place Names*. It was edited by society member Alice Andors, with research help by Arlington librarian Diane Gates, using items from old issues of the *Northern Virginia Sun*.

The ten-dollar stocking stuffer offers a factual tidbit to charm residents of nearly every county nook and cranny. Some of its findings are as historically grand as George Washington and Robert E. Lee's family ties to Arlington House. (Hey, I'm aware Falls Church and other Virginia towns boast historic ties to the mother country, but can you top this? Seventeenth-century English King Charles II had three major ministers in his cabinet: Lord Arlington, Lord Buckingham and Lord Clarendon.)

The book's lesser scoops include the origins of the name Rosslyn (coined around 1860, likely through combining syllables from the names of landowner William Ross and wife Carolyn) and Lorcom Lane (landowner Joseph Taber Johnson combined the names of his sons, Loren and Bascom).

But there is rich history here. Native American legacies abound in Arlington. It's fun to be reminded that the word "Potomac" meant "trading place" and that "Tuckahoe" was Indian for a plant used to make flour. The streets in my neighborhood known exotically as Twenty-second and Twenty-fourth at one time bore signs that read Indian Trail and Moccasin Trail, respectively.

Upton Hill off Wilson Boulevard was named for Charles Upton, a newspaper editor who came from Ohio to build a large house that would figure as a Civil War lookout. The name Columbia Pike is short for the Columbian Turnpike Co., which, in the nineteenth century, was a key transport line from the district across what then was the Long Bridge.

It's fascinating how much indulgence subdivision developers enjoyed in naming streets and neighborhoods—"Aurora Hills" got its moniker because someone got inspired viewing it at dawn. And who would have remembered that in 1935 Military Road was almost renamed North Chain Bridge Road? (Locals successfully resisted.)

Personally, I was gratified to solve a mystery. The book confirmed my notion that the Roosevelt Street on which I live was named for Teddy

Roosevelt and not Franklin. It's complicated, since the houses on our block were built in 1951, just six years after the death of FDR. But Williamsburg neighborhood folks have long recalled that Teddy, in the early 1900s, used to ride his horse around Minor Hill up top of Sycamore Street.

The book notes that when Arlington imposed its street grid (alphabetically, first with the one-syllables, then two and then three) in 1934, planners got stuck finding another three-syllable "Q" name to go between existing Quantico and Roosevelt. (They finessed it by importing "Quintana" from Mexico.)

Someday a future edition of the book will explain that Reagan National Airport used to be National Airport and that Virginia Hospital Center used to be Arlington Hospital. For many of us Arlingtonians, they still are.

Boilers by the Potomac

November 9, 2011

Mystery solved! The curious rusted objects encountered by hikers along the Arlington portion of the Potomac River banks are in fact…well, I'm getting ahead of myself.

In June, Vienna reader John Haffey III asked me to explain the odd "steel pipes and boiler-type structures" he has seen since the 1970s during jogs along the Potomac Heritage Trail. "One of the structures is on cement support, so it's not like they washed up there," he wrote.

I waited for a lovely day to enjoy the river with autumn leaves at their peak and made the trek to what, for me, was new territory. I couldn't compete with the hardy souls who hike or run (stumble?) the whole 4.2 miles of rugged trail from Roosevelt Island to Chain Bridge. But I learned that you can access the mystery objects more readily using the Windy Run Trail that begins off of North Kenmore Street at Lorcom Lane.

Or you can begin at the nature center of Potomac Overlook Park on Marcey Road, from which, after about thirty-five minutes of clambering over jutting roots and creek-wet steppingstones (nearly twisting both ankles), I hit pay dirt.

Poking from the shoreline foliage stood two rusted, cylindrical, rivet-lined metal tanks, one perhaps twelve feet long and a taller one perhaps eight, half-buried alongside a square concrete shed. Many of the hikers I

Boilers on the Potomac left over from the early twentieth century. *Charlie Clark.*

chatted up were familiar with the objects, but none knew the back story. So I asked Martin Ogle, chief naturalist for the Northern Virginia Regional Park Authority, who delivered the goods on a rich local tale.

The site was a quarry, dating from the late nineteenth to early twentieth century. Bluestone and gneiss were dug and moved by barge across the river to build St. Patrick's Church, the Healy Building at Georgetown University, St. Elizabeth's hospital, abutments to Chain Bridge and the seawalls at Hains Point. Rubble from the palisades was also used for the foundations of D.C. streets.

The hunks of metal were boilers used to generate steam to drill holes to penetrate the cliff rock of the Potomac Palisades. The shed was likely used to store dynamite.

The whole operation is discussed in the "Field Guide to Potomac Overlook Regional Park" (October 2003 edition). Though the stone was quarried for centuries by Native Americans and, later, eighteenth-century colonists, the original capitalist was Arlington's Vanderwerken family, who launched the Potomac Bluestone Company after buying the land in 1851.

Even more fascinating is the social history. As described in Eleanor Lee Templeman's *Arlington Heritage*, many of the quarrymen were Italian

immigrants, aided by African American laborers from Westmoreland County and Arlington's Hall's Hill.

Some twenty-four Sicilians occupied a village called "Little Italy" in early decades of the twentieth century near Donaldson Run. Prominent landowner Emma Donaldson recalled hearing explosions that shook her house, seeing quarrymen struggle with packed wheelbarrows and watching tugboats pull barges across the Potomac.

Once in the late 1870s, work on the university's building was delayed because the tug couldn't break through ice on the river, according to Georgetown spokeswoman Maggie Moore.

The quarrying stopped in 1938, when the George Washington Parkway was well underway, and "Little Italy" was dismantled after the National Park Service took title to this part of Arlington in 1956.

All that's left of this bygone adventure, devoid of signage, are the rusty boilers.

Those Many Broyhill Homes

January 30, 2013

A frozen-in-time document capturing Arlington circa 1952 came to me through a friend. The illustrated ad from the old *Washington Star* proclaimed, "Now open: One of the most distinctive developments in Metropolitan Washington real estate history."

For just $19,000–$27,000 (substantial cash required), Arlingtonians aspiring to own property adjoining the Washington Golf and Country Club could buy into Broyhill Forest, a planned community of 150 homes in eight styles that "represent the utmost in refinement, in luxury and in value that will increase with the years."

As owner of a Broyhill colonial myself, the ad reminded me that Broyhill endures as one of our county's most storied names.

Northern Virginia is dotted with subdivisions with such monikers as Broyhill Heights, Crest, Hill, Park, McLean Estates and others. My friend Carolyn Connell, an agent for Keller Williams Realty, says the solidly built colonials and ramblers "are known for good bones."

According to a brief family history of M.T. Broyhill and Sons written by the patriarch's grandson, Marvin T. Broyhill Sr. came to Arlington from Hopewell, Virginia, in the late 1930s to capitalize on what he successfully

predicted would be a post–World War II housing boom. In 1946, sons Marvin Jr. and Joel (the future congressman) returned home from military service and joined M.T. in establishing three businesses: the construction company, a rental firm and an insurance agency.

By 1952, the Broyhills were building three thousand homes a year. The company was declared "the world's largest builder of brick homes" by the National Brick Institute. The Broyhills also became the single biggest customer of General Electric appliances (even the kitchen cabinets were GE).

In 1958, Mrs. M.T. Broyhill was named "businesswoman of the year" by the chamber of commerce.

Reggie Massey, a retired Better Homes realtor who sold many Broyhill homes in the late 1960s, told me their value by then was not in terms of quality as much as it was location. Arlingtonians now wanted speed in getting downtown.

The neighborhood remains characterized by the Broyhill "enclave." In 1951, M.T. Broyhill built a huge white house on the hill at North Twenty-sixth and Vermont Streets, boasting multiple bedrooms, a ballroom and an indoor pool. His son Joel set up in a spacious home next door, and Marvin was on the other side of Joel. Cousin Tom was around the corner and the company's engineer across the street.

"With the compound, you had family around you all the time," recalls Jeanne Broyhill, my high school contemporary now chairing Arlington's Committee of 100. Her father, Joel, was elected to Congress in 1952 and served eleven terms. In 1967, he moved the family to a specially designed mansion on Old Dominion Drive dubbed the "House by the Side of the Road."

The congressman's previous house is now owned by Bobby Tramonte, owner of the Italian Store in Lyon Village. Tramonte, who grew up nearby knowing the Broyhills as a Little League sponsor, recalls asking his dad at age eight how much the big Broyhill mansions cost. And the woman who sold him the house in 2002 had done legal business with his father. "It was some sort of karma," Tramonte told me.

Representative Broyhill, who died in 2006, was an effective Republican not popular with Arlington Democrats, Tramonte notes. The neighbors still tell stories of young "protesters" in cars doing figure eights on his lawn, damaging the boxwoods.

The Lunch Counter Sit-Ins

November 6, 2013

A recent *Arlington Magazine* includes a haunting photo, tossed in almost marginally as part of a timeline of county history.

The image is of black civil rights activist Dion Diamond sitting on a counter stool at the old Cherrydale Drug Fair, engaging in a sit-in to protest segregation, on June 10, 1960.

The brave protester, calmly reading a newspaper, is surrounded by a pack of white teenagers—slicked-back hair, Elvis sideburns, T-shirts, some guys grinning, some with menacing nonchalance alongside a few curious bystanders.

The image jarred me because at the time, I was right across Lee Highway finishing first grade at the since-closed Cherrydale Elementary School. The photo credited to *Washington Star* photographer Gus Chinn captures that lost soda-fountain world. In the background, you can see telephone booths and shopper signs for books and tobacco. Those white kids circling around Diamond staring down the "outside agitator" could have been guys I encountered in my neighborhood.

I tracked down Dion Diamond, now seventy-two, semi-retired as a Washington-based financial planner. He suggested that I Google his work in the civil rights movement, and I learned from a website called the Washington Area Spark that he was a field secretary for the Student Non-Violent Coordinating Committee in Mississippi and Louisiana from 1961 to 1963. He was arrested more than thirty times, and famed radical Stokely Carmichael (later Kwame Ture) wrote him up in his memoirs.

Diamond cut his teeth doing anti-segregation sit-ins in Arlington when he was a nineteen-year-old Howard University student, one of thirteen in the integrated Non-Violent Action Group. Working up Lee Highway over a two-week period, they sat in at the People's Drug Store at Old Dominion Drive (now a CVS) and the Drug Fair, then at Lee-Harrison shopping center.

They were refused service at most and then arrested for trespassing at the Howard Johnson's, then at 4700 Lee Highway. They then moved on to Maryland, helping integrate Glen Echo Amusement Park.

"Howard was supposedly the epitome of black colleges," Diamond told me. "D.C. then was [de jure] desegregated. But all you had to do was cross over the district line to Maryland and Northern Virginia to find de facto segregation."

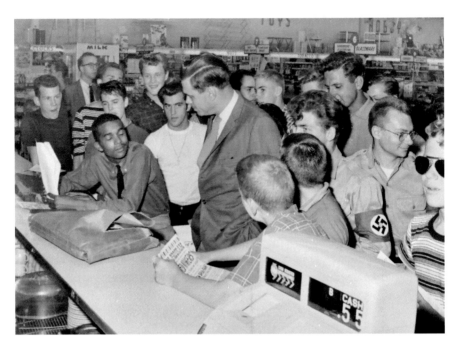

American Nazi Party leader Rockwell "debates" desegregation with activist Dion Diamond. *Reprinted with permission of the DC Public Library, Washington Star Collection.* © Washington Post.

Once the protesters sat at the lunch counter, they were harassed or pelted with cigarette butts. At one point during the Cherrydale event, American Nazi Party leader George Lincoln Rockwell traveled the few blocks from his Arlington headquarters on Randolph Street and arrived with his swastika-wearing minions to add their own style of intimidation (attracted, no doubt, by the news cameras).

Diamond said while he knew Rockwell by name, he didn't know the kids, who seemed young. "I stared at them, and they stared at me," he said. (Guessing that the white teens might be Washington-Lee High School students, I forwarded the photo to some alumni from that period. No one recognized anyone.)

Within days of the protest, the Arlington restaurants gave in and desegregated.

Was Diamond scared while executing the sit-ins? "Actually no, because the presence of camera people and reporters made me feel somewhat confident throughout my civil rights activities," he said.

But after I forwarded him the recently published photo, he wrote back by e-mail, "This is truly a photo which I do not remember! Had I been in that environment, I would have been insane not to have been frightened!"

Recalling Hoffman-Boston High School

October 17, 2012

High school reunions, for some, commemorate an alma mater that is no longer.

So it was in October 2012 at Arlington Central Library when nearly one hundred gathered to share memories of Hoffman-Boston High School, the Jim Crow–era "colored" secondary school that shut its doors in 1964 as the county moved to desegregate.

"We laughed, we cried, and people really rose to the occasion," I was told by alumnae Brenda Cox, the local real estate agent who organized the event for the Historical Society's "Arlington Reunion" series. It drew a crowd that blended the universals of school nostalgia with facts of a role on history's stage.

Founded in 1916 and named for two Arlington educators, Hoffman-Boston began as an elementary school that converted to a high school in the 1930s. "Textbooks were secondhand ones that had been used at the white high schools," said Cox's brief history distributed at the reunion. "For a long time, there was no library, and when they finally installed one, it was ill equipped with books; the science laboratory was also ill equipped."

Also lacking for years were athletic facilities. (Last March, a dozen members of Hoffman-Boston's 1961 undefeated football team were honored at a festival at the Langston-Brown Community Center.)

Sandra Costley Green, one of five speakers at the library, recalled how when she enrolled at Washington-Lee in the early 1960s, school rules blocked blacks from extracurriculars, so she did them at Hoffman-Boston. The school's choir regularly joined forces with singers from six black churches for an annual holiday concert.

Louise McGregor provided the perspective of teachers (retired at ninety, she's still in Arlington), many of whom were graduates of historically black colleges. Under longtime principal George Richardson (now in his late nineties), they prepared the "total person" to face the world using a curriculum that was academic, vocational, social and artistic.

"The teachers didn't treat you like a number," Cox says. "They interacted with the community. They knew your family, and some would go to your house."

Vivian Bullock recounted the statewide political drama of how some in Arlington's "colored" school community served as guardians to black student refugees from Prince Edward County in the late 1950s during Virginia's "massive resistance" to Supreme Court–ordered desegregation.

Dennis Turner, class of '64, moved many with a poignant talk about life with the final graduating class.

As noted in the printed program (which included lyrics to the school song), a special video was shown by Arlingtonian Milton Rowe Sr. Back in 1963, he shot several minutes of Super 8 footage of his football player son and the crowd at Hoffman-Boston's 1963 homecoming court. He gave a DVD of the recording to the library. Arlington cable recorded the event, which included remarks on the precious occasion by Virginia Room librarian Judy Knudsen and George Mason University archivist Robert Vay.

Since Hoffman-Boston's final graduates were prepped to face integration and transfer to Wakefield High School, the name has lived on—first as an alternative junior high in the 1970s that merged with "hippie high" to become today's H-B Woodlawn program and, since 2000, as the elementary school of the same name.

"We were a tight community," Cox says. "And we were well educated. Just because it was a black school didn't mean we were lacking. Teachers recognized what we were dealing with, and they gave more of themselves."

Feeling the Heritage in Hall's Hill

February 13, 2013

Of all Arlington's neighborhoods, I nominate Hall's Hill as the most transformed.

On a February 2013 weekend, I arranged a satisfying twofer by taking the Walk Arlington official guided tour of that historically black area while enjoying the "Feel the Heritage Festival" celebration of African American history and culture.

The annual event held at the Langston-Brown Community Center drove home how much the neighborhood has changed since I knew it as a boy in the 1950s–70s. It was long a place to which members of Arlington's wary white establishment seldom ventured.

"Because of segregation, all of our streets dead-ended, and no one wanted to discuss this history," I was reminded by Willie M. Jackson-Baker, president of the John M. Langston Civic Association, which composes Hall's Hill and four other diverse neighborhoods. When Arlington Hospital was established in the 1930s, it did not accept black patients.

Unpleasant remnants remain, of course, and the tour included a view of "the great wall" of six- by eight-foot wooden fences still visible along North Culpeper Street that for decades separated Hall's Hill from surrounding white enclaves.

Yet nowadays, the neighborhood—renamed High View in the 1980s—boasts numerous new elegant homes and other trappings of suburban affluence that materialized as some families with deep roots sold their simpler structures and their land.

What still thrives, however, is the spirit of the tightknit African American community from across Arlington. "In the old days, everyone knew everyone through cousins; everyone was connected," said our guide, Adreanne Bell-Justice, an official at Bank of America.

I was touched to witness many of them blending with visitors of all shades and backgrounds.

Organized by the Parks and Recreation Department, the four-hour festival for all ages offered performances of African drum music, a jazz harmonicist and gospel singers. Vendors sold Obama T-shirts, jewelry, purses, spices and cooking oils, as well as soul food—delectable collard greens and ribs. There were children's craft tables, a YMCA obstacle course and a raffle for round-trip tickets to Africa. Along the walls were banners keeping alive old African American neighborhood names such as Johnson's Hill (south Arlington's Nauck). Also displayed was a photo of the undefeated 1961 football team from the old all-black Hoffman-Boston High School.

The NAACP desk was manned for a membership drive, and planners of a neighborhood archive solicited oral histories, videos and memorabilia.

A wall lined with clippings documented the battle for desegregation from 1866 through the early 1960s. "Arlington White Schools Turn Down 8 Negroes," read one *Washington Post* headline telling the "story reported round the world." Resistance in the 1950s was mainstream, voiced by such figures as Congressman Joel Broyhill and Chevrolet dealer Bob Peck.

Our outdoor history stroll in the cold took us by the nineteenth-century Mount Salvation Baptist Church and Calloway United Methodist Church, as well as High View Park, site of the annual Turkey Bowl community football game. It ended at Gateway Park on Lee Highway in front of Heidelberg Pastry Shoppe, a sculpture garden including signed bricks from the previous Langston School.

Walk Arlington manager Lauren Hassel posed trivia questions and rewarded us with promotional bags. The program aims to "get people out

of their cars" for traffic abatement and health, fitness, the environment and community building, she said. And to its current twenty-one routes will soon be added a regular walk through Hall's Hill.

The Internet Invented in Arlington?

May 31, 2011

Arlington has played many roles on history's stage, but none is more surprising than its status as battlefield in the fight over who created the Internet.

The latest skirmish unfolded on May 17, 2011, when the county board dedicated two new historic markers commemorating the Net's roots at the Pentagon's Advanced Research Projects Agency (ARPA). Both are now mounted at 1400 Wilson Boulevard in Rosslyn, where the agency cooked up ideas from 1970 to 1975.

The board's ceremony was not typical small-town fare. With former ARPA director Steve Lukasik and colleagues looking on, a video produced

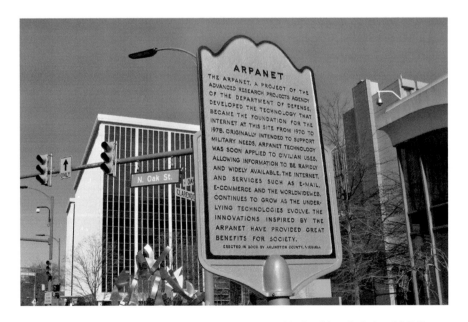

Though Al Gore lived in Arlington, the Internet was created before his arrival. *Anne McCall.*

by Arlington Virginia Network documented the first efforts at linking distant computers in the late 1960s. One plaque declares how ARPA "developed the technology that became the foundation for the Internet" and how the "innovations inspired by the ARPANET have provided great benefits for society." The second plaque displays 0s and 1s, a techie's in-joke spelling of "ARPAnet" in binary code.

Nanoseconds after news of the ceremony broke, naysaying bloggers piped up. Tom Bridge, a technologist with attitude, wrote in "We Love DC" that "Arlington is hardly the only place that can lay claim to that contentious 'birthplace' title, and that it's the municipality laying claim to the title makes me even more skeptical."

Bridge knowledgably recapped the varied roles at different stages of the Internet's genesis by contractors at RAND Corp.; UCLA; and Cambridge, Massachusetts–based Bolt, Beranek and Newman. He quoted Internet historian Janet Abbate of Virginia Tech: "It wasn't [Arlington] in terms of infrastructure...but it was in terms of money and 'vision,' so I guess they have as good a claim as any," she said. "Arlington County as such had nothing to do with it, though."

Ouch! That brought an online rebuttal from county communications director Diana Sun: "We never suggested that Arlington County invented the Internet! We are merely seeking to honor the scientists—the forward thinkers" who led the effort at locations around the country, she wrote. "It is the original ARPA team themselves who came up with the idea of creating a historic marker...and wrote the copy."

Next came the inevitable: a commenter joking he didn't know Al Gore lived in Arlington. Except Gore did. For decades, in Aurora Hills.

The charge levied by detractors during the 2000 campaign that Gore claimed to have invented the Internet was a distortion of his statement: "During my service in the United States Congress, I took the initiative in creating the Internet."

The record was set straight (too late for Gore) in 2001 with release of a letter by two undisputed Internet heavies: "No other elected official, to our knowledge, has made a greater contribution over a longer period of time" to the Internet's evolution, wrote Vincent Cerf, then of WorldCom in Ashburn, and Alan Gaines of the National Science Foundation, based in (ahem) Arlington.

There's another Arlingtonian who helped bring about our era's dominant technological feat: Google executive chairman Eric Schmidt, who, while at Sun Microsystems, led the team that built JavaScript. This native son is memorialized in the Yorktown High School Hall of Fame.

Finally, there's ARPA's successor, the Defense Advanced Research Projects Agency, still visioning away at Ballston, where it has a ringside seat for the next campaign in the battle over bragging rights in our digital lives.

Espionage in the Neighborhood

June 5, 2013

In some office in Moscow lies a secret map of Arlington. It highlights not our famous cemetery or the Rosslyn-Ballston corridor but some sites of Cold War spy drama.

In June 2013 at the Arlington Historical Society's banquet, David Robarge, chief historian at the CIA, delivered a rich talk titled "Spies Next Door." Detailing three major espionage incidents, he lent big-picture perspective to some juicy tales with Arlington settings.

The first unfolded at Arlington Hall, that federal multiplex on Route 50 where World War II code-breakers labored to break the secret communications of Japan and the Soviet Union. A hush-hush U.S.-British counterintelligence project called Venona assembled linguists and math whizzes to decipher Soviet messages to intelligence, diplomatic and trade officials.

"It was tough, dogged work," Robarge said, commending ace code-breaker Meredith Gardner, whose team found patterns in double-encrypted texts showing Soviet inquiries about the Manhattan Project and President Franklin Roosevelt's health. Venona eventually identified three hundred Soviet "assets" inside U.S. agencies. Years later, their names came out—Klaus Fuchs, Harry Dexter White and Alger Hiss.

Though Hiss remained a cause célèbre for decades, "he was guilty as charged, and it should be put to rest forever," Robarge said. Venona's findings could not be used in court, so prosecutions depended on catching spies in the act.

Venona collapsed in 1949 when the Russians were tipped off to the message interceptions by double agents Kim Philby and William Weisband. Arlington Hall "went deaf," Robarge said.

The notion of a mole inside the CIA became a twenty-year fixation for Arlingtonian James Angleton, the CIA's counterintelligence chief in the 1950s and '60s. "He was a strange, polarizing figure, an oddball who worked strange hours with the blinds down," Robarge said.

Angleton figured if his friend Philby could betray him, there must be others. So each hint of a mole from Soviet defectors was "music to Angleton's ears." The counterintelligence push ended up probing forty CIA employees, fourteen of whom became suspects whose careers were damaged, the historian said.

In December 1974, after the *New York Times* exposed the CIA's illegal domestic operations, Angleton was fired. As reporters mobbed his home at 4814 North Thirty-third Road, Robarge said, Angleton came out in a bathrobe looking drunk, leaving a bad impression. "Angleton's career went down in flames, so the bad he did was remembered and the good forgotten," Robarge said. For years, counterintelligence became the CIA's "stepchild," as the "Angleton syndrome" impeded efforts to find spies inside U.S. intelligence.

That, in part, led to the saga of Aldrich Ames, "probably the CIA's most destructive spy ever," Robarge said. An incompetent in charge of anti-Soviet strategy, Ames beginning in 1985 began selling classified documents to the Soviets he was supposed to be recruiting. One result: ten pro-U.S. agents in the Soviet Union were executed. After nine years, CIA monitors began noticing his expensive home at 2512 North Randolph Street, his $50,000 Jaguar, his new wardrobe and his wife's five hundred pairs of shoes.

Damaging evidence was found on his home computer and in his trashcans, and a pattern was noted: Every time he met with Soviets, his bank accounts suddenly swelled. His dramatic arrest was big local news in 1994. It added to evidence used later against long-missed FBI mole Robert Hanson, who picked up Russian money at Long Branch Nature Center. Yet another spy on the Arlington map.

Chapter 3

AN ARLINGTON BOYHOOD

W-L and the Wet Field

September 21, 2011

A four-decades-old mystery was revived in September 2011 when alumni of Washington-Lee High School teamed with the Arlington Historical Society for a fascinating evening of reminiscences by graduates from every decade since the 1930s.

Representing the class of 1971 was the highly reliable George Dodge, former president of the history society. He told the crowd of one hundred that his most vivid high school memory is the November 1970 mud-caked championship football game between Yorktown and W-L. My jaw dropped as he delved into long-standing rumors that W-L coaches had watered down the field, supposedly to thwart Yorktown's vaunted lickety-split running game.

Dodge may not have known the extent of it, but he was messing with a story that has haunted Yorktown graduates and ex-players (like myself) lo these forty-one years.

Yes, W-L has a proud history of first-class teaching and alums who've excelled in movies, philharmonics and the National Football League. Speakers recalled the forty-nine students lost in World War II, racial tensions in the '50s on prom night, hanging out at Mario's Pizza and the school's stellar international baccalaureate program.

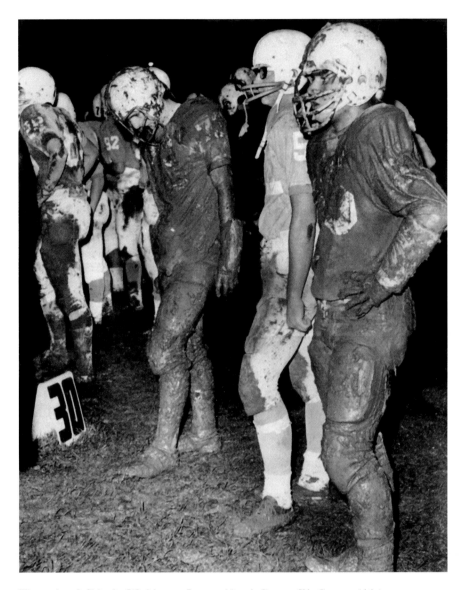

The author (left) in the Washington-Lee mud bowl. *Courtesy Skip Courtney (right).*

But the drama came when Dodge reviewed how the 1970 Yorktown team was 9-0 and W-L's 7-2. War Memorial Stadium was packed with a record ten thousand spectators. The night was misty—rain had poured for several days—which may well be why W-L won 12–0 (extra points aren't easy in the mud).

That shocking outcome denied undefeated Yorktown a trip to the regionals, a feat repeated in 2010 when, after twenty-eight years of victories by newcomer Yorktown (it opened in 1961), W-L (opened in 1925) again took district honors.

Fights broke out when the clock wound down, and the loss left many in north Arlington bitter at our team's misery from what newspapers called "a quagmire of mud." (Some of us have the framed photographs to prove it.) Yorktown coach Jesse Meeks still spoke of the heartbreak decades later, saying the game should have been postponed.

In 2011, Dodge said he was amazed after all this time to encounter Yorktown grads who insist W-L cheated by pouring water on the already sopping field. "Tonight, I'm going to set the record straight," he said, and he declared that a W-L lineman assures him there was no foul play.

Once word was passed, a contrary view lit up the Yorktown alum e-mail network. "I know that field was watered down—we got hosed, literally," said defensive back Sam Houghton. "I went to the junior varsity game at W-L that Thursday afternoon. The field was a little muddy but nothing like what we played in."

Offensive tackle Andy Extract disagrees. "They didn't need to water the field because it started raining the preceding Monday and hardly let up until hours before kickoff Friday evening," he recalled. He doubts W-L could have organized enough hoses. "The field was a mud bath. I don't know how the refs managed to keep track of the lines," he added. "I was completely soaked and was carrying about fifteen pounds of mud by the end of the game. It was even in my ear and never completely washed out of the jersey."

So my Yorktown mates shared one more round of might-have-beens.

But having just heard about all of W-L's character-building accomplishments through time, I've decided we should drop the charges.

The Durable National Pawnbrokers

February 2, 2012

Finally solved a music mystery from the wonder years of my Arlington boyhood.

The setting was National Pawnbrokers, the forbidding but enduring local business that has operated conspicuously at the Lyon Village intersection since 1963, when I was on the cusp of teenagedom.

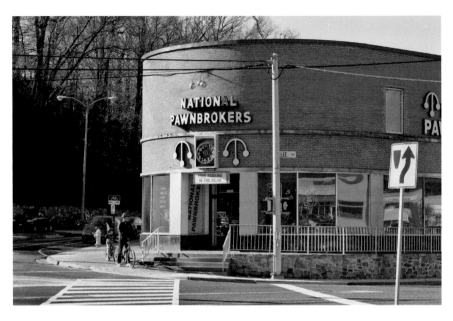

Pawnshop staff are sometimes taken as experts on musical instruments. *Anne McCall.*

Few ten-year-olds comprehend how a pawnshop makes money, how it differs from a bank, etc. (Not that we knew about banks, either.) But this mattered little at the time. That's because what captivated me was the pawnshop's window displays: curvy electric guitars, sparkling drum sets and macho-man amplifiers—all the vitamins and minerals a Beatles-crazed kid in the '60s would normally need to take.

I drooled over the objects at an age when trendy equipment trumped both talent and discipline in rehearsal habits. And though my bandmates and I grew familiar with professional brands such as Fender, Gibson and Mosrite, we were satisfied with the bird-in-hand discount brands our parents favored, such as E.W. Kent and Sears Silvertone.

And besides, who were we to gainsay the music experts at the pawnshop?

Flash forward to 2012. I finally raised the gumption to walk into National Pawnbrokers and determine once and for all whether this article of faith was true. Actually, I'd exercised this adult prerogative before, having purchased sentimentally, three years ago, a Vox mini-amplifier evoking the Fab Four.

Today, the shop's merchandise and loan window cashiers look orderly and prosperous. Signs tout gold, watches, jewelry, diamonds, firearms and tools. There's a framed 1977 clipping from the *Washington Star* profiling the business launched in 1939 by the Chelec family in Rosslyn (which,

until the 1950s, was practically the pawnshop/storefront loan capital of the eastern seaboard).

There's a clipping of an interview with longtime manager Joseph Horowitz, who helped move National Pawnbrokers to its present site. The owners got a raw deal on the move, ten cents on the dollar, I'm told by current manager Paul Cohen. He pulls out an early '60s photo showing the apartments across the street. In the foreground is a vacant lot that is now home to the Pawnbrokers and the Tarbouch Mediterranean grill.

"The music guy" at the modern store is Rico Amero, a working musician and a former sound engineer for the county. He shows me his range of Carvin, Marshall and Traynor amps; guitar straps and stands; and non-rock instruments such as clarinets. A few are new, such as the blue Percussion Plus drum kit.

Most are traded in, sold or hocked by people who need a loan, Amero says. He repairs some, "but if they're not in good shape, they won't make it into the store," he says, except occasional vintage items.

Customers include kids and teens. One began coming in at age twelve, and Amero is proud to think he helped him get into the Berklee College of Music. But most customers "come here to get a good deal," he says. National Pawnbrokers deals with professional musicians for prices that can top $2,000, he says. Fearing doing a disservice, he's not a huge fan of selling entry-level instruments.

That was me back in 1964.

So I asked manager Cohen the sixty-four-dollar question. He was hired thirty-five years ago "because he could reach the guitar," he says. Back in the day, the salesmen "didn't play instruments. All they did then was make money."

Hazy, Lazy, Crazy Summer Camps

June 12, 2013

When the school year ends next week, hundreds of lucky Arlington kids will shift to summer-camp mode.

These scamps have no way of knowing—if my experience can be trusted—that their coming blacktop adventures are as fun for grownups as for themselves, and the memories may endure a lifetime.

Recently I tracked down a man who was my playground counselor in the summer of 1965 at James Madison Elementary School. Bill Goodrich, now a Washington attorney, confirmed my fond recollections of weaving colorful lanyards and playing the dusty wooden billiard game Caroms. But he couldn't have appreciated how his time coaching me on the guitar playing the Byrds' "Mr. Tambourine Man" would have stuck with me.

"I can't think of a better first job for anyone to have," Goodrich said, recalling his hourly pay at $1.75 as a high school senior sporting a gray recreation department shirt. "Occupying thirty or forty kids all day wasn't working hard, just doing what we were asked to do. It was a very formative experience for me, to understand how much impact could result from small efforts you make."

A big difference back then, of course, was that there was no daycare to speak of, and we kids—once overdosed on summer re-run television—simply wandered over to the playground unchaperoned.

"By today's standards, the entire setup was remarkably unstructured—not to be confused with disorganized or unorganized," says my friend Glen Schneider, who spent summers in the late '60s as a counselor at Glebe and Patrick Henry Elementary. "Kids were largely on their own to choose their activities or just hang out and 'play.' This is in painfully sharp contrast to today's world, in which almost every kid's activity has a time slot, a schedule, a coach, a parent volunteer and a T-shirt or trophy for everyone."

Describing the few bats, balls and jump ropes the county provided to supplement the monkey bars, Schneider said, "Parents were almost nonexistent, though occasionally a mom would show up with popsicles, Kool-Aid or brownies."

His contemporary, Snooky Brooks, now a casino manager, spent summers during college as playground manager at Tuckahoe school, among others, and carries memories of molding kids' character. He halted the bullying of one boy who had cystic fibrosis (and helped him in later life become a scorekeeper for men's softball). And one of the tots he taught not to traipse through the mud was Ramsay Midwood, who today is an Austin, Texas country rock musician with a few CDs under his belt.

What has changed in Arlington camps, says Carol Hoover, a section leader in the Parks and Recreation Department, "is the diversity of workforce. We pay more attention to the community so that camps feel welcoming to all races, nationalities and skill levels." What is the same, she adds, is that kids who attend often grow up to be counselors and managers, now trained to protect health, safety and inclusion of those with disabilities. Today's staffers

wear blue T-shirts, and the army of volunteers, she reports, wear shirts of baby blue.

Hoover, beginning in the fall of 2012, helped set up ninety camps in schools and community centers, in themes ranging from soccer to history to nature to creative arts. Parents applied as early as February. The lanyards, she said, are still around. The Caroms? Not so much.

Cotillion at Lyon Village

February 19, 2013

My ancient grudge against the Lyon Village Community House resurfaces whenever I drive by it.

True, I've enjoyed some private parties over the years in that quaint facility off Lee Highway. But it will forever be linked to the agonizing hours I spent there as a bewildered preteen attending cotillion.

In the early 1960s, the baby boomers' generation gap was just unfolding. So I was none too pleased that my mom joined with dozens of Arlington parents and insisted we give over a series of Saturdays to this ballroom dancing dress-up class. It meant missing a youth basketball game and letting down some teammates who were most un-wowed by cotillion.

Five decades of character improvements later, I'm still in touch with friends with the same bittersweet memories of those afternoons learning to act like stuffed shirts. We were being groomed for a world of debut parties that, for most of us, never materialized.

I remember being dropped off at Lyon Village in an ill-fitting suit and clip-on bow tie, avoiding the gaze of girls in their lace finery and patent leather shoes. Inside, instructors Josh Cockey and Joe Courtney called out dance steps and tips on how to fetch a young lady a glass of oversweet punch. These guys were backed by a middle-aged combo with a piano, clarinet and stand-up bass performing—just as the Beatles were hitting—"Tea for Two," "Autumn Leaves" and "Heart and Soul."

The adults' assumption was that the box step and foxtrot would serve us in later life. They couldn't have guessed that the free-form flail dancing inspired by rock-and-roll would require no such formalism.

Eileen Powell, an Alexandria landscaper who was my cotillion classmate, recalls those gents in the band "as incredibly old, but they were probably

about forty." Her strongest memories are of "preparing to go, with lots of giggling and excitement" among friends, as well as "buying new clothes and wearing stockings for the first time," even suffering through a shopping trip to Hecht's with her father.

The girls wore white gloves, Powell recalls, which made it hard to hold drinks. Mysteriously, the girls were taught "not to cross the center of the dance floor but to walk around the side, perhaps not to attract attention," she speculates. "Once a session, girls had to ask boys to dance, and I would agonize over whether to ask a boy I actually liked, thereby broadcasting it to everyone, or one who didn't count." Basically, she attended because "my mother was preparing me for the kind of social life she thought I should have."

Arlington mom Audrey Courtney, whose late husband ran cotillion for thirty years, recently enlightened me on its history going back to when the community house opened in 1949. Joe was asked to broaden the variety of dance steps and to intervene when boys hid in the restrooms. "He kept the kids interested," she says. "Beyond dance, there were basic good manners—if you danced with someone, you excused yourself when you left for a new partner."

Eventually, cotillion switched to recorded music and the dress code softened, she recalls, and kids came in "sport jackets and jazzy stuff." She confirmed that boys definitely didn't enjoy it as much as the girls. "But it was the center of our life, and the community house was such an important thing."

Those Old Church Dances

June 13, 2012

The school year's final youth dance at Little Falls Presbyterian Church came off on Friday night in June 2012 without scandal. Nor, I'm guessing, were there too many bruised pre-teen feelings that won't heal with passage of time.

The church's annual gift to the community of nine monthly middle school dances has been going on for some twenty years in its "current stretch," I was told by its pastor, the Reverend Dr. Matt Merrill. But many of us locals recall an array of such dances during the 1960s—a source of junior high drama.

Churches put on dances for many reasons: as a good deed, to make use of idle facilities, to get kids off the street and to keep the church alive as an institution to which teens can belong.

"We provide a fun and safe environment for middle-schoolers," Merrill says of the four-hundred-plus action-seekers whose parents' cars can be seen snaking down the block for the 7:00–9:30 event. Coordinator Dave Wilson plays recorded music with any vulgar language excised and creates nifty lighting effects.

There are scant problems with drugs, alcohol or violence, the pastor says, recalling only one minor scuffle between two boys, which was broken up by two hired off-duty cops. They're aided by a dozen volunteer chaperones.

The sex issue is trickier. "We've worked hard to lock down the church," Merrill says, but "dance styles continue to change and, today, can be pretty sexual." A poster the kids find amusing reads, "Dance *with* someone, not *on* them."

My older daughter (now grown) hit the Little Falls dance floor in the late 1990s and recalls the scene as cool. "But people danced inappropriately to rap music, which was weird with all these church people walking around."

My younger daughter remembers being "an envious fly on the wall, eating stale pretzels and shooting Dixie cups of Safeway brand cola, hoping some shaggy-haired skater boy would notice me."

I have my own lurid memories of Little Falls dances, those discontinued in the '60s, Merrill believes, after more teens got their own cars. While thrilling to cross the room from the boys' to the girls' side for my first slow dance, I heard embryonic Arlington bands with names like the Cornerstones and Mother Murdoch's Marvelous Array of Animated Art.

On a grimmer night, the rescue squad rushed in to pump the stomach of a kid (name withheld) who'd consumed a fifth of the hard stuff.

We danced at other churches, too, most of them white dominated. (Black churches didn't hold dances, the kids preferring friends' basements, a classmate tells me.)

At St. Peter's, fellow Williamsburg students and I were accosted by some unfamiliar toughs who puzzled us by asserting that Williamsburgers were "a bunch of [unprintable]." POW! came their fists. We ran home and told the biggest dad in our circle, but he had no way of finding them.

At St. Andrew's, The Hangmen, an area band with a national hit ("What a Girl Can't Do") drew thousands pouring out onto Lorcom Lane.

My own church, St. George's, hosted lesser-known groups but filled its parish hall with kids from, ahem, different high schools.

This notion of "outsiders" may have been the reason that St. Mary's, if memory serves, had to cease holding dances after too many fights.

But Little Falls presses on, helping kids make memories that last.

Vanished Arlington Businesses

May 2, 2012

The Arlington Historical Society recently gave me a chance to expand on earlier research on the bygone haberdasheries, entertainment venues and hardware emporiums that now exist only in our collective memory.

I was pleased that the crowd of eighty-plus at Arlington Central Library accepted my invitation to enrich the presentation with their own recollections.

No matter which nook in the county you occupy, there's bias toward your own points of orientation. So when I mentioned a long-gone People's Drugstore or a Howard Johnson's on Lee Highway, old-timers chimed in with memories of branches on Columbia Pike.

The universal was the nostalgia with which people recall the routine commercial relationships of their past.

To prepare, I spent many happy hours checking vintage issues of Polk's and Hill's business directories and the old-fashioned Yellow Pages. But most fun were the e-mail queries I farmed out to friends, whose passions sometimes outran their memories' reliability.

Take Wally's Aquarium. There were major debates over its location in the '60s. Many recalled buying snakes and tarantulas at Wally's in the basement on Fairfax Drive and North Glebe Road. But it moved. Some recalled it going southward on Glebe, near Carbone Animal Hospital and Arlington Hobby Crafters (Mercedes-Benz of Arlington is there now). But in the mid-'70s, Wally's shuffled off to Little River Turnpike, and in 2010, it folded.

Arlington's business history was on my mind when I recently got a sneak peek at some artifacts that provide a snapshot of hometown commerce from a certain era.

Ali Ganjian, a board member of the Arlington Historical Society, let me examine two fascinating items not yet on display at the Hume School museum.

A pair of wooden card tables, probably handmade, are emblazoned on their leather surfaces with soft-sell advertisements for local businesses going back to the 1940s or early '50s.

They were donated in 2009 by Ray Anderson, the retired founder of H-B Woodlawn Secondary school, who discovered them at the Columbia 285 Masonic Lodge in 2004. One guesses they were fundraising tools. As a sort of Yellow Pages frozen in time, the tables offer a glimpse of our everyday past neglected by local history books.

The card tables, one for Arlington and the other broadened to include merchants in McLean and Falls Church, date back to pre–zip code days (before 1963). The phone number prefixes use the old-fashioned Oxford or Jackson. There's an ad for a Packard dealership, and since Packard's final model year was 1958, that takes us back even further, to the days when the milkman from Alexandria delivered to Arlington homes. (One ad's slogan: "Let the smiling Thompson milkman serve you those delicious Honor Dairy products."—Hollin Hall, Virginia, established 1881.)

Because there are no ads for war bonds, I'd place the artifacts as post–World War II.

The hub of Arlington's commerce was clearly the Rosslyn-Clarendon patch, on Washington and Wilson Boulevards.

Lots of car lots. You get Kirby's Sales and Service, Al's Motors, Arlington Motors, Edmonds Motors, Joyce Motors and Spurrier Motors (which sold Packards). There are also some long-gobbled-up banks I recall—Arlington Trust, Old Dominion Bank—and funeral homes such as Fitzgerald and Ives.

Also some stores with antiquated themes—Arlington Bootery and The Woolery ("blanket specialists"). Some popular eateries (the Colonial Kitchen and the Quality Frozen Custard, both on Wilson Boulevard). Long-overtaken hardware stores—Harry W. Cuppett, Columbia Hardware and Appliance, Dale Lumber. And various family merchants: Barnes & Kimel Co. Furniture, Grover E. Payne Insurance, Gamble Bros. Florists.

Falls Church entries include Yeatman's Hardware, Wallace and Monroe Pharmacy (listed at 438 South Washington Street, now the Bike Club bicycle shop), J.W. Koons and J.V. Birch Falls Church Garage, Bryant's Restaurant (East Falls Church) and Bethel No. 1 Job's Daughters (a Masonic youth organization).

A few businesses from this era survive. One ad was for the Public Shoe Store (I'm a customer), which has been on Wilson Boulevard in Clarendon since 1938. (Curiously, there is no ad from nearby T.L. Sullivan & Son Monuments, even though its sign boasts that it's been on Washington Boulevard since 1885. Nor is there one for Sam Torrey Shoe Repair, cobbling away since 1945.)

But the bulk of these local trade stalwarts now belong to the ages. Some doubtless fell to competition, conglomeration or the march of technology. Each demise doubtless brought some lost investments, some family heartbreak, some loss of local tradition.

My friends were stumped when I demanded the name of the billiard lounge I could picture at Glebe and Lee Highway. It was the Q Ball Club, not Jack and Jill's nor Cue and Chalk.

The Public Shoe Store has lined Clarendon's streetscape since the 1930s. *Courtesy Arlington County Public Library Center for Local History.*

But lots came through with vivid memories, such as the pal who, as a high schooler, performed home deliveries for Major Bo's Chicken Delight (a '60s alternative to pizza located near today's Metro 29 Diner). Another recalled the specific salesman (a Mr. Hancock) at the old Hahn's Shoe Store in Clarendon. Many who attended high school proms in Arlington from the 1960s onward recall Tom Sarris's Orleans House, the steakhouse in Rosslyn that closed in 2008.

From the audience came a man who rekindled a memory of Swiller Brothers Music Store in Clarendon, where my mother bought me my first 45-rpm records, and Cooper-Trent printing shop. When I mentioned Speedy Gonzales, a popular Tex-Mex restaurant in Ballston of the 1970s, a man testified it was in the home in which he grew up.

Nearly all recalled Kann's department store, which dominated Virginia Square before the advent of George Mason law school. (Yes, Kann's had caged live monkeys, but no one can find a photo.)

I inventoried the other beloved shopping mecca, Parkington, the predecessor to Ballston Mall that used its gigantic façade to spell messages like "School's Out. Drive Carefully." Inside was McCrory's, a five-and-dime near the "Arcadian Garden" and its lunch counter that offered banana splits for whichever price

tag (as low as a penny) was contained in a balloon you popped. Across the street was the much-beloved Putt-Putt mini-golf orange-painted delight.

Many merchants had slogans. Progressive Cleaners claimed, "Arlington is progressive, so are we." And matchbooks used to read, "Don't say Drug Store, say Drug Fair. There's a big difference!"

I reported unofficial details as well. The old Williamsburg Pharmacy had a fountain counter with an underside lined with wads of chewing gum. The Blue and Gray Market on Quincy Street tempted underage Washington-Lee students in the '40s and '50s to buy cigarettes.

Credit an old friend with recalling the most obscure vanished Arlington business: the bait shop and Esso station on the finger of land beside Chain Bridge. I hung out there, too.

Our Four Oldest Shops

September 19, 2013

Arlington's roster of venerable old businesses reset in 2012 when the granddaddy of them all, T.A. Sullivan & Son Monuments (founded in 1885), moved from Clarendon to Vienna.

I've since chatted with proprietors of what may be the oldest shops still serving our county, four paragons of entrepreneurial tenacity.

The longest-standing has to be the Public Shoe Store on Wilson Boulevard (established in 1938). It's run by Sholom Friedman, age eighty, who began working for his father when he was five. After struggling during the Depression, founder Sam Friedman borrowed money and rented across the boulevard in the old Jones building (now Clarendon Metro stop). He doubled its size when the Ashton Theatre was torn down, moving the shoe store to the current location in the 1970s. "He was a smart man," says the son, showing a photo of his parents meeting President Carter.

My mother took us there as kids in the 1960s, and Friedman confirmed a memory that the store kept three-by-five cards recording customers' shoe sizes. The Public Shoe Store remained competitive with as many as six nearby stores, Friedman says, among them Hahn's, Thom McAn, Miles, Stein's Bootery, Kinney and Chandler's.

Today's threat is from the Internet. "Many people don't go out retail shopping," Friedman says.

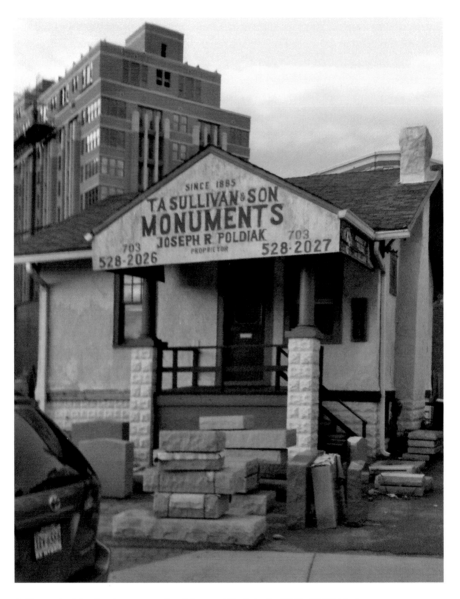

Arlington's oldest business moved to Vienna, Virginia, in 2012. *M.W. Montgomery.*

Stop by Sam Torrey Shoe Service (established in 1945) at Lee Highway and George Mason and meet hardworking Armenian American Kevork Tchalekian. He and his father bought the business from founder Sam Torregrossa (who died this April at age ninety-one) in 1986. Tchalekian,

fifty, has five employees and a collection of testimonial letters from satisfied customers. (I go there for heel plates and luggage repair.) "It's a living, but it won't buy me a Mercedes," he told me. With people replacing shoes more quickly, his "is a dying trade," Tchalekian says. "A matter of time."

Near Virginia Square on Wilson Boulevard, you'll spot Hurt's Cleaners (opened in 1948). It was a family business for three generations until the founder's grandson Richard Hurt sold out in 2006.

Enter Korean entrepreneur Dong Hyun Na. Choosing the motto "faithful, honest and kind services," he remodeled to modernize and added the latest technology for organic cleaning, shirt-press machines and computerization. "To build Hurt Cleaners as a brand, we have adopted a new logo as well as a vision statement that best reflects our goals," he said through a translator. "We have designed a new website and hope to open social media outlets."

Despite the economic downturn, he said, "our business has fortunately been profitable. Our customer base has been consistent, and we haven't had to cut the number of employees."

Next stop was in Westover, to Ayer's Variety and Hardware (also established in 1948). Ron and Wilma Kaplan have run the old-fashioned five-and-dime since buying it from John Ayers's estate in 1977 and have since brought in new staff (which now number nineteen).

Ron Kaplan says business is steady no matter the economic climate. "The only bad time was around 1996 when Home Depot opened." But eventually, customers came back in droves "because their time is more important than money, and they can get in and out of Ayers in five minutes," he says.

Though Kaplan would feel threatened a bit if a Wal-Mart came near, "I don't check other stores' prices—I charge what I have to to keep my business going."

May they all.

Buddy the Mover Man

November 28, 2012

A death notice for a memorable moving man made the rounds in November 2012 among a slice of my Arlington boyhood pals.

Arthur "Buddy" Frey, of Spotsylvania County, who died in June 2012 at sixty-eight, may never have known his impact on the lives of dozens of

suburban teens back in the 1970s at what then was an Arlington institution known as Newlon's Transfer.

The e-mails flew, forty years after Buddy and the other furniture estimators, truck drivers, packers and warehousemen gave our gang of "college help" our first adventures in blue-collar work.

My brother, sister and a dozen-plus friends spent summers at Newlon's at the North Nelson Street yard still visible off I-66 at Quincy (between Hayes Playground and the vanished Skor-Mor bowling alley). We packed household goods and humped hide-a-beds up walk-boards for hourly wages that

A vestige of the moving company that gave college kids a real-world education. *Elizabeth McKenzie.*

(memories differ) ranged from $1.56 to $2.25. We rode around the Beltway to homes of military families for moves dispatched from the old Cameron Station in Alexandria.

My friend Willie swore he would have "worked there for free just to build character and nobility!" Winnie recalls feeling "like a voyeur" while packing others' belongings that, for some Newlon's veterans, included dirty dishes.

Most of us were hired by gruff owner Harry Earl Newlon Jr. Steve recalled how Harry Earl "would come out of his office, go to the shed and holler at us for standing around and not cleaning up" but then look at Steve privately and wink. My sister Martha remembers Harry's impatience when some callow employee couldn't get a truck running—the boss removed his jacket and applied his "diamond-ringed fingers" to make the engine roar.

My friend Dickie, who in college folklore class wrote a fifty-page paper on Newlon's, recalled the Saturday he and pal Randy were driven to Harry's Fairfax home in a flatbed truck. They picked up a backhoe to spread topsoil. "His wife made us tuna salad sandwiches for a fifteen-minute lunch," Dickie remembers. "We went back to the office, and

Harry told us he would fill in our time-clock cards. He docked the travel time and the tuna fish–eating time."

Much more approachable was Newlon's son, Harry Earl III, called "Butch." One guy in our college crowd threw a beer party and invited the whole Newlon's crew to his parents' home; Butch was the only professional to show.

Buddy Frye, as James recalled, once passed out a memo declaring a guaranteed vacation time for long-term employees, allegedly signed by Harry Earl, though he delayed giving the boss his own copy.

Buddy was a silver-tongued salesman with customers. My brother recalls Buddy mocking him for believing the 1969 moonwalk really happened. My friend Donley recalls getting in trouble and hearing Buddy say, "Let ol' Bud take care of it."

Many of us worked during the floods from 1972's Hurricane Agnes. A black crew leader who couldn't get home to D.C. spent that night on a cot in our Arlington home.

Newlon's was still going in 1993 when I booked a local move. Eventually, its property was taken over by technology contractor System Planning Corp, and Newlon's shrunk to a moving supplies office run by Butch near Landmark shopping center. Butch died in 2004 and his father in 2010.

Today, the old Newlon's yard belongs to Arlington Public Schools. I treasure my education from both owners.

Wonderful Radio Waves

April 10, 2013

The word "radio," I'm reliably informed, was first used by broadcasters a century ago in 1913 right here in Arlington. The transition from the quainter "wireless" was accomplished at the Naval Radio Station, the area's first such facility, located at what is now South Courthouse Road and Seventh Street, according to research by my history buff friend Tom Dickinson.

Successors in the burgeoning radio industry would include country station WARL, which broadcast for decades at Lee Highway and North George Mason Drive. It later became WAVA—all news, hard rock and then Christian programming.

Another local radio asset was longtime Arlington resident Willard Scott, originally of the 1950s–70s "Joy Boys" on WRC-AM. (As a twelve-

year-old, I delivered his *Washington Post*.) He was later famous as Bozo the Clown, Ronald McDonald and, eventually, the weatherman for the national *Today Show*.

But for most with ears and Arlington in our blood, music radio will always mean WEAM. It reigned at 1390 on the AM dial from 1948 into the 1980s and baptized many a youth in the joys of top forty. "The lively lineup" and "WEAM Team Redcoats" of voices like Terry Knight and Jack Alix (JA the deejay defected to WPGC) were major influences on boomers' formative years. The call letters originally stood for the licensee's daughter, Ellen Ann Miller, according to a 2013 online history by Thomas White.

Though a modest five thousand watts, WEAM shouted its Arlington location over the airwaves (the office was at 1515 Courthouse Road, but the studio was above Minor Hill, off Williamsburg Boulevard). My pal Dave McGarry recalls hiking to the studio and witnessing the jock sending out the Beatles' "Hey Jude" to teens around the Beltway. Dave still owns copies of WEAM playlists and an early '60s photo gallery of WEAM personalities Lee Stevens, Paul Christy, Les Alexander and Johnny Rogue. Sports news was delivered by a young-looking Nat Albright.

In an online reminiscence in 2010, Bill Prettyman, a WEAM deejay from 1961 to 1965, recalls the fabulous reverb the engineers used to create that high-energy sound. Most of the jocks had stage names (his was Doug Vanderbilt). "There was no news department," he wrote, just "rip and read" off the wires.

Whether you heard WEAM in your car, from your kitchen intercom or crackling out of your Japanese transistor in bed at night, you got the latest pop and rock singles punctuated by promos and call-ins that conjure up an array of Arlington's eateries, schools, sports and shopping meccas.

I got a nostalgic taste of WEAM in 2005 when a local history nut gave me a CD recorded from SiriusXM radio. Current satellite radio host Terry "Motormouth" Young conducted detailed research to re-create WEAM from the years spanning the 1960s. Between his own voice and that of WEAM veteran Russ Wheeler, you hear hits by the Marcels, Tommy James and the Shondells and the Swingin' Medallions alongside shout-outs to waitresses at Hot Shoppes, Tops Drive-In and the Broiler. You could buy the latest hits downtown at Waxie Maxies or Swillers (in Clarendon) and then hit Woodward and Lothrop to score a pair of Levi's for four dollars, perhaps to wear to a movie at the Sunset Drive-In.

Motormouth congratulated Wakefield High School for being school of the year and described O'Connell High as the place where girls have to

kneel on the floor to prove their skirts are long enough. He also sent kudos to the Black Knights Little League team for capturing the 1968 championship. Out in radioland, more than a few ex-kids were thrilled.

Cheery Old Cherrydale

February 1, 2011

Once every fifty years, I revisit my boyhood home. At least that's the pace I set in winter 2011 when I imposed on a certain homeowner in Arlington's charming Cherrydale neighborhood.

Trustingly, this stranger allowed me a Proustian tour of a memory-rich house whose floors I hadn't traipsed since my age was single digits back in the 1950s.

Sure, I've often driven past the two-tone wood structure on North Monroe Street that my parents sold in pursuit of larger dreams over by Chain Bridge. But that was more as a lurker than a denizen of the historic community off Lee Highway named for an orchard in the nineteenth century.

Cherrydale was my family's Arlington road not taken. So I boned up on its macro-changes—I-66, gentrification in this National Historic District—before indulging the personal.

"Fifty years ago, Cherrydale was a close-knit community with a small hometown feeling, a thriving downtown and our own overcrowded school," says Kathryn Holt Springston, the all-but-official Cherrydale historian who gives Smithsonian walking tours of its century-old Sears homes. "The houses were mostly small, the yards were big and there was plenty of room for the kids to roam. Today, Cherrydale is still close-knit, with neighbors who look out for each other and enjoy community activities—our annual parade, picnic and Christmas with Santa at the fire station," she says. "We still have adorable smaller older homes, including many kit houses, despite the influx of newer huge monstrosities."

(Springston, by the way, was my first-grade classmate at Cherrydale Elementary, which closed in 1970, giving way to the Cherrydale Health and Rehabilitation Center.)

Bob Witeck, a Cherrydale stalwart of twenty years who bought in part because of fond memories of nearby St. Agnes School, loves the proximity to Washington. There's a "healthy mix of blue-collar families and younger

professionals," he adds, though "we're not immune to developer appetites to tear down the old and stack up McMansions."

The threat of "supersizing" also bugs the owner of my former home, who wonders why quantity of space is valued over quality. Having "loved the place the minute" she saw it, she gasped when I showed her my photo of the 1930 vintage house around the time she arrived in the 1980s.

My reminiscences may have bored her, but she cheerfully guided me to the kitchen that, for me, is the primordial kitchen, with its cozy pantry where my mother stored mysterious bottles labeled "quinine water." Still intact was the back porch, where I burned my hand on a Fourth of July sparkler. And the stairs down which my father fell and broke his leg, having slipped on a grape dropped by me or my brother (more likely him!).

Recognizable beneath the current decorating scheme is the TV room where I watched *American Bandstand* and mocked my dad for watching something called *Meet the Press* (which I now watch).

The changes have been minor, my hostess assured me—new exterior vinyl, a fancier backyard garden, front-door surroundings recast after the rotting of a bench and lattice.

Back outside, I strolled and recovered more memories: the vanished alley once occupied by Mr. Dortzbach's plumbing truck, our penny-candy store (now a Philippine market) and, down the block, the wooden box that I believe is Arlington's smallest house.

It was a lovely walk down the road not taken.

Majestic Old Cinemas

March 7, 2012

I was part of a pre-selected audience assembled at Arlington Cinema and Drafthouse in the spring of 2012 for a special, locally flavored screening.

We were treated to the offbeat rock musical comedy *The Adventures of Buckskin Jack*, written, directed and produced by Arlingtonian Liv Violette and her artsy extended family.

The self-financed film set in pre-Revolutionary Virginia—which Violette is aiming at national distributors—got commercial marquee exposure on Columbia Pike, the crowd got a fun free flick and a party and the drafthouse got a stream of dinner orders and wait-staff tips.

As an economic model, this was a far cry from the days when the hybrid drafthouse was simply the Arlington Theater, one of a half dozen cavernous cinemas that became the settings for many highlights of my Arlington youth.

Nowadays, I faithfully patronize the trio of still-hanging-in-there multiplexes at Ballston, Courthouse and Shirlington. But somehow their blur of choices and shopping mall surroundings make the visits less memorable than my yesteryear trips to those ornate single-screen emporiums of fantasy.

I decided to conjure up a sort of Arlington theater "revival." I combined my powers of recall with local history books, a microfilm check of theater listings from the old *Northern Virginia Sun* and an online search that uncovered a nifty amateur website called cinematreasures.org.

The oldest county cinema I found was the Ashton, which opened in 1927 at 3166 Wilson Boulevard (now the heart of yuppie Clarendon). It had been dark since the 1950s when it was demolished in 1974, but I suspect there are Arlingtonians alive who spent some vivid date nights there.

Just down Wilson toward Rosslyn was the Wilson, which opened in 1936 (with Fred Astaire and Ginger Rogers in *Swing Time*) and served nearby Colonial Village apartments. It went under in 1978.

Closer to my north Arlington neighborhood was the Glebe Theater, which opened in 1945 at Lee Highway and Glebe (current site of Duron Paints). In 1965, its name was changed to the Dominion. I have intense memories of seeing Edgar Allan Poe movies there. Its lights went out in 1972.

Arlington's outdoor cinema, the Airport Drive-In, opened in 1947 on Jefferson Davis Highway and could fit one thousand cars. It flickered until 1963.

That was about when I became old enough to visit the Buckingham Theater, at Pershing Drive and Glebe. I saw an early '60s monstrosity there called *Santa Claus Conquers the Martians*, though my mother forbade me from seeing its showing of *Never on Sunday*. It is now a post office.

The Byrd Theater was on Washington Boulevard near South Courthouse Road. It switched from popular fare to skin flicks in the 1970s and was long ago paved over. The Lee Theater did business in East Falls Church in the 1930s through the early '50s at what today is the intersection of Lee Highway and I-66.

A late starter was the Crystal City Theater, which launched in the early 1970s, when its namesake was spanking new. It lasted twenty years and is now an auditorium. Just down the road, the Pentagon City Theater launched in 1989 but succumbed in 2003.

Local borders being permeable, we Arlingtonians ventured beyond to the State Theater in Falls Church (now a fine rock venue), the Centre on

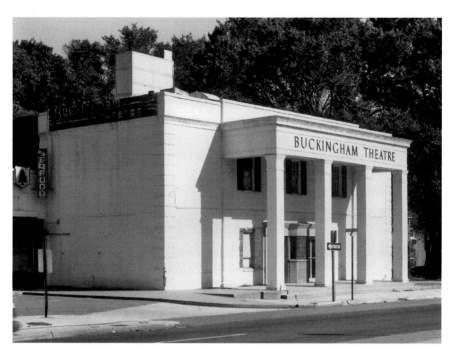

Now a post office, the Buckingham's fare ranged from *Never on Sunday* to *Santa Claus Conquers the Martians*. *Arlington County Public Library Center for Local History.*

Quaker Lane, the Tysons on Leesburg Pike, the Annandale (on Little River Turnpike) and the Jefferson (Arlington Boulevard and Annandale Road). When we were truly adventurous, we hit the Lee Highway Drive-In (1954–84) in then-rural Merrifield. Like seeing *Buckskin Jack* at the drafthouse, going there was half the fun.

Our Good Humor Man

February 28, 2012

An odd and unsung sight in Arlington is the vintage white Good Humor truck I drive past regularly on a residential street just off Bluemont Park.

To chance upon it as a child would be rather like pulling into a highway rest stop with your parents and encountering Santa Claus—his sled and celebrated animal team taking a well-earned out-of-the-limelight breather.

The magic of Good Humor memories, which, for the nation, go back to the company's founding in 1920 by Harry Burt in Youngstown, Ohio, are vivid for Arlingtonians for another reason: so many of us live in secluded, noncommercial subdivisions where access to fresh cool desserts comes more often through infrequent car journeys to supermarkets.

What a treat it was, back when your young age restricted transportation options, to have the playtime routine broken by that unmistakable four-pitch chime. Who among us didn't rush home to scoop up loose change and join friends for our pick of a chocolate éclair, toasted almond or frozen fruit delight?

This particular Good Humor truck parked on an Arlington side street is an astonishing 1969 model Ford F250. It has 693,000 miles on it, says owner Rick Hancock, a four-decade veteran of curbside ice cream vending who, on this day, is spiffing up his open-sided truck for the March–October season. Arlington kids may be disappointed to learn that for the past two decades he has been servicing a route in Sterling, Virginia.

So he's not really your local Santa (though he used to be).

That honor now belongs to a dozen other independent ice cream vendors who drive Arlington's routes, I was told by Guy Berliner, president of

Do neighborhood kids knock on the Good Humor man's door? *Charlie Clark.*

Hyattsville, Maryland–based Berliner Specialty Distributors. He supplies 225 local mobile vendors who work mostly part time and seasonally.

Hancock, a trained mechanical engineer and technician for Verizon, is among the most committed to preserving Good Humor's white-uniform traditions. "They're a bit of a dying breed," he says.

He is unusual in parking his vehicle at home. "Most vendors drive their own vehicles to Hyattsville, where they buy the merchandise and switch to an officially labeled truck," says Berliner. "Some neighbors may frown on" a commercial truck inhabiting a home driveway, he adds. (Hancock is in compliance with Arlington's code because his commercial vehicle is under the weight maximum. His neighbors appear to love him.)

Despite its folksy image, Good Humor in the twenty-first century is part of a complex chain of evolving corporate ownership. There were mergers with Breyers, Sealtest and Kraft Inc. before current owner Unilever took over in the early 1960s. "Though sales are flat in some parts of the country, it really is popular here—lots of growth," Berliner says.

Nostalgia websites give the history of Good Humor's first ice cream on a stick, now made in Green Bay, Wisconsin. "In the early days, Good Humor men were required to tip their hats to ladies and salute gentlemen," one says. There was even a 1950 movie called *The Good Humor Man*.

Corporate changes in the snack food world have come with changes in Arlington, where development emphasizing the urban village has probably moved a greater percentage of residents near markets to which they can walk when they get the munchies.

But ice cream never tastes nearly as good as when that chummy white truck brings it right down your street.

Student Activism Then and Now

November 19, 2013

In Arlington, budding politicians start young.

In October 2013, one hundred middle-schoolers gathered at H-B Woodlawn for a "teen leadership" exercise in a mock general assembly. The kids researched and debated bills according to Richmond's procedures, telling fellow solons, per the *Sun-Gazette*, a certain parliamentary ruling was "cool."

What was cool for me was noting that the event took place at the Woodlawn program, itself the creation, in part, of prodigy student activists I knew in the late 1960s and early '70s.

Things back then were more contentious. Before that "hippie high school" was launched in 1971 under then–Wakefield High School teacher Ray Anderson (now retired but still active in education), it was incubated under a student rights group called the Arlington Youth Council.

In 1969, its big issues were student rights to protest the Vietnam War, read underground newspapers, battle oppressive dress codes and experiment in free-form education. Those Youth Council presidents were uppity, articulate teens, among them James Rosapepe (now a Maryland state senator and one-time ambassador to Romania), Jim Massey (living in Phoenix doing real estate and technology startups) and Jeff Kallen (now a linguistics professor at Trinity College, Dublin). Kallen became the Washington-Lee High School pied piper who teamed with Anderson to found Woodlawn.

Our crowd then was obsessed with demanding a student smoking court—an issue I'd now say hasn't stood the test of time. But we wanted student views respected, and that proposition took flight.

Nowadays, half the states allow student school board members, according to the National School Boards Association. In Takoma Park, Maryland, this month, sixteen- and seventeen-year-olds for the first time had the right to vote in city elections.

Deference to student sentiment over adult objections continues at Woodlawn in the form of the Thursday town meeting. That decision-making forum—open to students, teachers, custodians and parents—"is well attended, depending on the issue," I'm assured by Principal Frank Haltiwanger. "Anyone can put an agenda item outside the main office door," he says, whether the topic is a school dance or overcrowding.

One issue that raised emotions two years ago, Haltiwanger says, was Arlington schools' online parent portal, which was conceived to allow parents to remotely look at their child's attendance, grades and assignments. "The initial reaction from many was that it doesn't make sense to do this for parents before students," he says. So the Woodlawn town-meeting folks wrote to the school board, and soon students, too, were in on the portal.

The Arlington School Board has no student member, "but we do have a Student Advisory Board made up of representatives from all high schools," I was told by Linda Erdos, assistant superintendent of school and community relations. It touches all democratic bases, meets monthly and is assigned a school board liaison and staff liaison. The advisory

board addresses topics submitted by the school board, working with administrative staff on upcoming agenda items while funneling broader student input on "issues of importance."

These teens meet with the school board quarterly, and like all of the board's thirty advisory committees, they report to the board during a year-end meeting.

Though I'm as impressed today with Arlington's young activists as I was back in 1970, I can't help but feel—in this age of helicopter parenting—that most teens would find democracy's accompanying policy minutia...a bit dull.

LOTS OF PERSONALITIES

Our Homeboy John Glenn
February 15, 2012

Presidents' Day 2012 pulled double duty and marked the fiftieth anniversary of uber-astronaut John Glenn becoming the first American to orbit the earth.

And though Glenn's heroics in February 1962 made him a historic global figure, he was also, at the time, an Arlingtonian.

Revisiting the early spaceman's footprint on our soil, I was recently reminded of some drama that unfolded here in an era far more romantic than ours.

When Ohio-born U.S. Marine lieutenant colonel John Glenn was completing his three-year preparation to pilot the "Friendship 7" spacecraft, he resided at 3683 North Harrison Street. That's across from my old junior high, now Williamsburg Middle School, which Glenn's children also attended.

Williamsburg's current librarian, Adela Eannarino, agreed to show me her John Glenn memorabilia, even though it wasn't on display.

Today's kids may be less enthralled with space than their predecessors, she suggests. So it's vital we recall Glenn from a time when the space program was new and exciting and wrapped in life-and-death competition against the Russians.

Glenn's nearly five-hour flight began atop an Atlas rocket at Cape Canaveral, Florida—after numerous frustrating postponements—and took him to a velocity of 17,500 miles per hour and an altitude of 162 miles before he splashed in the Atlantic near Grand Turk Island.

The feat would make him "more famous than Elvis Presley," as a reporter said in one of the library's laminated news clippings. The collection also includes Glenn on the covers of *Parade* and *Newsweek*, as well as a signed portrait reading, "Best regards to the faculty and students of our favorite school, July 27, 1962."

Glenn became so famous that President Kennedy rode with him to address a joint session of Congress. Daughter Lyn Glenn, according to the March 30, 1962 issue of the *Williamsburg Patriot*, was thrilled when walking with her parents to see onlookers "stand there, with their mouths wide open, and stare."

Glenn went on to be a Royal Crown Cola executive and a U.S. senator (D-Ohio). In 1998 at age seventy-seven, he would return to space for a nine-day mission.

Little known until later, when author Tom Wolfe published *The Right Stuff* in 1979, was the family struggle inside Glenn's home the month before his epic flight.

With the astronaut down in Florida rigged up for a January 1962 flight that would be delayed, Glenn's wife, Annie, was holed up on Harrison Street dodging an obtrusive press corps. Though eager to be a model patriotic wife, she was terrified of speaking on camera because she stuttered. So she sat in her living room with a few friends, other astronauts' wives and one reporter, Loudon Wainwright of *Life* magazine, while journalists and voyeurs teemed outside.

"The lawn, or what was left of it, looked like Nut City," wrote Wolfe. "There were three or four mobile units from television networks with cables running through the grass. It looked as if Arlington had been invaded by giant toasters."

A few blocks away in a limo sat Vice President Lyndon Johnson. Feeling left out of the hoopla, he was pulling strings with NASA to be allowed in the home to comfort Annie Glenn on the stresses of space exploration. Both she and her husband refused him.

LBJ was so furious, Wolfe wrote, "you could hear him bellowing and yelling over half of Arlington."

The Man Behind the Northern Virginia Sun

July 10, 2013

As a newly minted college graduate back in 1976, I applied for a reporting job at the *Northern Virginia Sun*.

Thirty-seven years later, I landed an interview.

Herman Obermayer, the longtime editor and publisher of the old *Sun* (predecessor of today's *Sun-Gazette*), accepted my lunch invite so we could compare notes on Arlington history and the state of journalism. Obermayer was his own man in Arlington long before my time, and at eighty-eight, he continues locally as an active author.

My boyhood memories of reading the *Sun*—a jaggedly typeset broadsheet delivered six days a week by neighborhood kids—skew toward coverage of Little League (including thrilling team photos). I recall features not found in the larger dailies, such as the Gil Thorp sports comic and fishing/hunting columnist Duck Duckson.

In my garage, I recently discovered a yellowed *Sun* edition from June 16, 1972. Headlines: "I-66 Path for Metro Likely" and "Students Draw Bead on Rights Revision," quoting the old Arlington Youth Council. On the front page was Obermayer's "Editor's Viewpoint," in which he saw a rare defeat of a Fairfax school bonds referendum as a sign that "no growth" was growing in popularity.

The hometown paper for many postwar Arlingtonians was delivered to their homes in the afternoons. *Elizabeth McKenzie.*

"I never missed a week on the column," Obermayer told me, "even if I was sick or traveling or had a birth in the family." From 1963 to 1989, he wrote 1,700.

Obermayer bought the *Sun*, which dated from the 1930s, from "a bunch of New Deal liberals," as he calls them. A Philadelphia native and Dartmouth graduate with news experience in New Jersey and New Orleans, he also brought his World War II combat zone experience. He spent much of the '60s battling a strike by mechanical unions.

The editorial line was "center right," Obermayer says, "though I went out of my way to endorse a few Democrats since I didn't want it to be a Republican paper like Fox News." To compete, the *Sun* published editions for Falls Church and Vienna, which the big Washington papers often ignored.

Today's weekly tabloid *Sun-Gazette*, says Obermayer, "is a dubious heir because it has been through so many turnovers and changes. But they do a pretty good job, and I admire what they're trying to do."

Obermayer's *Sun* stood out with coverage of the American Nazi Party in Arlington (he had witnessed the Nuremberg trials). Far from intimidating the staff, the assignment "was a coveted job," he recalls. "A school board meeting could be pretty dull" without some protest by George Lincoln Rockwell or followers. When the county board in 1983 allowed a Nazi demonstration at Yorktown High School on free speech grounds, Obermayer wrote editorials saying the board should be ashamed.

The *Sun* drew national attention in the late 1970s when it adopted an unusual policy of naming rape victims, on grounds of treatment equal with suspects commonly identified. "I still think I was right," Obermayer says, arguing that allowing accusers anonymity conceded too much power to the state.

But the policy may have dented profits when he sold the paper in 1989, he admits. Still, Obermayer did all right for himself by transforming his business into a printer for college, trade and association newspapers. The new owners were uninterested in his *Sun* bound volumes, so he made sure they ended up at the Arlington library and the Arlington Historical Society.

Martin Ogle the Naturalist

May 9, 2012

Living space in Arlington offers glass towers and loud-lettered commercial signs but also leafy residential lanes and havens that leave nature undisturbed.

Tender loving care for the havens is the legacy of Martin Ogle, retired in 2012 after twenty-seven years as chief naturalist and manager at Potomac Overlook Regional Park off Military and Marcey Roads.

Though Ogle's employer, the Northern Virginia Regional Park Authority, covers six jurisdictions (Falls Church among them), the Arlington County Board felt moved to honor him during last month's Earth Week. I'm personally grateful for Ogle's help with journalistic research over the years on history and botanical matters.

"I'm in a different park system, but it's clear citizens of Arlington value their nature centers," says Ogle, recalling how Arlingtonians rose up several years ago to quash a proposal to close the nearby Gulf Branch Nature Center. "It's a traditional center where people can learn natural history, but it's also where we, as society, can learn sustainable ways of living, which I hope will continue to grow."

Immersion in nature leads to a desire to protect. One of Ogle's proud accomplishments is getting the ball rolling on recycling back in the early 1990s. "We held meetings and became a drop-off point where we collected aluminum and sold it to raise funds for the park," Ogle says. When the county adopted its own system, his team no longer had to.

Ogle also took on energy sustainability. "One of the themes is how human activities interact with the rest of nature around us," Ogle says. So twenty years ago, the exhibit center at Potomac Overlook was outfitted with a solar hot water system, modern insulation, double-paned windows and an efficient heating and cooling unit. "By virtue of having been here this long, I've had the luxury of being able to build slowly among all the pieces," he says.

If there's any unfinished business, it's that nature centers are underutilized. "If you come on weekdays, it's kind of quiet but still a nice place to take a walk, the largest wooded area in Arlington," he says.

Ogle is leaving "a pretty well-developed energy education program"—ten to fifteen programs a year. "But it's just been me trying to get the word out," he says, and "publicity has to be on a larger scale than one employee can do."

Ogle's work with elementary schools is legendary. He draws inspiration from *Last Child in the Woods* by Richard Louv.

ARLINGTON COUNTY CHRONICLES

Beth Reese, a longtime Arlington environmental educator who worked with Ogle on outdoor classrooms, says he "has the amazing ability to carry on the highest scientific or philosophical conversation at the same time he is playing with worms or up to his waist in pond scum. He's a cross between a mad scientist, a Boy Scout and Thoreau."

The county board's proclamation cites him for helping make Potomac Overlook a "natural oasis" and for serving on the Urban Forestry Commission, the Task Force on Arlington's Future and the Community Energy Advisory Group.

George Mason University gave him its Green Patriot Award.

Retiring from his first and only full-time job with a pension at the fortunate age of fifty-one, Ogle is moving his family to Colorado, where he will "take up to a year to find new work or create new work."

When next you head to the woods for fresh air, thank him.

Mary the Redskins Fanatic

September 14, 2011

Forget your gender stereotypes—I can report that our county's most exuberant Redskins fan is of the female persuasion. The proof is the Redskins room that Mary Holt, age eighty-seven, maintains in the north Arlington rambler she and her husband have occupied for fifty-seven years.

Mrs. Holt's phantasmagoric gallery of burgundy and gold gathers some 1,500 team knickknacks ranging from napkin holders to clocks to team photos to Redskins Wheaties cereal boxes. The middlebrow collectibles cascade from every inch of her "woman cave"—a spare room with an organ, an easy chair and a large TV where you can find her every game day.

"Who knew when I started with a Hogs Christmas wreath that this would go hog wild," she says to the bemusement of her husband, Roger, who, though lukewarm on the Redskins, has built his wife several gems, such as a Redskins miniature covered wagon.

Since the 1980s, Holt estimates she has spent some $2,300 on such Washington-area must-haves as Redskins toy buses, playing cards, coffee mugs and a champagne bottle. Others came as gifts, such as the poster congratulating the 1991 NFL champs that once adorned the Falls Church Giant Food store.

Mary Holt's uncluttered "woman cave." *Samantha Hunter.*

Once the collection began to bulge, Holt's son and daughter surprised her when she returned from vacation to the room with its door shut. She flung it open, and there the collection was arrayed against a two-tone burgundy-and-gold paint job (four coats) with chair rails and an upper ceiling strip of Redskins-colored tape.

The variety of objects overwhelms the visitor: a Redskins Tiffany-like lamp and Redskins message-holders, sweatshirts, pompoms, book covers, dolls, beer mugs, helmets (real and toy), mini-airplanes, tissue dispensers, a flag, napkins, towels, gloves, birthday cards, earrings, footballs, stuffed hogs, cup warmers, light switch covers, scarves, shot glasses, coffee mugs, Christmas stockings and ornaments, puppets, brooches, bedroom slippers and a broom. Holt can locate any one in a flash.

The favorite is the Hogs Christmas wreath, says Holt, who wears a Redskins necklace and a watch.

On her walls are team portraits for Super Bowl seasons '82, '87 and '91; sports-page photos; and cheerleader squad portraits. She owns jerseys of Hall of Famers Art Monk and Darrell Green and signed portraits of Joe Theismann and huge Hog Joe Jacoby.

On her floor is a stencil reading "Redskins Drive," which a friend found discarded at Ashburn. She also has a large "R" logo floor tile.

Oddities include a Redskins blanket with a wrong date for their arrival in D.C. (1935 instead of 1937) and a *Washington Star* farewell edition with a feature on Billy Kilmer.

A Redskins red brick is made of sponge so she can throw it at the TV after a bad play.

Though Holt once had season tickets and would wear her Redskins jacket to the stadium, she now prefers acting out her obsession in front of the TV.

She's not sure the Redskins office is aware of her devotion—they were surprised the time she phoned and ordered, as a woman, a personalized plaque declaring her the "Redskins' Biggest Fan."

Someday, when the Redskins must take the field without her one-track attentions, Holt hopes her children will preserve her treasures. She says, "I tell them, 'Don't you dare destroy this. Find someone who wants it, or I'll haunt you the rest of your life.'"

Glen the Panhandler

November 14, 2012

You may not be interested in panhandlers, but panhandlers are interested in you.

On the umpteenth sighting of the same bearded Arlington man at his station on the median at North Sycamore Street and Washington Boulevard, I finally let my curiosity take control. I whipped out a handy six dollars (though checkbook journalism is frowned upon) and asked the street-side solicitor for an audience.

Like a quarter-million others in the naked county, Glen has a story.

Standing mere inches from cars stopped at the traffic lights, he holds up a shifting selection of signs bearing such messages as "Bet you can't hit me with a quarter."

"If you think I don't work, look at my hands," he exclaims as he holds up his calluses. "That's what I say when people tell me to get a job." His only alternative, flipping hamburgers, he doubts would be successful.

Some onlookers doubt that Glen is deserving, and recent Arlington blog posts have mocked some panhandlers for operating with expensive-looking signs made at Kinko's.

Declining to give a last name, Glen is a roofer by trade. But decades of drug and alcohol abuse have left him, at age fifty-four, squatting on a slice of public property he takes pride in.

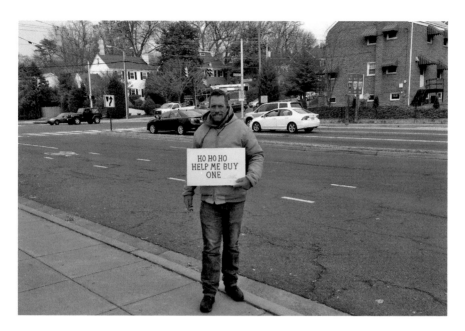

Hundreds pass by Glen's panhandling station daily. *Charlie Clark.*

Standing in his jeans, flannel shirt and hoodie across from the East Falls Church Metro parking lot, he also picks up trash, cuts up branches and digs drains for the grass on the median strip. He once put out a fire before firefighters arrived, he says, and has caught three bicycle thieves.

After seventeen years on the streets, "I know more people in Northern Virginia than you," he says.

Glen attended McKinley Elementary and Swanson Middle School, but by the ninth grade, he found himself at the Beaumont Juvenile Correctional Center in Powhatan, Virginia. As a young adult, he hit rock bottom with his habit when he ruptured a femoral artery with a heroin needle. "I almost bled to death before they took me to the emergency room," he said.

Since an arrest eight years ago, he has received regular treatment through Arlington programs, where he submits to a biweekly urine test. He's used the Arlington Homeless Services Unit Residential Program Center as well as Narcotics Anonymous and Alcoholics Anonymous.

Panhandling provides a return he claims is only five dollars a day. Glen refuses to "reveal trade secrets" as to how, while enjoying music on earphones, he judges drivers' openness to giving or the timing of stoplights for approaching cars. Police are concerned about safety—his and that of the drivers, an officer told me.

"I know the area like the back of my hand," Glen said. "The police call me a landmark."

He also knows the blonde female artist who spare-changes on the same site and the combat veteran who asks for money daily nearby at Fairfax Drive at Lee Highway on the ramp from I-66. Glen's wife, with whom he lives nearby, has panhandled on the same territory but now has a job at Starbucks.

Glen jokes that he'd like to retire with a gold watch. He'd also like to deejay for twelve-step organizations. He confides he has assembled a music collection with thousands of songs, along with computers and laser lighting equipment. "In the junkie's kind of mind," he says, "you will get what you want. But it will take time."

A Glimpse of the County Manager

December 15, 2010

Barbara Donnellan, Arlington's witty but earnest county manager, is a tad self-congratulatory when talk turns to her hometown's inarguable status as the most livable Shangri-La in these United States. But she makes her case.

Donnellan spoke in December 2010 at a banquet with the Arlington Committee of 100, that open-admissions club of county elite that meets monthly at Marymount University. She declared how "lucky we are to be in Arlington at this time, this place." She said her "caring community" is the "envy of others in the region" because of low tax rates and its mixed-use transit-oriented vision that "allows us to recover faster" from the recession.

She was just warming up.

A twenty-seven-year county veteran who has worked in finance and libraries, Donnellan shared thoughts on her first year in a job to which she was promoted from "acting" status following what felt like a "seven-month job interview." Her familiarity was reassuring after the board's unsuccessful attempt to have an outsider succeed Ron "Walks on Water" Carlee, who moved on to walk the floors of the International City/County Management Association before becoming city manager in Charlotte, North Carolina.

Donnellan moved here in the early '80s, back when county offices used typewriters, the current courthouse was a parking lot and Clarendon nightlife meant Lum's restaurant and Sears. Her role models then were two

local political stars, the late Ellen Bozman and state senator Mary Margaret Whipple, who has since scaled the prestigious heights of being a columnist for the *Falls Church News-Press*.

Donnellan vowed to continue Arlington's progressive zoning and transport vision laid out in the 1960s and '80s. She honored the small businesses that died then to make room for eleven Metro stops and the canyons of the Ballston-Rosslyn corridor. "Sometimes you have to have a vision and be brave enough to see it through," she said.

During Donnellan's first week on the job, days before Thanksgiving 2009, a water main broke near Walker Chapel. It caused the death by electrocution of a county employee. Knowing the risks of a water shutoff for Arlingtonians preparing to bake pies and receive guests, she was thrilled that Fairfaxians helped by filling cisterns and supplying piping. When staff phoned her on Thanksgiving morning with news that the water was back, she knew she had a great team.

Now Donnellan presides over a huge agenda that includes revitalizing Columbia Pike and reconceiving Crystal City, forging a rare partnership with Fairfax and Alexandria to build light rail. She must preserve the social safety net, having just visited the county's winter homeless shelter. And she can't stint on amenities—the new Cherrydale firehouse, the Trader Joe's bound for Clarendon, the area's most plentiful bike paths and the "generational investment" in open-space playing fields in Long Bridge Park.

"Don't take these things for granted," she said. The downturn forced the county to cut 160 positions and $33 million from the budget. Revenue growth is now at only 1 percent (last year it was minus 7.2). Employment will be impacted by coming cuts in Pentagon contracting. The schools must accommodate one thousand new students, and no one can find $2 million to refurbish the Lubber Run amphitheater.

"Change is necessary for sustainability," she said, and "we will continue to move forward and create new realities to adapt to change."

The audience was its usual exemplar of politesse, but a few skeptics posed questions. Does Arlington need an inspector general? ("That's a gotcha thing, and we prefer to do it in-house.") What about the decline of free parking? ("Our goal is to get more people out of their cars.") What have all the tax hikes and new initiatives gained us? ("There's no easy answer because it's incremental," but you wouldn't do without technology such as computers in police cars.)

Donnellan said she learned a lesson after vocal citizens shouted down county proposals to close the Gulf Branch Nature Center and the Cherrydale Library.

Asked how she would reach out to the twentysomethings moving to Clarendon—who're more into social networking than reading the staid county newspaper—she joked, "I'm considering requiring all my staffers to go to bars every night."

In running a $1 billion organization of 3,500 employees, Donnellan rightfully calls herself a "steward of the public trust." She sleeps better now that she's no longer just "acting," enjoying confidence in her staff and clear board support. I won't argue.

Justice from John Paul Stevens

May 15, 2013

Eminent Arlingtonian John Paul Stevens brought down the house. The unassuming retired Supreme Court justice wowed Arlington's Committee of 100 in May 2013 with wit and sports talk on top of the expected legal insight.

Freed to speak his mind at age ninety-three, Stevens also hazarded predictions on the high court's next moves.

Retired Arlington circuit Judge Paul Sheridan introduced Stevens as "one of the judicial giants," the court's third longest-serving member (1975–2010). "There is documentation he still has the top grade point average in the history of the Northwestern University Law School," the advance man said. "His only known flaw: when he plays Trivial Pursuit, he's weak on TV and movie stars."

Stevens verified a few legends from the sports world. Yes, he knew Branch Rickey, the Brooklyn Dodgers executive portrayed in the current film *42* who brought up pioneer Jackie Robinson to integrate baseball. He also interviewed Ty Cobb while researching baseball economics.

Most memorably, he did witness, at age twelve, Babe Ruth pointing to the outfield stands during the 1932 World Series in Wrigley Field and placing a home run right where he promised. Decades later, when the Chicago Cubs invited Stevens to throw out the first pitch, "I was a hero to my grandchildren," he said, "which is more important than these other things."

Memories the justice volunteered included several from his 1975 confirmation hearing after having been named by President Ford. As the first nominee to undergo a new tradition of personal visits with senators, Stevens recalled that Barry Goldwater promised his vote because the two shared

enthusiasm for airplanes. Strom Thurmond knew not to ask how Stevens would vote on the death penalty—"It's not proper to probe candidates' views, one requirement being to keep an open mind until you hear the parties and read their briefs," Stevens said. But Thurmond conveyed his support for capital punishment, and at a later meeting, Ted Kennedy conveyed his opposite view.

Stevens told of a bellhop in Washington's Mayflower Hotel who cornered the puzzled nominee in the elevator to relay the thrilling news that he had spotted the new Supreme Court justice having breakfast. The nominee happily confirmed it.

In response to audience questions, Stevens opined that the high court needs more diversity, legislative and military experience and trial lawyers such as Thurgood Marshall; that the Bush v. Gore case resolving the 2000 election "should have been rethought," as suggested recently by Justice Sandra Day O'Connor—"It was nonsense to apply an equal protection argument to hanging chads versus dimpled chads when the voter's intention for both was clear"; that the 2010 Citizens United decision on campaign spending was "incorrect," but "don't hold your breath for the court to change it"; that the 2012 decision mostly upholding Obamacare vindicated his confidence in Chief Justice John Roberts's "integrity and independence" in following the law even when it's not his policy choice; and that in the coming twin rulings on same-sex marriage, he guesses, the court will dismiss the California challenge for lacking jurisdiction and strike down the Defense of Marriage Act as unfair tax policy.

Asked by state delegate Patrick Hope whether he backs mandatory retirement for judges, Stevens said people seventy and older can still contribute. He would have loved to keep working but realized during the Citizens United case that he was having trouble "articulating."

The Folkie Mary Cliff

November 16, 2011

I was tickled to hear a favorite voice on the radio in 2011 reveal that she grew up in Arlington.

For more than three decades, Mary Cliff has hosted Washington-area public radio's *Traditions*, a two-plus-hour serenade of folk music, blues,

ballads and ethnic offerings you'd be hard-pressed to encounter among the screaming ads of trendy commercial stations.

You can catch her Saturday nights at 88.5 on WAMU-FM from 11:00 p.m. to 1:00 a.m., Saturday afternoons on a longer version on that station's sister HD location (105.5 FM) or on worldwide streaming via www. bluegrasscountry.org.

You may also bump into Cliff at live concerts of "folk music or things you can see from there." She is revered by area musicians for giving over precious airtime to announcements of who's playing where and when. (She's a bit shy around fans.)

When I heard her on-air mention of her Arlington connection, I e-mailed her and received a cool set of particulars about my own neck of the woods.

"I grew up near Lee Highway and Lexington Street when that part of 26th Street was virtually rural," she wrote. "I remember a donkey in the field behind us; we awoke to the roosters on at least two working chicken farms nearby (one now a park, the other McMansions), and fields of flowers being grown for Johnson's Florist. By high school, I didn't want to go with everybody else, so I bussed to Washington Circle in D.C. to Immaculate Conception Academy—since replaced by a hotel. But I do have one of the bricks from the old school."

Cliff's official WAMU bio tells you her next phase. In what music snobs called the "folk scare" of the early '60s, she sang in hootenannies and worked at Georgetown's nationally famous Cellar Door nightclub. She broke into radio in 1966, beginning as a typist but eventually landing a shot at programming. Her mellifluous voice was first broadcast in 1968, when she spun progressive rock for the long-since transmogrified stations WAVA and WHFS.

In 1970, she joined the public WETA, having already spent years, she told me, singing live and deejaying under the mentorship of folk impresario Dick Cerri. She took over his show in 1973, by which time her engineering, editing and producing skills would qualify her as a utility player for the Arlington-based station (doing classical music, news, public affairs and the arts).

Despite her versatility, soothing voice and repeated WAMMIE awards for boosting local troubadours, Cliff saw her career upended by WETA's sudden move in 2007 to an all-classical format. (After an ill-advised lurch into talk radio, the station took over the genre from dying commercial station WGMS.) Cliff was quickly picked up by WAMU, though with less-desirable hours for *Traditions*.

I asked Cliff if she recalled the presence of one of my childhood idols, country singer/TV star/sausage salesman Jimmy Dean, in our neighborhood

in the 1950s. "My brother, when he was in high school, worked at the Lee-Lexington drugstore, across the parking lot from the Gulf station, and would tell us when Jimmy Dean stopped in," she said, adding that her first home as an Arlington wife was a couple blocks from Dean's.

"That little mile of Lee Highway has been very important in my life," Cliff said. "Thanks for the memories."

Frank Howard in Person

June 5, 2012

Hondo took a swing through Arlington in June 2012 and touched base with some old jock buddies.

The legendary Washington Senators slugger Frank Howard gave the keynote speech at the Better Sports Club of Arlington's annual awards banquet.

For many with memories of his larger-than-most power frame taking the field at D.C. Stadium (renamed RFK in 1969), it was a treat to shoot the breeze with such a courtly and unassuming gent.

At seventy-five, Howard, who lives with his wife in Loudoun County, appeared to have lost a bit of that famous six-foot-seven-inch height as he arrived early at Knights of Columbus sporting a black golf shirt.

He signed autographs at a display of his old baseball cards, the backs of which detail a stellar career that saw him named four times to the All Star team, hit 382 career home runs and lead the American League twice in homers and total bases.

The Columbus, Ohio native made All-American in basketball and baseball at Ohio State. Drafted by the NBA, he opted for baseball with the Los Angeles Dodgers. It paid off. In 1960, he was National League Rookie of the Year (a feat Howard seems to relish—he includes it in his autograph).

In 1965, he moved to Washington to star for the hapless Senators ("first in war, first in peace, last in the American League"). He retired in 1973, continuing to coach and manage.

I asked Howard if that celebrated seat in RFK's center-field upper deck was still painted yellow to mark a long blast from the hitter known as the "Washington Monument." Howard said it was now painted over, recalling telling fellow All Star Frank Robinson, "If you can't hit it to the upper deck, you don't belong in this league."

Did he spend time in Arlington back in the glory days? "The only places I saw were ballparks and motels."

Yet Howard has friends galore in my hometown. He rattled off the names of Jack Bell, local dentist, and George Varoutsos, Juvenile and Domestic Relations District Court judge, both present.

As I watched, Howard enjoyed a surprise reunion with Bobby Lee, the owner of Mister Days café in Clarendon who, in the 1960s, ran a D.C. bar called Gino's at Southeast Pennsylvania and Alabama Avenues. It was a hangout for Washington Senators, including Howard, who lived with shortstop Eddie Brinkman in a group house in Suitland, Maryland.

Inside the banquet hall, the Arlington establishment was out in force as county board chair Mary Hynes, Sheriff Beth Arthur, chamber of commerce president Rich Doud and former Georgetown University basketball coach Craig Esherick, who chairs the Arlington Sports Commission, were all present.

Howard was introduced by Washington Nationals broadcaster Byron Kerr as the "Capital Punisher."

Standing before a row of tall trophies ready for presenting to county youth, Howard was self-deprecating. "It's not the first standing ovation I've received," he joked, describing being heckled during a double-header at Boston's Fenway Park by thirty-four thousand Red Sox fans. "Go to work for a living," they shouted, as Howard proceeded to strike out seven times.

"The United States is the greatest country in the world," he said, praising our different ethnic and socioeconomic backgrounds. "These future leaders of America are a heck of a lot smarter than we were."

He ended with a mandatory needling of the late New York Yankees moneybags George Steinbrenner.

Deejay Dave Arlington

August 28, 2013

Comin' to ya live from the Maryland studio manned by deejay Dave Arlington (not his real name) high up a tower overlooking scenic Rockville Pike.

I'm watching Dave anchor WASH-FM's Saturday *Best of the '80s Weekend* show in the near-deserted studios that also house Clear Channel stations WMZQ, WBIG, WWDC and Hot 99.5.

No, Dave Arlington is not his real name. *Charlie Clark.*

I'm here to grasp how twenty-first-century pop radio works, as well as surface some mutual radio memories from growing up in Arlington.

Dave's microphone hangs over four computer screens facing the 97.1 wall sign, the main monitor scrolling a color-coded list of pre-programmed songs, ads and station promos. The others allow him to edit audio transitions, rehearse his own spiels and monitor breaking news and real-time weather online and from a TV.

"We improve the segues," he says. "I can move things around to make the timing work," but the music selections and order were prepared earlier

in the week by a staff programmer—which is how rock stations have always operated, he assures me.

The difference back in the early 1970s, when Dave was a recent University of Pennsylvania graduate getting his start at Arlington-based WEAM, was that the jock checked off songs on a mimeographed sheet. The challenge was the stations' policies against repeating songs within a week, which required Saturday dudes to get creative.

Those were the days when deejays actually spun platters, mostly 45s, before those teen tokens gave way to cartridges, compact discs and now digital files. Back then, a trained ear could make out the on-air "splifft" sound at the start of a song, Dave says, the result of "cue burn" wear and tear on a record caused by years of previewing the song's opening.

Today's hosts can electronically pre-test any track, announcement or ad. Dave does it as an impressive one-man band. "There's no technical training," he scoffs. "You learn from other jocks."

As a student at Yorktown High School (class of '67), Dave got the radio bug helping with interviews broadcast by WAVA in Rosslyn and by winning a contest to become "Rogue of the Week," a secret student promoter of WEAM personality Johnny Rogue. "I was a nerdy kid in high school," he says, but he made a career of "talking like one of the popular kids. When I started, I was younger than the demographic. Now I'm older," he says, adding that the average age of a WASH listener is forty.

The Arlington charm goes out on the airwaves as Dave takes calls for a Jiffy Lube oil-change giveaway, politely informing the first nine callers he's waiting for "caller ten." To the strains of Belinda Carlisle's "Heaven Is a Place on Earth," he sings along and strums air guitar.

During breaks in the programming that are his to fill, "it's important to show you're live," Dave says. That's why he arrives for his five-hour shift with a typed compilation of current movies, county fairs, news events and school starts he can rattle off as needed.

He handwrites his spoken interludes on paper and rehearses them before executing his completely natural delivery. Coolness.

I asked Dave if he's ever recognized on the street. "Happily, no," he says. "One of the great things about radio is that you can be in people's bedrooms and cars talking to them and the next day pass them on the street and, nothing."

An Illegal Sign Vigilante

March 15, 2011

One person's commerce is another person's clutter. Hence the outdoor sign war is heating up in Arlington, where spring brings a flurry of "decorations" on telephone poles and median strips presenting suburban poetry: "yard sale," "earn at home," "we haul," "open house."

My high school classmate Robert Lauderdale is an anti-sign vigilante—as a hobby, mind you. One Saturday in 2011, he drove me around on his rounds.

Lauderdale's latest target is the handsome new Crescent Apartments at Lee Highway and Westmoreland Street. In just ten minutes, he counted thirty-three of Crescent's "lavish living" signs he says are illegal. In enforcing the tricky rules, he adds, the county is effectively AWOL.

The red-and-blue promos tacked on sticks populate median strips, the no-man's land by the W&OD bike path and even the Metro stop.

"This is a preventable, pernicious form of litter that a citizen cannot help stop," which is unfair, says Lauderdale, whose twenty years of confiscating signs once landed him in court, costing him $3,000 in legal fees. The judge required him to cease removing signs erected by the sign installer with whom he'd been feuding, the exception being those in the designated adopt-a-highway area around East Falls Church, for which Lauderdale has the volunteer permit with the Virginia Department of Transportation.

With impressive spycraft, Lauderdale shares the subtler points to which "99 percent of people are oblivious." Sign companies mark their sticks with stripes of color-coded paint. VDOT places "public notice" stickers on the back of traffic signs warning against illegal signs in its right of ways. And many sign installers fail to remove their dangerously sharp sticks from medians once the weekend real estate campaign is over. He shows me a ditch near the EconoLodge—it is lousy with discarded signs and related junk.

"I live, work and play in Arlington," Lauderdale says, "so it's no trouble to get out for a couple hours on weekends and pick up the trash—expensive trash that someone's paid to put up."

County officials have responded politely to Lauderdale and his allies. More broadly, in December, they launched a two-year review of commercial and residential sign policies. In January, they beefed up enforcement powers by no longer requiring eyewitnesses to an illegal sign's installation for action. In February, they warned and began monitoring Crescent Apartments.

But they cannot encourage citizens to do their own sign removing. "The consideration of something as 'trash' is most times subjective," a zoning officer said in a letter Lauderdale showed me. He cited safety risks in removing signs near vehicular traffic and warned against trespassing.

Most unhappy with the anti-sign activism are the real estate agents, who depend on the law's window (Friday dusk to Sunday dusk) during which they can mount directional signs to catch drivers' eyes. Kristen Mason Coreas of Weichert Realtors told me having one's sign removed is "an irritant and an expense" that impacts her ability to serve clients. "Our signs are temporary," she says, acknowledging that some realtors break the rules. "I can see why people see them as an eyesore if signs are up all the time."

Lauderdale isn't buying: "There are thousands of businesses in Arlington that don't use roadside signs, which mainly just promote the realtors." He has "no wish to be seen as a whacko." But he shows no signs...of letting up.

Mrs. Miller's First Century

December 26, 2012

Arlington's progressive political establishment is well entrenched for many reasons, not least of which is the continued presence of many of its dedicated forebears.

An exemplar is Martha Ann Miller, still in her prime at age 101, who just published an Arlington-centric autobiography titled *The First Century: And Not Ready for the Rocking Chair Yet.*

I met her at the Arlington Committee of 100 and purchased a copy to learn of her adventures in the 1940s and 1950s organizing to improve Arlington's then-mediocre schools and her eyewitness memories of the historic integration of Stratford Junior High.

Her addition to the spate of new Arlington books is proof that our county is a great place to think globally and read locally.

The Indiana-born Miller arrived in Arlington in 1937, having married a soon-to-be government attorney and settling first in Colonial Village and later on Quintana and Huntington Streets. She and her husband joined the influx of federal workers who hit Northern Virginia and grew appalled at schools that had "no libraries, no cafeterias, no gyms," she writes.

They wanted kindergarten, higher funding and localized school board elections rather than accepting appointments dominated by Virginia's famous but distant Byrd Machine.

They formed the Citizens Committee for School Improvement (CCSI), compiled voting rolls and went door to door to get five thousand names on a petition for a ballot bond. Their efforts made a *March of Time* newsreel, but powers that be said no. So the Arlington activists went to Richmond to lobby.

"I learned in recent years that we caused a great deal of disturbance in the political realm of the county," Miller writes. "The machine was not happy with the progress and publicity of the CCSI. Real estate investors were not pleased with the idea of paying more property taxes to cover the cost of improving the school system."

They won, only to see school board elections abolished in 1956 during "massive resistance" to court-ordered desegregation. (Elections were restored in 1992.)

During that late '50s racial battle, Miller was a math and home economics teacher at Stratford. She describes the tension when four African American students made their first entry amid tight security in which police escorted teachers to the parking lot.

She recalls the principal asking if teachers were willing to teach blacks. When whites organized a separate prom, one ticket was accidentally sold to a black student. The assistant principal "called the boy into her office to explain the matter to him, to retrieve the ticket and to refund his money," she writes. "Both were crying."

In 2011, Miller's 100th birthday was toasted by county board member Chris Zimmerman, one modern progressive to whom her torch has been passed.

A One-Man Legal Establishment

June 26, 2013

The closest thing to a museum of Arlington's legal establishment is the law office of Earl Shaffer. During a visit to his longtime suite across from the courthouse, I was stunned to behold his frozen-in-amber wall filled with photographs—sixty years of rubbing elbows with the county's notable jurists, celebrities and less-savory characters.

"Every picture has a story," says the eighty-seven-year-old attorney who, though retired from the bar, still frequents the courthouse and is greeted by a nonstop parade of former colleagues.

Shaffer is "a courthouse institution," I was told by Arlington attorney George Dodge. "He's one of the few to serve as attorney, prosecutor and judge."

He's probably the "only lawyer left in Arlington who practiced in the old red brick courthouse back in the 1950s," says George Varoutsos, the Juvenile and Domestic Relations Court judge whose swearing-in is documented in the photo gallery. Shaffer was a "substitute judge for over forty years, the longest ever in the state," Varoutsos adds.

Shaffer's "Who's Who in Arlington Law" showcases such legal talent as Paul Varoutsos, Lou Koutoulakas, Bob Arthur, Harry Lee Thomas and Paul Brown (father of the late astronaut David Brown).

There's a photo of Thomas Monroe, Arlington's first African American judge, and Circuit Court judge Walter McCarthy, for whom the courthouse law library is named. There's the announcement of Shaffer's first law partnership, with Berton Kramer, the juvenile judge during my youth who terrified my less law-abiding classmates.

On the fun side, Shaffer has photos of super-athlete Jim Thorpe with Arlington politician Frank Ball Sr. There's country music star Jimmy Dean with his band, along with impresario Connie Gay, the radio mogul who gave Dean his start at Arlington's WARL.

Shaffer is most associated with being assistant to famed Commonwealth's Attorney William Hassan during the 1960s. "We were inseparable friends," Shaffer says, recalling the time a furious Hassan called a staff meeting to say the county manager had found an error in a memo. "Who's the SOB who prepared the memo?" he demanded. Later, Hassan called another meeting to admit the SOB was himself.

It was with Hassan that Shaffer came to know George Lincoln Rockwell, the notorious head of the Arlington-based American Nazi Party whose Williamsburg Boulevard home he and Hassan raided for weapons in 1959.

Shaffer points out another iffy personage on his photo wall—Debra "Muffin" Mattingly, a sweet-looking mom sitting for a portrait with children. In 1970, she was a fourteen-year-old runaway who returned to her home in Arlington with two hippie-biker friends from downtown who proceeded to strangle her father.

That Shaffer's career involved heinous crimes is driven home by a panoramic photo of the last public hanging in West Virginia, in Ripley in 1897. The drama involved the murder of widow Green and two kids by John

F. Morgan, who was dispatched before a crowd of five thousand. When asked about it, Shaffer plays a Flatt and Scruggs song dramatizing the hanging.

Gentle in retirement, Shaffer sits surrounded by his collection of dozens of pigs—ceramic, stuffed and plastic. He looks back in gratitude that a West Virginia boy in the 1940s could graduate from Potomac State College and then use the GI Bill to attend George Washington Law School.

"Those were certain advantages we wouldn't dream of now," he says. "I did about anything one can do in practicing law."

Editor's note: Earl Shaffer died on November 25, 2013.

Chapter 5
LOCAL FOLKS MAKE GOOD

Arlingtonians in Hollywood
May 29, 2013

Washington-Lee High School is rightfully proud of the actors it has sent to the national spotlight—1950s graduates Shirley MacLaine and her brother Warren Beatty and the 1980s generation's Sandra Bullock.

But there are other accomplished thespians, from W-L and Greater Arlington, whose work you've seen on screen or stage or heard over the airwaves, perhaps without awareness of their local provenance.

Older W-L alums recall Forrest Tucker, class of '38, from such films as *The Westerner, Sands of Iwo Jima* and *Auntie Mame*. On Broadway in the late 1950s, he dominated as the lead in *The Music Man* and, later, as frontier capitalist Sergeant O'Rourke on the '60s TV comedy *F Troop*. Tucker died in 1986.

Nor have Generals forgotten Gena Rowlands, class of '47, two-time Oscar nominee and two-time Emmy winner who starred in such films as *Gloria* and *A Woman Under the Influence*, directed by her husband, John Cassavetes. More recently, she did the 2004 hit *The Notebook*. She's still at it on television's *Monk* and *NCIS*. They're also proud of Academy Award–winning special effects wizard Stan Winston, class of '64.

Nicholas Hammond, who attended Williamsburg Jr. High in the early '60s, boasts seventy-nine actor credits, including the movie *Sound of Music* and the 1963 classic *Lord of the Flies*. He played on the TV series *The Defenders*, *Hawaii Five-O* ('70s version) and, most recently, *The Jesters*.

Nancy Robinette, Yorktown '69, has been called the "doyenne" of Washington theater. She has performed over the decades with the Shakespeare Company at the Lansburgh Theater and Arena Stage, as well as around the country. She's won four Helen Hayes awards and four nominations. Her movie credits include *Serial Mom*, plus a passel of TV roles, including a part in *The Day Lincoln Was Shot*.

Arlington private-school spawn Zach Cregger currently stars in the NBC comedy *Guys with Kids*, having also done *Friends with Benefits*. A veteran of New York City comedy, Cregger co-wrote, co-directed and co-starred in the (raunchy) 2009 film *Miss March*.

Wes Johnson is an Arlington-based actor, comedian, radio personality, voiceover specialist and pro sports announcer who attended Swanson Middle School (and Falls Church High School). He voiced for the video game *The Elder Scrolls*.

Doug Nelson, Yorktown '69, has thirteen film credits on the International Movie Database, including *Night at the Museum*. He also has appeared in TV movies such as HBO's *Game Change* and *Eleanor and Franklin* and cable shows such as *The Wire* and *Veep*.

My friend and Yorktown classmate Jean Lichty in 2010 played the character Cherie in a production of William Inge's *Bus Stop* at Maryland's Olney Theatre Center. She also played Lila in Inge's *A Loss of Roses* in June 2012 at the Arkansas Repertory Theater. Both were directed by New York City playwright and film and stage actor Austin Pendleton.

Outside the spotlight, Arlington's contributions to the entertainment industry include multiple-Emmy-winning TV producer Greg Garcia, a 1988 graduate of Yorktown who is creator of *My Name Is Earl* and *Raising Hope*, among other works. From Yorktown's class of '72 there's Stuart Neumann, a long-successful film industry location manager, and Phil Fravel, a well-traveled Hollywood stuntman.

When brightest lights MacLaine, Beatty and Bullock return to Arlington, they tend to keep it quiet. I recall once that when Beatty, who left our area in the late 1950s, was being interviewed on *The Today Show* by Katie Couric (Yorktown '75), she commented that he'd gone to W-L and she to Yorktown. His reply: "What's Yorktown?"

Arlington Music Notables

March 27, 2013

Utilitarian Arlington may not look like a hothouse for musical talent. But over the decades, we've spawned our share of tunesmiths and instrumental notables. I've assembled a rough list with a little help from my friends.

Perhaps most legendary is Virginia-born Kate Smith, the alto who belted out Irving Berlin's "God Bless America" and other standards on 1950s TV variety shows. She kept a second home for years at North Thirty-seventh and Abingdon Streets.

A close second in cross-genre name recognition is country music star Jimmy Dean, whose 1961 smash hit "Big Bad John" won him his own TV show. Dean got his broadcasting start in the 1950s at WARL radio across from what is now Virginia Hospital Center and owned a home on North Roosevelt Street.

On the arena rock stage, when the Eagles play, they often include guitarist Steuart Smith, an Arlington guy who played locally with Root Boy Slim and in Nashville with Rodney Crowell and Roseanne Cash.

In the years before "Big Bad John," Jimmy Dean was a radio and concert king based in Arlington. *Courtesy Jimmy Dean.*

Plugged into the Los Angeles studio scene is Arlington native Corky James, who was with me at Yorktown High School in the early '70s under real name Jimmy McCorkle. An accomplished session guitarist, he played on Avril Lavigne's 2002 hit "Complicated" and has backed LeAnn Rimes, Meat Loaf and Kelly Clarkson. Recently, Corky did the film soundtrack to *X-Men: First Class*.

Another Yorktown music alum is Chris O'Connell, on-and-off singer for the 1970s-vintage country-swing band Asleep at the Wheel. Her contemporary in the bluegrass industry is Robin Dale Ford, an admired banjo player who attended Tuckahoe Elementary. Down in Austin, Texas, you can go to clubs and hear country-folk songwriter/guitarist/recording artist Ramsay Midwood, a graduate of Yorktown High School, class of '81.

Arlington's black high school Hoffman-Boston, which closed in 1964 with desegregation, produced two talents recorded on wax. Roberta "Killing Me Softly" Flack had huge hits in the early 1970s and still performs, while Buddy Owens, a baritone in the late '60s and '70s doo-wop group the Velons, died in 2013. Another African American artist who lived in Arlington is Stephanie Clark, who in 1970 became the first Miss Black America and released a song called "Liberate Yourself."

The psychedelic '60s spawned a bevy of local groups, among them the Cherry People, featuring Washington-Lee High alumnus Doug Grimes. Their hit record *And Suddenly* won them a chance to record with Jimi Hendrix. In 1969, a local combo called Magic Reign lived in Arlington and made the charts with a song named for our own Jefferson Street. The 1967 national acid-trip hit "Incense and Peppermints," by a one-hit wonder called Strawberry Alarm Clock, was sung by current Arlingtonian Greg Munford, a Republican political consultant.

In the '70s, local guitarist Jimmy Nalls made a splash playing with the Allman Brothers, Paul Stookey and an Allmans offshoot band called Sea Level. And mustn't we forget the late bluegrass giant John Duffey of the Seldom Scene.

The '90s brought the indie band Weezer, co-founded by Arlington bassist Matt Sharp, as well as SOJA (also known as Soldiers of Jah Army), a reggae band founded in 1997 that records on the Innerloop label. A few years later, young hearts nationally were broken by the teenybopper band Hanson, whose twelve-year-old percussionist Zac Hanson had an Arlington boyhood.

I shouldn't neglect stage music and classical. Nancy Dussault, a W-L alum, hit Broadway in 1962 performing the lead in *The Sound of Music*. (She later moved on to TV sitcoms.) More recently, W-L graduated recording

artist Carl Tanner, a professional operatic tenor since the 1990s who sings with the Washington National Opera.

Also still recording and performing globally is classical pianist Daniel Blumenthal, a member of Yorktown's Hall of Fame and Inspiration.

Our Roster of Jocks

July 3, 2012

Local boy makes great.

I seldom study the innards of pro basketball in the off-season, but I did note that O'Connell High School graduate Kendall Marshall in June 2012 became a first-round draft pick for the Phoenix Suns. He joins an elite roster of Arlington athletes to make good on those widely shared boyhood dreams of turning pro.

The twenty-year-old Marshall first came on my radar screen in January 2010, when my Durham, North Carolina–based nephew blew into town and asked if I'd be willing to walk the two blocks from my house to O'Connell for a taste of the famous Duke-UNC college hoops rivalry.

At the time, Marshall was O'Connell's star point guard, all-Met, veteran state champion and already committed to becoming a North Carolina Tar Heel. We got to see him go up against a powerful Gonzaga squad featuring Tyler Thornton, who had already committed to becoming a Blue Devil. Both were cocky and quick in the matchup that Gonzaga won 66–59.

I'm usually skeptical of hype surrounding young jocks, but Thornton went on to hold his own as a regular and is returning to Duke's team. And Marshall nabbed the glittering payday after only two years at Chapel Hill.

Arlington through the decades has produced—through its omnipresent youth sports empire and well-coached high school programs—dozens of postsecondary performers. But the ones who made it to the big leagues I can count on two average-skilled hands.

Start with baseball great George McQuinn (1910–1978), an Arlington native and Washington-Lee graduate who played first base for the Cincinnati Reds, St. Louis Browns, Philadelphia Athletics and New York Yankees from 1936 to 1948. I used to shop at his McQuinn's Sporting Goods in Ballston, which was also a Little League sponsor.

Other diamond men include San Diego Padres pitchers Clay Kirby and Jay Franklin, who grew up as Arlington next-door neighbors.

Another old-timer is football Hall of Famer Wayne Millner (1913–1976), who starred as an end for Notre Dame and then was drafted in 1936 by the team that became the Washington Redskins. He caught two long touchdown passes from Sammy Baugh when the Skins beat the Chicago Bears for the title in 1937. Though raised in Massachusetts, he coached and scouted (and died) in Arlington, which got him in the Better Sports Club Hall of Fame.

Preceding Marshall in the National Basketball Association was John Hummer (born 1948), a W-L star in the mid-1960s who, following his brother Ed, went off to shine on the court for Princeton. John's six years in the pros saw him in uniform for the Buffalo Braves, Chicago Bulls and Seattle SuperSonics.

Washington-Lee grads can also boast of Eric Sievers (born 1957), a University of Maryland football star who, throughout the 1980s, played tight end for the San Diego Chargers, Los Angeles Rams and New England Patriots. Washington-Lee's sports legacy also includes two NFL Super Bowl veterans: Jake Scott (class of '63) of the Miami Dolphins and Reggie Harrison (class of '69), who played for the Pittsburgh Steelers.

On the global stage, the most notable Arlington athlete, though not technically professional, is Olympic swimmer Tom Dolan (born 1975). After boyhood training at Washington Golf and Country Club, Yorktown High School and the University of Michigan, he won gold and silver medals at the 1996 games in Atlanta and the 2000 games in Sydney.

In reading of Marshall's triumph, I learned that, though raised in Dumfries, Virginia, he began showing up for training at O'Connell at the ripe age of seven. So Arlington claims him.

O'Connell's other stars include offensive lineman Bob Asher, who blocked for the Dallas Cowboys in the early 1970s; tight end Mark Wheeler, who caught passes for the Detroit Lions in 1987; and running back Eric Metcalf, who scampered for the Cleveland Browns in the early 1990s. More recently, the Knights sent up Terrence Wilkins, a wide receiver for the Indianapolis Colts in the late 1990s, and tight end Casey Crawford, who ran routes for the Tampa Bay Bucs in the early 2000s.

Thanks to encyclopedic reader Greg Paspatis, I can point to two famous Wakefield Warrior heroes: running back Tom Michel, who was drafted by the Minnesota Vikings in 1964, and Bill Darnall, a wide receiver for the Miami Dolphins in 1968.

Heralded Washington-Lee gave the National Football League '65 graduate John Leypoldt, a placekicker for the Buffalo Bills and others in the 1970s,

and offensive tackle Brian Blados ('80), who wore the Cincinnati Bengals uniform from 1984 to 1991.

More prominent among Generals' stars was Reggie Harrison, a running back and special teams player for the Steelers who, memorably in Super Bowl 10 in 1976, blocked a fourth-quarter punt, setting up a victory over the Cowboys.

Reached in Woodbridge, Virginia, where he lives with his third wife on an NFL disability pension, Harrison confirmed what I had long heard—that he has converted to Islam and changed his name to Kamal Ali Salaam-El. The name "Reggie," however, is still fine, he told me, for those who knew him back in the day.

Though he has performed on national television with some of football's greatest, Harrison retains many memories in common with any veteran of Arlington youth sports. In Little League football, he played for the old Cherner-Ford Black Knights and in other sports under coach Johnny Lange, the longtime Arlington plumbing supplies vendor.

At Stratford Junior High (now site of H-B Woodlawn School), Harrison learned fundamentals from Dick Mitchell. When he moved to W-L, he worked under coach and, later, athletic director John Youngblood. These are all men for whom Harrison "still has all the respect in the world."

Perhaps his Arlington high-water mark came during his senior year, when he scored six touchdowns in a 46–6 Thanksgiving Day romp over George Washington High School, the last of the Old Oaken Bucket games that dated back to the 1930s.

Teammates Harrison looked up to at W-L include football and basketball star Tyrone Epperson ('67), the school's best all-around athlete; Jerome Green, "the most aggressive running back I'd ever seen in my life," Harrison says; and Clayton Deskins. "I'm not worthy of carrying these guys' cleats," Harrison said. He also (fondly) recalls contemporary stars from archrival Yorktown during the 1968 season: Bill Carter, Bernie Kirchner and Milt Drewer.

Harrison insisted that, as a boy, he was present at the much-shrouded creation of the annual Turkey Bowl tackle football game held in Hall's Hill every Thanksgiving since the early 1960s. He regularly visits Arlington, though a grandson plays in Vienna.

Having endured two back surgeries, knee problems and memory loss, Harrison says he can't recall his name at times. But he's never forgotten his Arlington glories.

Jim Morrison Slept Here

May 10, 2011

Florida governor Charlie Crist's parting shot in December 2010 was his posthumous pardon of the legendary rock star Jim Morrison. Ripples were felt here in Arlington, for reasons I will break on through to.

Unmentioned in books on the front man of the psychedelic Doors (famous for "Light My Fire" and "Touch Me") is the fact that Morrison was an intermittent Arlingtonian before his drug-abused heart stopped in that bathtub in Paris in 1971.

It's complicated. The crooner who made leather pants hip came from a military family that moved dozens of times. Morrison "hometowns" include Los Angeles, Mountain View (California), San Francisco, San Diego, Kingsville (Texas), Albuquerque, Bethesda, Tallahassee and Falls Church (6913 Jefferson Avenue).

Alexandria has the best claim because Morrison was a 1961 graduate of George Washington High School (now a middle school). His teen years in a hilltop house on Woodland Terrace are detailed in *The Lizard King Was Here* by local author Mark Opsasnick, who chronicles Morrison hanging out at Alexandria's Queen Street library, the waterfront, the Wolfe Street tunnel and blues dives on Route 1.

The unsung Arlington connection, I assure you, is not just my own fascination with the poet and sybarite whose baritone rivaled Bing Crosby's (only with a better scream).

True, I associate many Arlington sites with memories of the Doors' carnivalesque organ, with Morrison's family estrangement that so dramatized the '60s generation gap and with parties at which pals recited Morrison's reverb-enhanced pronouncements on petitioning the Lord with prayer. The first journalism I published for money was about my visit to Morrison's freshly dug Parisian grave in December 1971. (Some friends in 2009 sent me a photo confirming it still draws crowds.)

What I'm presenting that's fresh are Morrison's actual Arlington addresses:

2320 North Evergreen Street. My high school mate Lowell Schuyler, a retired Arlington policeman, confirmed recently what he said when we were kids—that his sister spoke of "little Jimmy Morrison" living in this house in the 1950s.

4907 North Twenty-eighth Street. Rhonda Baron, an Arlington-based marketer of etiquette DVDs whose mother still lives in this house, says that in the

'70s, she occupied the singer's former bedroom. Her evidence is backed by former neighbor Alan Weimer, who recalls coming home from Yorktown High School in the late '60s and seeing the longhaired Morrison sitting on the home's front stoop. Perhaps the most astonishing sign of his impact is Baron's tale of experiencing on three occasions the restless spirit of Morrison in her room—real enough, she told me, to leave a dent in the mattress.

1327 South Glebe Road. On a 1996 visit to the Rock and Roll Hall of Fame in Cleveland, I saw on display (along with Morrison's Cub Scout uniform) a letter from the sheriff of Dade County. It asked the father, Admiral Stephen Morrison (a key officer in the Vietnam War), whether his son was a good boy. I copied down this address in Arlington. It is now a condo.

The late Robin Richman, my colleague who covered pop music for *Life* magazine, once told me that an eager Morrison brought her his poetry to publish. He was more vulnerable than his bad-boy rep let on, she said.

The governor's pardon has put to rest four-decades-old unproven charges that Morrison had exposed himself on stage. Local boy makes good—after a fashion.

Arlington Schools Publish a Book

December 7, 2011

How many school systems can boast of publishing their own book?

A veritable in-crowd from Arlington's education establishment earned joint authors' credit in 2011 with the release of *Gaining on the Gap: Changing Hearts, Minds and Practice*, published by Rowman & Littlefield.

The challenge of boosting minority achievement in an affluent system stocked with tough customers is something I've been following since my kids entered Arlington schools twenty years ago. I'm pleased to see our locals getting national attention.

At the center of the project is Rob Smith, who was Arlington's superintendent from 1997 to 2009 and is now associate professor of education leadership at George Mason University. The book recounts his vow, during his job interview with school board member Libby Garvey, to disprove the assumption that one can predict how a child will do by his racial or ethnic background.

I watched Smith make a splash in 1999 when he joined fourteen other superintendents from around the country to launch the Minority Student Achievement Network. Its plan was to track and publish data on the achievement gap among blacks, Latinos, Asians and whites—not just test scores but also uncomfortable stuff like suspensions and dropout rates.

Leaders, Smith writes, should "admit they have a problem and put data front and center in a form that can be understood easily; measure and report progress consistently; make the goal of eliminating or narrowing gaps a priority for everyone in the organization; distribute resources equitably with an eye toward achieving the goal; and implement interventions that focus on key variables early and consistently."

Credit for what would become Arlington's remarkable progress is shared with co-authors Alvin Crawley, Cheryl Robinson and Timothy Cotman Jr., who occupy key positions in Arlington schools dealing with diversity. In a tone that avoids self-congratulation, they write of how they went about achieving the impressive stats (percentages of all students passing the state Standards of Learning exams jumped, with blacks and Hispanics marching up steadily from the fortieth percentile up past the eightieth).

But the soul of *Gaining on the Gap* comes from co-authors Marty Swain (a retired Arlington teacher) and Palma Strand (a law professor and activist Arlington parent). Several years ago, I participated in book discussions these two ran on cultural bias. They take some brave positions, stressing the importance of "outing race" as a factor in school communications.

They know that in today's competitive economy, not every parent warms to the priority of spreading achievement more widely, perhaps for fear of disadvantaging one's own children. Yet Arlington's surveys found that two-thirds of teachers and parents and a majority in the overall community see closing the gaps as the schools' responsibility.

Strand writes of "fixing the system, not the kids," addressing "the fears whites have of being accused of being racist and the fears people of color have of being hurt."

Swain discusses practical cultural differences, noting, for example, that Latino parents may get offended if a teacher fails to open a meeting with some disarming small talk.

As if the book needed more of an Arlington imprimatur, a cover blurb was provided by Larry Cuban, who ran Arlington schools in the '70s, and Daniel Domenech, who now heads the Arlington-based American Association of School Administrators.

An afterword by current superintendent Patrick Murphy makes it plain: the movement to close the achievement gap carries on.

The Mayor of Maywood

October 30, 2013

Count me privileged to be among dozens of cake-munchers who gathered on October 27 to help Arlington stalwart citizen Bob McAtee celebrate his 100th birthday.

"Mr. Mac," as he is called by the guests from age groups ranging from the terrible twos to the ninety-somethings, has been a fixture in the age-mellowed Maywood neighborhood since he moved there in 1915, at age two, into the brown brick home he still occupies.

McAtee's loyally local life and community contributions have long made him a go-to guy for Arlington history buffs. But equally impressive is the expansive network of friends and professional caretakers who hover to help him age with dignity.

I first encountered McAtee in the late 1970s, when his name was often credited for supplying the *Journal* newspapers series with nostalgic images of bygone Arlington. A few years ago, I paid him a visit, which gave me a chance to stroll past the stately trees and welcoming front porches in his domain of Maywood—"one of the oldest of Arlington's residential districts and one of the best remaining examples of early trolley suburbs," as it is described by its Yahoo Internet listserv group. Sandwiched between Lorcom Lane and Lee Highway, Maywood was founded in 1909, designated an Arlington Historic District in 1990 and added to the National Register of Historic Places in 2003.

McAtee proudly showed me, in his bedroom with packed wooden shelves, rows of albums containing the photos he's assembled from multiple sources, as well as shots of his trips to Scotland and Ireland.

In September 2011, I heard McAtee speak at the Central Library with a panel of Washington-Lee alumni from different eras. He recalled the walk from then-rural Maywood to the high school from which he graduated in 1932 (as he was sharp enough to remind me Sunday). McAtee held on to his W-L cadet uniform, which has been on display at the Arlington Historical Museum.

Centenarian Bob McAtee as a Washington-Lee High School cadet, 1932. *Courtesy Robert Beck.*

He regularly shares memories of attending movies at Clarendon's long-gone Ashton Theater and swimming in the Potomac at Arlington Beach.

At Sunday's party, Arlington Historical Society president John Richardson presented McAtee with a framed certificate wishing him many happy returns. He and others marveled at the assemblage of "this is your life" photographs of Mr. Mac as a boy, as a student and as a professional running a trailer rental business, working after World War II for Arlington businessman Mike Munley, with U-Haul and then on his own operation at Seven Corners.

Also framed is a collection of envelopes addressed to McAtee that the postal service successfully delivered to an ever-changing set of jurisdictional addresses for his same lifelong abode—Twenty-second Street, Cedar Street, Route 1, RFD 4 and care of the Maywood, Thrifton and Cherrydale neighborhoods.

Katherine Skerl, who has known McAtee for more than thirty years and for twenty-four has helped with his (now twenty-four-hour) care, relays his story of how a horse-and-cart moving company in 1915 misrouted his family's belongings to Cedar Street in Alexandria rather than Arlington.

McAtee has inspired decades of loyalty from friends and neighbors who team up to look after him. Robert Beck, an organizer of what is an annual party, reads him news articles on his beloved Arlington.

As another friend, Carla Barilla, says, "Every aging person should have someone to take care of them the way Mr. Mac does."

Chapter 6

LANDMARKS AND HOT SPOTS

Arlington's Other Cemeteries
July 17, 2012

Consider the *other* Arlington cemeteries.

This March, the graveyard at the Calloway United Methodist Church in the Hall's Hill neighborhood gained status as a historic district for its newly confirmed graves of former slaves in Arlington.

It's an overdue reclamation of lost history that got me thinking about the quiet messages local cemeteries send out.

A tour of notable graves in Arlington must begin with the seminal Ball family. That means the eighteenth-century markers at the Ball-Carlin cemetery at the Glencarlin Library on South Kensington Street, as well as the larger Ball family graveyard on Washington Boulevard at Kirkwood Road (enter next to the historic sign near Baird Automotive). Buried with the big landowners' relations rests a Revolutionary War veteran, Ensign John Ball (1748–1814) of the Sixth Virginia Infantry.

Another Revolution-era veteran lies at the Shreve-Southern Cemetery, on North Harrison Street near St. Ann's Catholic School. John Redin died at age eighty in 1832 and is interred in a chain-link enclosure alongside stones for five generations of Shreve and Southern families.

Forward to the War of 1812. A Colonel Samuel Birch bought an Arlington tract stretching from Little Falls Road to Lee Highway. He's

there in the Birch-Payne cemetery, which I pass regularly at Sycamore and North Twenty-eighth Streets. It contains about twenty graves—Samuel and two wives, children, grandchildren and five or six "colored servants," as described by Arlington historian Eleanor Lee Templeman in 1959. She lamented damage to the site by Arlingtonians seeking Christmas decorations and rocks for gardens. (Last week, two humongous trees felled by the storm lay across the property.)

The oldest active church in Arlington, Mount Olivet at Glebe and North Sixteenth Streets, boasts a cemetery dating to 1854. Its graves include those of Civil War vets, and it was used as a hospital during the conflict. The cemetery has lots of Donaldsons and is the final resting place of Sue Landon Vaughan, who was key to creating Memorial Day after she began decorating the graves of Civil War soldiers.

A spinoff Methodist church stands as Walker Chapel at Old Glebe and new Glebe Roads. Though the church didn't open until 1876, the graveyard is labeled circa 1848. I used to walk by it at dawn as a twelve-year-old delivering the *Washington Post* and was spooked by graves for such Arlington families as the Marceys and the Gutshalls.

In the residential Douglas Park neighborhood on South Monroe Street lies the unobtrusive Travers family yard dating from the 1830s. It contains fifteen graves from the farming families named Travers, Whitehead and Dyer.

A modern-era must-see is Columbia Gardens, founded in 1917 at the 3400 block of Arlington Boulevard. Longtime Arlington auto dealer Bob Peck rests there with a Chevrolet logo on his stone. There's a mausoleum for Senator Robert Byrd (D-West Virginia), who lived in Arlington. Down the pathway lies a black stone for blues guitar genius Roy Buchanan. Though he grew up in Arkansas and California, he made Washington, D.C., his base in the late 1950s. Buchanan was residing in Reston and battling alcohol issues when he died in 1988, an apparent suicide.

The 146-year-old Calloway Church at 5000 Lee Highway names as its oldest the grave of Margaret Hyman, born into slavery in 1853, dying in 1891. There's also Hesakiah Dorsey, a once-enslaved man who served in the Union army, and perhaps as many as one hundred other unmarked graves.

In the South Arlington historic neighborhood of Nauck, less-ancient African American graves from the twentieth century can be seen at Lomax AME Zion Church.

Our rapidly filling planet doesn't have room for each of us to rest under our own gravestone. But cemeteries do leave us with a durable community record.

Politician Sightings in Arlington

September 13, 2012

Because it's spitting distance from the political city, Arlington has long been a crossroads for presidents and those who aspire to the gig.

In the 2012 election year, our fair county long appeared a lock for Democrats. (Stop the presses!) But a scan back through history during my sentient lifetime shows plenty of prominent Republican candidates who've committed politics here on Arlington soil.

The eventual 2012 man, Mitt Romney, blew through on May 2, 2009, when he appeared at the Pie-Tanza pizza parlor at Lee-Harrison shopping center. He spoke at a "town hall" before cameras with former Florida governor Jeb Bush and current House majority leader Eric Cantor (R-Virginia). Footage was broadcast on *The Daily Show*, and the pizza staff still talk about it.

George W. Bush established a more substantive presence in Arlington when he set up the 2004 Bush-Cheney reelection headquarters in a high-rise on Wilson Boulevard. He also made his local mark in 2001 when he dined on Tex-Mex at the El Paso Café at 4235 North Pershing Drive. The proprietors still keep his chair on display. (Before he became president, Bush the younger was spotted in 1988 with his father in an Arlington Chinese restaurant. Bush the elder would have passed through Arlington on any number of occasions on his way to his favorite Chinese restaurant on Route 7 in Falls Church and earlier on his way out to CIA headquarters in Langley.)

President Reagan, like dozens of predecessors, appeared often at Arlington Cemetery and in 1980 set up his Reagan for President headquarters on South Highland Street. (In his private life, Reagan had two other Arlington connections. During his presidency, he dined frequently at the Rock Spring Road home of his longtime aide Nancy Reynolds, and years earlier, his daughter Maureen briefly attended what today is Marymount University.)

President Obama may have set the modern record for personal appearances in Arlington. Call them field trips to promote school reform—with a smattering of politics. Over his three-plus years, Obama has made appearances at Wakefield High School, Washington-Lee High and Long Branch Elementary, where he read aloud from his children's book. (W-L, during the 2008 campaign, was also the site of a well-publicized visit by Obama's then-rival, Hillary Clinton, whose own campaign headquarters were on Arlington's North Fairfax Drive.)

More tantalizing was Obama's 2009 meal at Ray's the Steaks restaurant on Wilson Boulevard, which he followed up in 2010 by bringing Russian president Dmitry Medvedev to the affiliated Ray's Hell Berger.

John Kerry, the Democratic standard-bearer in 2004, arrived in 2006 to boost the Senate candidacy of fellow Vietnam War veteran Jim Webb—the two appeared near Webb's headquarters in Clarendon with all manner of Arlington officials.

The peripatetic Bill Clinton doubtless zoomed through Arlington uncounted times. I've got a report of him speaking at the Crystal City Marriott in February 2011 at the Agriculture Department's Agricultural Outlook Forum.

And the 2000 nominee Al Gore for decades lived in Arlington's Aurora Hills neighborhood.

My earliest memory of a national candidate sighting took place at National Airport in the fall of 1968. There on the tarmac, I watched as Democratic hopeful Hubert Humphrey stepped out of a plane. An exuberant woman from his campaign led the crowd in the theme song: "Let everyone here kindly stand up and cheer!"

The Venerable Mario's Pizza

December 11, 2012

"Everybody goes…to Mario's…It's Mario's Pizza House…in Arlington town!"

Those radio jingles from the 1960s re-invaded my brain in December 2012 when word came online that the venerable Wilson Boulevard pit stop for all with the late-night munchies would be sold.

Well, not quite. The underlying sixteen-thousand-square-foot parcel hosting Mario's and its leased partner, Carvel soft ice cream, was offered at commercial auction on December 20. But the fifty-four-year-old pizza stalwart, I have it on the best authority, will continue baking and frying for years—though intriguing changes are in the works.

I have two personal connections to Mario's. (That's not counting my role as a customer—what self-respecting graduate of Yorktown or Washington-Lee High Schools never detoured over to savor Mario's emblematic four-by-four pizza slices and wickedly tempting steak-and-cheese subs?)

As a boy, I played on the Mario's Little League team. And I grew up three doors down from Mario's founders, the Levine family.

For decades, Mario's was the pizza of choice for Little Leaguers and high schoolers with late-night munchies. *Anne McCall.*

Mario's president Alan Levine and I met up at the circus white- and red-colored restaurant to get reacquainted just before the auction was announced.

Alan had a career in commercial real estate after he joined his mother in running Mario's. When the parents died in the late 1980s and he was battling some health issues, the property went to his older sister Lesley, a prominent physician in California. He worked for fifteen years to buy her share, allowing him to move to Florida and Southern California to nurture other investments, though he now lives in Arlington.

"Owning Mario's gives me a unique opportunity to see many people that I grew up with and now grow old with," Levine says, noting that three on his staff have been serving the hot stuff for more than fifty years. "We don't treat employees like normal fast-food places do, and there's very little turnover," he said. "People don't stay for fifty years if they're not treated well."

Mario's neon flashes 365 days a year, 7:00 a.m. to 4:00 a.m. (Staying open the remaining three hours would be "just trouble," Levine says, calling it a high-crime window.)

In all its fries and onions glory, Mario's earns decent grades from health inspectors given that the building, originally a florist's and later the site of a mini-golf course, is sixty-five years old, he adds.

The biggest threat now is competition from gourmet pizza in nearby Clarendon. For years, Mario's ruled the late-night market, Levine says, but now many hotels have vending machines and mini-marts.

A decade ago, Levine decided to take advantage of the fact that hotel room service tends to stop in the late evening. Using phone lines in the back of Mario's, he started Dr. Delivery, a take-out driving service contracted with one hundred restaurants. It catered to mom-and-pop stores that lacked insurance coverage for deliveries.

In 2012, Levine sold Dr. Delivery to make time for more entrepreneurial ambitions. These include expanding Mario's building to create display space for his pursuits in solar energy and electric bicycles.

The reason for selling the land assessed at $3 million, Levine says, is to create cash by acknowledging it as prime real estate near Metro, possibly attractive for high-rise development. "Progress is hard to fight," he says, "and I want to be a part of this progress here in Arlington."

Editor's note: In 2013, Levine sold Mario's to Tony Hassan, who is expanding it.

Arlington Metaphysical Chapel

July 24, 2012

Even pragmatic, feet-on-the-ground Arlington has its metaphysical side.

Next time you find yourself speeding down Wilson Boulevard, slow down around Bon Air Park and keep your eye out for the Arlington Metaphysical Chapel.

The modest shingled white structure punctuated by stained glass is the gathering site for what is likely the county's least doctrinaire flock of worshipers.

When I pulled in this rainy Saturday, its community of nondenominational spiritualists was celebrating "Rainbow Weekend," a gala featuring a free concert, services, classes and séances marking the thirtieth year of a local movement that strives to take its enthusiasts beyond the mundane.

"Metaphysics is looking for spiritual truths beyond the physical, and we find them in all the major religions," I was told by the Reverend Allyson Jones, one of several current leaders of the congregation of about 120. "It embraces all of the sacred texts. It's inclusive."

Arlington's nod to the metaphysical was founded in 1981 in the Military Road home of psychic medium F. Reed Brown, who retired four years ago but is available for consultations. "It was built on the strength of his personality," Jones says.

The church belongs to a national network of thirteen metaphysical churches, including franchises in Takoma Park, Maryland, and headquarters in Roanoke, Virginia. Arlington's boasts a mailing list of three thousand.

Its 105 charter members took over an early twentieth-century facility built as Bon Air Baptist Church, which by 1949 had morphed into an Odd Fellows Lodge. Entered best from the paved parking lot on its North Eighth Road side, the restored chapel is flanked by two outbuildings. One is a "parsonage" with an empty apartment used as an office and for classes, while the other is a "school," though there presently are no children. There is a bookstore and lending library, as well as a tent outside for the weekend's book sale.

The lobby of the sanctuary is bedecked with framed charters and signs bearing adages ("Wherever there is a human being, there is an opportunity for kindness"). Inside are pews, a portrait of Christ, Hindu-themed windows and an organ and piano used for services, weddings and funerals.

During my visit, I glimpsed a class on Tarot cards and another on readings from the nineteenth-century study of theosophy. Others involve eclectic offerings such as massage, Vedic astrology and healing through colors. Classes during Rainbow Weekend cost $100. "Circles" (séances) go for $25, though Jones stresses that "all member donations are given by free will." Funds are also raised via yard sales. The garden and fountain are tended by volunteers.

This weekend's guest speaker was Reverend John Lilek, in from Indiana. He's billed as a "developed clairvoyant, clairaudient, as well as a trance, transfiguration and materialization medium." His talk, "About Heaven: What Really Happens on the Other Side," examined "what happens when our physical body shuts down, and the spirit and soul moves on."

Skeptics, says Jones, don't interfere. She ascribes the receptivity among locals to the fact that "Arlington is cosmopolitan, with people of all backgrounds."

Pondering the Metaphysical Chapel before resuming my suburban physical lifestyle, I noted that the church endorses a familiar prayer called Desiderata ("Go placidly amid the noise and haste…"). It was as big as a college dorm poster back in the late 1960s.

I recited it as I drove placidly back onto the solid ground of Wilson Boulevard.

Solar Power on Ivy Street

January 9, 2013

Arlington sits a mere 93 million miles from a most practical energy source.

So notes Scott Sklar, the solar power luminary whose nonconformist home on Ivy Street may be the county's most energy savvy.

The bearded and jovial Sklar, a longtime lobbyist, author and lecturer, is on friendly terms with his neighbors, who are accustomed to his standing on their lawn to afford visitors a view of the photovoltaic panels on his slanted roof.

The house is easy to spot. Out front is a demonstration van laden with solar panels and a wind turbine that, while not strong enough to run the vehicle, powers the television and DVD player used at events. The van carries the world's most powerful batteries.

By day, Sklar runs the Stella Group Ltd. (named for his daughter), a strategic marketing and policy company that leases on-site clean power solutions for commercial customers and government agencies.

He served on Arlington's Community and Energy Sustainability Task Force, whose 2011 report recommended policies to reduce greenhouse gas emissions per capita.

Across Quincy Street from Washington-Lee High School rests another Sklar demonstration: a "mobile power station" with photovoltaics and a turbine mounted on a shipping container.

Sklar's residence—which some might consider cluttered—is a ninety-one-year-old Sears home. He bought it in 1984, before the Clarendon Metro boom, adding a second story via Arlington-based Merrill Contracting. He eventually powered the home off the grid (except in the peak of summer).

The house was eating up 5.2 kilowatts at peak hour, Sklar explains, and he got it down to 3.2 kilowatts. How? He put in efficient R-38 insulation and double-pane windows containing argon gas. He lathered thermal barrier paint on the attic roof beside a solar attic fan. He added compact fluorescent lights (approved by the federal Energy Star program). He bought a Whirlpool washer that consumes only 40 percent of the water and half the electricity of its predecessor. He installed a solar water heater.

Over his porch, he put in a metal-seamed roof with peel-and-stick photovoltaics. He enclosed his back porch with electro-chromic glass that reduces summer heat. In his yard, he dug four one-hundred-foot holes for a geothermal heat pump that cut air conditioning costs by 67 percent.

Disguised as a drain spout, its pipe transfers heat into the ground. He also captures rainwater in barrels.

Along walkways in the backyard, he installed geothermal light-emitting diode lights. "You can buy them at Cherrydale Hardware," Sklar says. "All of this is commercial, not experimental."

In his separate office, he put in R-50 insulation and a solar daylighting system that makes workers more productive and students healthier. Photovoltaic roofing shingles husband electricity. His basement is lined with twenty-four high-efficiency batteries, and on cloudy days, a hydrogen fuel cell augmenter prevents overload that drains batteries. An Internet monitor displays power used and money saved.

Atop his daughter's old playhouse is a heavy solar panel, and inside sits the first commercially leased fuel panel. Nearby is a solar-powered trailer designed for Third World markets to transport vaccines and for powering schools and irrigation.

"There should not be a freedom to waste energy," says this passionate solar salesman. But Sklar understands why fossil fuel companies prefer the status quo. "It's not an either/or choice—they can coexist," he says. "We have to educate people that energy has to change. They shouldn't be scared."

The Audrey Meadows House

March 1, 2011

Why is it called the Audrey Meadows house?

For years, my Arlington pals conjectured about the handsome Colonial Revival manse that bestrides a huge tract of land at Wilson Boulevard and McKinley Road. Hearing no satisfying answer, I finally went to the horse's mouth.

I contacted the expert horseman, king home builder and one-time husband of the late actress Audrey Meadows, who wowed 1950s America with her portrayal of wife "Alice" opposite Jackie Gleason's Ralph Kramden in the early TV classic *The Honeymooners.*

Randy Rouse, now in his nineties and famous in Middleburg foxhunting circles, was happy to explain the Arlington connection to the "dear person" to whom he was married from 1956 to 1959.

In 1950, Rouse was building houses in the Falls Church–Tysons area. A real estate agent told him of Arlington's hilltop Febrey-Lothrop house

The nineteenth-century Febrey-Lothrop house is known informally as the Audrey Meadows house. *Anne McCall.*

on twenty-six acres, which a divorcing couple was willing to unload for $125,000. Not yet in that league, Rouse came up with $10,000, and the owners assumed a first trust. For several years, the home stayed empty while he built forty to fifty houses off McKinley.

It was on a water-skiing trip to Annapolis that Rouse took up with a New York–based actress. Meadows then was a player on the *Bob and Ray* radio comedy show. But soon she auditioned for the "to the moon" role of a Brooklyn bus driver's ever-tolerant wife, a yuks-making gig she won only after reacting to an initial rejection from Gleason by dressing more frumpily.

Rouse and Meadows were married by her father, a Connecticut clergyman, with Gleason not in attendance, Rouse explains cheerfully, because the "roughneck" was a bit "crude, outspoken and overbearing."

Meadows's 1994 memoir *Love, Alice* (a signed copy of which I scored on amazon.com) mentions Rouse only in one passage, about a time funnyman Gleason "corked" her off: "I had been married in May of 1956 and was living in Virginia," she wrote. "I commuted to New York on Fridays. Saturday nights I hired an ambulance to get me to the airport so that I could jump in my car and be back in my house by 10:30. A call came from the office to say that Jackie was calling a rehearsal for Thursday afternoon. At that time, my husband had the mumps, which can be serious in an adult male.

Not wanting to leave him, I asked to beg off, saying I could learn whatever it was on Friday, but Jackie was adamant. So I flew to New York Thursday. I reached my apartment to find a message saying rehearsal had been canceled. I called the office and laid a few thousand on them. Unconscionably selfish, no compassion, et cetera, were the mildest."

To Rouse, those were "fun years" that his famous wife spent decorating the spacious nineteenth-century home and driving to the Seven Corners Safeway in a red convertible given her by TV sponsor Buick. "She was smart and sensitive but insecure and needed adulation," he says. Eventually, she "got bigger than I was, and I resented being Mr. Audrey Meadows." She also suspected him of consorting with old girlfriends during her absences, which wasn't true, he says.

Rouse gave his blessing to her second marriage, to Continental Airlines president Bob Six. He wrote to her once before her death in 1996 (Meadows never replied), content in his own remarriage, which endures.

Ye Olde High School Transformed

October 24, 2012

Recall the mind teaser: If you take an old axe, replace the handle and then replace the blade, is it still the same axe?

Such a riddle confronted a crowd of Yorktown High School alumni on a Saturday in October 2012 when they returned to their Arlington campus a half century after graduation to size up a spanking new building—with nary a brick left from the edifice in which they grew up.

I was on hand at my alma mater to observe several dozen of Yorktown's "founders" reacting to this unusual dose of proof that time marches on.

Members of the original gangster classes from 1962 to 1964, in town for reunion parties at the Key Bridge Marriott, can lay special claim to the Yorktown heritage. It was they who chose the school colors (Carolina blue and white), designed the class ring, nicknamed themselves Patriots, named the yearbook the *Grenadier* and christened the newspaper the *Sentry*.

Their choices were faithful to themes from the 1781 Battle of Yorktown, in which our French allies were instrumental in defeating the British. Inclusion of the fleur-de-lis on the school insignia was hotly debated, the alums recalled, and they were pleased to see it continue in the school's twenty-first-century incarnation.

"I'm pleased to see the colors restored throughout the school," said my friend Melody Miller ('63) as she marveled at the fruits of the two-phase, five-year $103 million construction feat. "It's a magnificent modern building with high-tech big-screen TVs that even tell you what the guidance counselors are doing," she said. "It made me want to be in high school again, but then I thought about the SATs."

Miller, with whom I've worked on the Yorktown Hall of Fame (temporarily disassembled due to construction), said the joined founders classes "retain a visceral loyalty that later classes don't quite feel." She recalled with pride Yorktown's stature among the then-newly constructed north Arlington subdivisions as the birthplace of WETA and a "show school" for visiting foreign diplomats.

Her fellow alums, in their latter sixties and enjoying retirement, arrived with their vintage school portraits on reunion nametags. One woman wore a '62 letter sweater bedecked with awards for football, basketball and track earned by her husband, Bob "Moose" Ellis, a hero of that first gridiron victory over rival Washington-Lee.

Some expressed shock at the new structure, with its green attributes and post-9/11 security features. Jane Frisa from Lynchburg, Virginia, said she had attended elementary school at the old Greenbrier building that for decades was a wing of the high school but is now a parking lot.

Joel Hamaker, who settled not so far in Bethesda, Maryland, said he'd had no idea of the changes until he recently got a hint using Google Maps.

Woody Greenwood from Washington State said he was having difficulty reimagining the layout of the old Yorktown, recalling a parking lot where he once got in trouble for starting a scooter drag race.

Most returnees looked on wide-eyed as they split into three groups for tours led by three current Yorktown student volunteers from the National Honor Society. "There's nothing left of the old building, and some lockers were sold off," they were told.

These guides, all seniors, professed little recollection themselves of the vanished original building. "It's weird imagining coming back to see this one in fifty years," said Jacqueline Verrecchia.

The axe has been passed.

The Evolution of Ballston's Skyline

January 4, 2012

Ballston looms majestically as Arlington's reach-for-the-stars economic nerve center. But it is also a scene of lost horizons.

My love-hate relationship with the neighborhood goes back decades, at least to the early 1970s, when the first high-rises on Fairfax Drive began to dwarf the quaint old St. George's Episcopal Church where I spent a boyhood as an easily awed observer of Arlington's progress.

Several years ago, I watched with a grimace as the National Rural Electric Cooperative Association doubled down on its existing tower and planted, on the site of the old Putt-Putt mini-golf course, an edifice that completely blocked the view of distant treelines enjoyed by my mother from the seventh floor of the Jefferson retirement community.

The latest Ballston onward-and-upward project is a modern ten-story mirror-glass structure at Glebe Road and Wilson Boulevard that JBG Companies completed on the longtime site of Bob Peck Chevrolet. It pretty well eclipses the view of the cross-county skyline we drivers used to behold while approaching from the north on Glebe.

That location—heavily trafficked for two centuries and once known to rural locals as Ball's Crossing—today is home to a solid ring of tall towers, the conspicuous exception being the still-low-lying Rosenthal Mazda dealership. (Its employees declined my invitation to speculate on whether their days at the site are numbered.)

The larger Ballston panorama of medium-gauge skyscrapers, when viewed at certain angles from, say, Washington-Lee High School or George Mason Law School on Kirkwood Road, resembles not so much a stirring Manhattan-worthy vision as a jarring, higgledy-piggledy mélange of stalagmites.

Methinks the builders of Ballston have gotten over-exuberant. And they're planning more tallboys on Randolph Street.

But I'm a reasonable man about Arlington. I accept the county website's characterization of Ballston as a destination where "elegant high-rises, national and regional corporate and association headquarters, upscale hotels, shopping, restaurants and green spaces all contribute to create a vibrant, pedestrian-friendly mix of business and pleasure." I'm aware that each elevated unit contributes to our tax base.

And I give credit to the public-private partnerships hard at work on the old Bob Peck grounds. The smaller building now houses a Virginia Tech

In the 1960s, Ballston's main department store displayed messages. *Arlington County Public Library Center for Local History.*

Ballston's skyline has, shall we say, evolved. *Anne McCall.*

Some feel that Putt-Putt was, at one time, the center of Arlington. *Photo by Michael Horsley, 1988.*

Courtesy Johnathan Thomas.

Research Center, and the larger one will soon host a batch of employees from the Accenture PLC management consulting firm, lured to Arlington's closer-to-town digs from Reston Town Center. Both office buildings achieved Leadership in Energy and Environmental Design (LEED) certification. And right next door are ninety units of spanking new affordable housing co-owned by Arlington Housing Corp.

The project's graduated height differentials—what developers call a "wedding cake" design—are more soothing than Ballston's other monster towers. And I admire the way architects curved the building to hug the

road's bend. Indeed, every sightline at the crossroads seems well thought through, right down to the detail of allowing Macy's to keep its logos viewable behind the triangular office building that went up later and now fronts Ted's Montana Grill.

Yet on my crankier days, the jam-packed feel of Ballston's oversubscribed airspace makes me long for those lost horizons.

I'm no civil engineer, but how feasible would it be to demolish the ten tallest Ballston high-rises and reconstruct them underground? Such a modest adjustment would retain the convenient facilities for their occupants but place them, for us passersby, out of sight and out of mind.

Just a stray, blue-skyin' thought.

Bright Knights of Columbus

April 26, 2011

Arlington boasts its own medieval city tower. I admire its bluestone cylindrical form each time I'm a guest at the Knights of Columbus mansion on Little Falls Road, where, under various auspices, I've combined a chance for fellowship with a peek through a window into local history.

Next time you drive by, take note that the colonnaded home built on land that since the Civil War has been Reserve Hill was created in 1904 by German American inventor George Saegmuller (1847–1934). He could afford what then was 240 acres of farmland because of his success designing optical lenses for the U.S. Naval Observatory and the company that became Bausch and Lomb. He would later apply treasure and know-how to building an Arlington school and financing the county's first courthouse.

Saegmuller married into the family of the property's original owners, the Vandenbergs, and for two decades occupied a fine southern-porched home. (Fun fact: it was outfitted with the county's first private telephone.) But in 1892, the house burned down. So the inventor decided on a twenty-two-room stone successor modeled after buildings from his boyhood memories of Nuremberg.

All this you learn from basic Arlington history books. But there's juicier stuff in Saegmuller's autobiography, which, I just discovered, his descendants have posted on a website called www.burnsorama.com. Browse through and you see that Saegmuller considered the farm a "millstone" around his neck.

He looked forward to the time when, "owing to the Washington area's rapid growth, the farm has become very valuable and it will not be long before it will be laid out into building lots." Little did he know.

Saegmuller's dream house stayed in the family until his son put it up for sale in 1951, to the delight of the Arlington Knights of Columbus, who had outgrown their headquarters on Washington Boulevard. For this tale, I came across another fresh source. The deal was facilitated by lawyer and Knights leader Vince Tramonte. Newsletters shown to me by the Tramonte family show that their father got the price down to $86,000 and financed it, in part, via a minstrel show. He put out a membership appeal "for sincere and hard workers to appear, ready for work, on Saturday morning, bright and early, to help move the furniture and equipment in from the barn and elsewhere; clean up the place, install the bar, and redirect water lines etc."

Such joyful volunteering is what I, a non-Catholic, encounter at the home of the Knights. I was first a guest in the mid-1960s as a player on the Knights Little League team. I've since been there for a high school reunion, birthday parties, a Better Sports Club's banquet and monthly barroom gatherings of still-developing middle-aged dads.

Over the decades, this warm but spooky house has spawned Halloween ghost stories and rumors of long-ago foul play on the premises. But my only complaint about its owner—a fraternal lodge fully committed to aiding the needy—is that Little League alumni don't get free beer.

When I stop to admire the tower that gives our suburban landscape some flavor of Europe in days of old, the spell is broken only by the sight of a window-unit air conditioner. And the fact that guards atop its heights would peer down not on attacking barbarians but on the Knights of Columbus swimming pool.

A Centerpiece for the Arts

January 16, 2012

How better to humanize the glass canyons of Crystal City than with offerings of fine local art?

South Arlington's office jumble that booms by day but fades to sterility in off-hours now hosts a gallery of homegrown art that sprung largely from private efforts. Combine it with Arlington's newly approved post-BRAC

economic investment strategy—which includes a streetcar line that will link to Alexandria—and Crystal City's future appears warmer.

The Northern Virginia Art Center, launched in July 2012 by the twelve-year-old nonprofit Arlington Artists Alliance, displays and sells a classy array of paintings, drawings, ceramics, sculpture, jewelry and art glass. It's not easy to find the place in the underground of the Shops at 2100 Crystal Drive, but I came away impressed with the sophistication of the works, which sell at artist-set prices from $200 to $800 and up.

No artist sets to work expecting a steady paycheck, and it's against the spirit to knock competing creators. But the juried artists who joined the alliance's cooperative and show their stuff in Crystal City feel they achieved a breakthrough.

Arlington's cultural affairs division, I'm told by Sandi Parker, one of the center's three paid employees, zeroed out the Artists Alliance grants. That stands in contrast with the thousands in public funds shelled out for Rosslyn's Artisphere, which combines working artists' space with performance art, theater and national music acts.

Nor could the fledgling center take advantage of assigned public space like that enjoyed by the more regionally focused Arlington Arts Center, housed in the historic Maury School on Wilson Boulevard. The alliance for years made do with renting space at the Arlington Arts Gallery and frame shop on Lee Highway and displays at Cassatt's (Kiwi) Café and Gallery and St. Andrew's Episcopal Church.

But in 2012, it won space from the Crystal City Business Improvement District and the Vornado Charles E. Smith Company, and that has spelled the difference.

"It's a great example of a partnership between a business community and a nonprofit," says my friend Elise Ritter-Clough, a painter who has sold works at the center. "In an economy where art galleries are closing down at a fast pace, this one has turned out to be very successful." An opening reception in September drew 473 guests. Sales average one or two per day.

Many of the artists are nationally known, though about 80 percent are from Arlington. (Others are from Alexandria and Falls Church, where, I can vouch, talent also resides.)

One proof of the quality and commitment of the artists, Parker says, is that they must each pay $300 every six months, spend four hours a month on the premises to answer questions and give the center a 15 percent commission. To keep things fresh, each must change the works on display the first Monday of every month, and no work may be repeated in less than three months.

Buyers, Parker adds, are residents in nearby condos, convention-goers from Crystal City hotels and tourists from as far afield as Alaska. Employees of PBS come from upstairs, and neighboring restaurants in the Crystal City underground cater events. On January 12–13, the Washington Wine Academy steered upward of one thousand by the center during its 1K wine walk, followed two weeks later by a beer walk.

Without such action, Parker says, "this area would be a wasteland."

Spinning the Artisphere

May 4, 2011

Wherefore Artisphere?

The ambitious new dome-topped arts venue has for six months been hiding amid the glass canyons of Arlington's forbidding mini-city of Rosslyn.

Designed for "people and art to collide," Artisphere is a public-private arts center with offerings for every taste from Shakespeare and opera, to county-based painters, to hip musicians (Saturday night featured surf rock by the Cuban Cowboys), to the just-ended show of costumes and dance under the theme "Art and Culture of the Mongolian People of Arlington."

As a concept, it is fascinating. As a reality, Artisphere finds itself crosswise with the county board. Revenues reported in April were 75 percent below projections, a shortfall of some $800,000, which prompted the board to balk at a new cash infusion.

County board member Mary Hynes told me this eventuality occurred to her in 2008, when, with recession looming, the board warily approved a consolidated arts budget built around Artisphere. The idea was to add some human factor, nightlife and new revenue-generators to the mod complex that was the Newseum.

Studies show that each dollar appropriated means seven dollars in new revenue from consumer spending on meals, entertainment and parking, Hynes says. So it bothered her that Artisphere came in with the "gimmes" instead of rethinking a management process that delayed key hiring and postponed the project's online ticketing (it finally went live in February) and restaurant. (The HERE café bar, serving "comfort food with a Latino flavor," opened in April 2011, only to close months later.)

Hence the board for fiscal 2012 gave the Artisphere not the $800,000 it sought but $500,000 contingent on having a new business plan ready for review by early July.

Annalisa Meyer, Artisphere's upbeat communications director, said the new plan is happening. "We had a longer-than-anticipated ramp-up period to build our program infrastructure," she says. "It takes time to support new and emerging artists."

The tour she gave me Saturday showed off a twenty-first-century edgy arts buffet that attempts to provide "stuff you can't find elsewhere," she says. Open eighty-five hours a week, Artisphere honors rich cultural heritage as well as new media—a video wall, shadow puppetry using opaque projectors, laminated photos on café tabletops and free Wi-Fi to attract Rosslynites for business meetings.

Much is avant-garde. A "transition gallery" shows how art is made. A bio-wall is made of live plants; cork floors and bamboo siding embrace sustainability, and the restaurant food is Virginia grown. Visitors can roam between short films, auditorium lectures and passageway exhibits.

Event prices range from free to pay-what-you-can to ten to fifteen dollars. Donations are up, Meyer notes. The ballroom rents out, and special donors pay to select inspirational quotes for display.

Signage needs to improve, she acknowledges, particularly the route from Metro. "Our goal is innovative and thought-provoking art."

Arlington's bet on Artisphere has brought out the political knives. Local GOP chairman Chris Berg called it "red meat in the November elections." Also blasting away is Green Party candidate Audrey Clement.

Hynes says it's an "unfortunate situation, but it has the potential to work if the Artisphere becomes more nimble." If it offers esoteric dance and juried art shows but "people don't know it exists," then perhaps it should shift to more basic community attractions, she says.

But like true artists, Artisphere planners seem ready to take a risk. "Being an incubator to the arts," says Meyer, "we expect scrutiny."

On Stage at Lubber Run

June 14, 2011

After two years of darkness, the comfy, rickety amphitheater at Lubber Run Park prepared in June 2011 to resume its evening magic. It's a

fine Arlington example of collaboration between the governors and the governed.

For thousands who like their culture in the open air, summer isn't complete without nights of entertainment under the stars and sheltering trees off Route 50. My personal faves from Lubber Run over the decades include legendary singer Richie Havens, a rich production of *The Fantasticks* and the annual a capella nights hosted by the goofball Tone Rangers and Da Vinci's Notebook. All for free.

"Built in 1968" is the factoid bandied about in the debate over the county's 2009 decision to suspend the shows for budget and safety reasons. But the venue's history goes back further. The original Lubber Run stage opened on Flag Day 1941, and the first free concert series began in 1956, according to news items in a history by civic activists.

I personally recall gallivanting before a Lubber Run audience as a seven-year-old summer camp performer in a 1960 cavalcade featuring the then-smash song "Itsy Bitsy Teenie Weenie Yellow Polka Dot Bikini."

It was similar memories in the hearts of those living in the Arlington Forest neighborhood that led residents to mobilize to lobby county staff, circulate a petition that earned eight hundred names and eventually launch the Lubber Run Amphitheater Foundation Inc.

The campaign got started after "neighbors walking their dogs in the park discovered yellow tape across the facility in 2009," local activist Chris Scheer told me. With a recession on, the county cultural affairs staff had stopped assembling the annual schedule of stage performances. Even when the budget crunch eased, "the county was doing so much with the arts, Lubber Run kind of got left behind," Scheer said. The foundation will tap civic federations and arts groups to build support that is "countywide and regional," he added.

Worried about a decaying structure and code violations, the county commissioned a study by Neale Architects. This March, the firm recommended a $2.5 million renovation (or a new amphitheater for $3.5 million), not counting compliance with the Americans with Disabilities Act and resource protection and floodplain regulations. It was a sad catalogue of "open trenches, steep grades, deteriorated benches, tilting walls, crumbling paving," mold and grim bathrooms.

Enter the foundation folks. They argued that the study was exaggerated. They recommended instead an interim "no-frills" renovation to keep live bodies in the amphitheater.

Following the usual ultra-thorough community meetings, the board this May agreed to provide $100,000 to replace the wooden stage, replace the

area and stage lighting and add accessible parking spaces, portable restrooms and accessible seating. There's a nifty $45,000 worth of performances for late July and August and another $100,000 to study future construction.

Are neighbors happy? Arlington Forest activist Tricia Freeman told me there was a bit of resistance when the amphitheater "was upgraded over forty years ago addressing concerns of traffic, noise and parking. But at this point, most residents have moved in knowing the amphitheater was there and, in fact, are delighted to have a free performance venue within walking distance," she says. The county has "worked with performers and residents to make sure those issues are rare. I have had the good fortune to have the amphitheater provide background music for a small dinner party on the back deck." Bravo.

Arlington's Jewish Community

August 14, 2013

When I chose a Friday night to hit the 2013 county fair, I had no inkling I would encounter this sign at a vacant booth: "It's not that we don't want to be at the county fair…but we're celebrating Shabbat at Congregation Etz Hayim."

On the table was a stack of maps with directions to "Arlington's only Conservative synagogue." The document reminded me not only of our county's vibrant community of practicing Jews but also that its history has flourished too often under-noticed by many of us gentiles who grew up alongside it.

My friend Lore Schneider, age eighty-eight and German-born, recently recalled how when her family arrived in Arlington in 1960, they knew of no synagogue, having heard of one that once met near the (still open) Public Shoe Store in Clarendon. A look in the phonebook introduced her to the Arlington Jewish Center on Route 50.

Thus began a decades-long relationship that included sending her son, as a sixth- and seventh-grader, twice a week via the public bus from north Arlington to the center's Hebrew school and its countless Boy Scout meetings. Anti-Semitism was more flagrant in those days, and more than once kids in her neighborhood near Nottingham Elementary School threw rocks at the bus.

An old Jewish canard has it that every community must have two types of temples—one you join and another "you won't set foot in." Hence many Arlington Jews of the Reform persuasion began commuting to Alexandria to worship at Temple Beth El on Seminary Road (founded in 1859 but at its present site since 1956).

In 1962, a slice of them (thirty-six families), some of them disillusioned with the leadership at Beth El, joined with Fairfaxian co-congregants and opened the Temple Rodef Shalom in Falls Church.

There, many of my Arlington friends over the decades held confirmations and bar and bat mitzvahs to which I was invited. To this day, as I drive by on Westmoreland Street I continue to marvel at the beauty of that expanded edifice.

In the early 1990s, organizers from the Reconstructionist Jewish community Kol Ami began what continues as religious services and community outreach in the library and fellowship rooms at the Unitarian Universalist Church of Arlington, at Route 50 and George Mason Drive. Its mission is to "celebrate our Jewish souls, expand our Jewish minds and reconstruct our Jewish hearts."

There is no Orthodox congregation in our county. But the oldest congregation is the Conservative Etz Hayim, a capsule history of which was provided to me by its past president, Jerold Jacobs. The rumor about old-timers meeting above the shoe store is true, he said, describing how from 1940 to 1947, what then was called the Ohev Shalom Congregation met for high services in the Jones building on Wilson Boulevard.

Then ground was broken at Arlington Boulevard and South Fenwick Street for what began as a below-ground structure called the Arlington Jewish Center. By 1952, the name had morphed into the Arlington-Fairfax Jewish Center, and two years later, construction began to create the building in use today, which was dedicated in 1955.

"At its largest size in the 1960s, the congregation had almost three hundred members and some two hundred students in our religious school," Jacobs told me, referring to baby-boom days when Lore Schneider's family was active there. "We are striving to regain that stature."

The Folks at Hidden Oaks

August 21, 2013

Barry Becker hails from Arlington, but more precisely, he hails from Hidden Oaks.

Becker and his wife, Susan, occupy one of the eighteen town homes on a circle just off Arlington Boulevard that constitute a kind of private enclave, a semi-independent carveout from the county's street system.

Since the handsome red brick homes were built in 1987 on an old farm, the owners have been "responsible for the care and feeding of the street that is South Pershing Court," Becker told me. That means repaving, plowing snow and maintaining streetlights. "The homeowners' association has articles of incorporation, bylaws, elected officers, dues ($120 per month) and anything else the resident lawyers could create."

The founding owners were a platoon of self-sufficiency-minded military officers, retired and active duty, who favored an easy commute to the Pentagon and a short walk to the National Guard Readiness Center. "The developer's dealings with the county were complicated," says Becker, a consultant who bought his house in 1994. They would allow no gated community.

The self-sufficiency goes only so far—the county supplies water and performs trash and recycling pickup.

"We have an official business meeting twice a year," says Becker, who has twice served as president. Unlike the county board chair, the Hidden Oaks president's major duty is "hosting the meetings and providing wine and food," he says. "We try not to discuss politics—for obvious reasons."

But there is work involved. Snow removal and the changing of streetlamp bulbs are contracted out. Officers solicit bids, pick a vendor, ride herd on the execution and inspect results for quality.

"The sense of community has changed a bit over the years," Becker says. "When the original eighteen founders were still all here, I'm told they were a tightknit group. But in the last few years, a number of homes have changed hands. We're down to one retired air force three-star, a retired army bird colonel, a retired air force bird colonel and one active-duty national guard colonel."

The county's handling of the Hidden Oaks quasi-separatists is not difficult, I was told by Dave Hundelt, who heads Arlington's streets maintenance. There are dozens of similar arrangements, many of them condominiums,

with parcels used as common areas or parking lots that reflect a mixture of county and private ownership, he says.

"The developer went through the site planning process and did not dedicate a right of way for the county to create a public street," Hundelt explained. "They wanted to build the homes at a certain density, and the bargain the county strikes is to pass along to future owners additional responsibilities, such as maintaining the cul-de-sac's asphalt and curbs."

Hundelt says the enclave shows up on county maps as private property (a short median sign declares it so), though official maps track how county sewer and waterlines link to it.

The county keeps records of every residential unit and what services owners are entitled to. Because Hidden Oaks homeowners have individual water meters, they retain the common "fee simple" arrangement that provides them with county water, sewer service and trash and leaf removal. But the county wouldn't drive a snowplow onto the cul-de-sac because it wouldn't be legally protected.

Becker says he heard that some of Hidden Oaks' do-it-yourselfers fifteen or twenty years ago attempted to "give the street back to the county. The county laughed."

Culpepper Garden

April 25, 2012

"If you plan on growing old, you want to grow old in Arlington." So proclaimed Barbara Thode, service coordinator at the renowned Culpepper Garden retirement community, speaking in April 2012 to a passel of dinner guests from the Arlington Committee of 100.

Thode was thanking the Arlington Agency on Aging for the county-provided social services on which her facility on Pershing Drive depends "to help people aging in place with dignity and independence."

If you yourself are not in the relevant age bracket, then perhaps, like me, you have relatives whose unfolding gerontological predicaments prod you to get familiar with the labyrinth of issues surrounding care for the elderly.

Culpepper Garden is a thirty-seven-year-old nonprofit founded by 1960s-era volunteers from the Unitarian Universalist Church of Arlington. It provides both independent and assisted living services to low- and moderate-income elder residents.

It was named for Charles Culpepper (1888–1980), a notable U.S. Agriculture Department botanist who gave the once-rural Arlington land he'd owned for five decades to the cause of elder housing. (I met Culpepper in the late '70s on a reporting assignment, when he was nearing ninety.) His innovative daffodils and day lilies still thrive on the grounds.

His namesake facility has a national reputation. Its assisted living wing was first to receive funding from the Housing and Urban Development Department, and in 2011, it won Virginia's Commonwealth Council on Aging's Best Practices Award. It also houses the largest of Arlington's six senior centers, which offer classes, lectures, games, crafts and music.

Culpepper Garden's 349 residents (the vast majority of them female) range in age from 62 to 103 and range in capabilities from those who work and drive to those needing round-the-clock care. Their average income is $1,200 a month, and since care costs $2,000 a month, the facility relies on donations.

All of them benefit from taxpayer-provided social services, protection, mental health counseling, transportation, legal aid for wills, special large-print library books and the county's tax relief for the elderly.

But none of it comes easy. Tom Fonseca, chair of the Arlington Long-Term Care Residences Commission, told the gathering that in national ratings of nursing homes, Arlington's don't fare well—of thirteen residences, only the private Jefferson has a four-star rating from the Health and Human Services Department. He rattles off the demographics that make this no small issue: of Arlington's 211,000 residents, some 2,800 are eighty-five or older, 8,000 are seventy-five or older and 18,000 are sixty-five or older.

Don Redfoot, a policy adviser with AARP's Public Policy Institute, was there to congratulate Arlington for its preparations for the coming onslaught of baby-boomer retirements. The county planned ahead—its task force plan on elderly readiness was adopted by the county board in December 2007. He stressed the value of relying less on institutional nursing homes and more on keeping the elderly connected to their homes and community.

What is clear is that there's no simple path that applies to all families. Many elderly resist change and understandably cling to independence long after the time to get help has passed.

It's a tribute to the network of elderly housing professionals that their solutions mix the public and private, the paid and volunteer, the insured and the out-of-pocket payers.

When it comes to growing old, the end of life isn't fair. But Arlington takes on the challenge.

Capital Hospice

January 11, 2011

The 1:00 a.m. phone alert seemed just the latest in a series we'd come to know since the onset of my mother's final illness. This climactic call, however, displayed the instant intimacy our family had been granted by the round-the-clock team at Capital Hospice.

Though headquartered in Falls Church, Capital Hospice for me is embodied in the classic Colonial-style schoolhouse whose exquisite gardens front onto Arlington's Sixteenth Street, near North Glebe Road.

The Halquist Memorial Inpatient facility is a building to which my family has multiple ties. My sister attended high school there when it housed Arlington's experimental Woodlawn program in the early 1970s. Her husband spent his formative years there in the '60s, when it was Woodlawn Elementary. And my mother herself taught a course there in biblical scholarship.

But neither I nor my siblings could have guessed that this Eden-like setting, with beds for just fifteen, would suddenly in August 2010 become the site of my eighty-seven-year-old mother's final hours.

Our first contact with Capital Hospice was a comforting voicemail left in July by a staffer named Miguel, a response to our tentative inquiry. At this stage of my mother's battle against lymphoma, we were shuttling between her apartment at Ballston's Jefferson retirement community, George Washington University Hospital and Virginia Hospital Center.

We were adjusting to being active health-care consumers, making decisions fraught with uncertainty, having no inkling whether the patient would end up back home, in a hospital or in a rented room at a Sunrise complex. Soon we had another choice.

Capital Hospice, a pioneer of the nationwide hospice movement since 1977, has helped more than 60,000 patients and families "live their best lives with advanced illness." It treats 900 patients daily in Virginia, the District and Maryland. Palliative care is delivered in homes, hospitals or rehab facilities by 22 staff physicians, 600 employees and 850 volunteers.

Though sometimes controversial, the hospice's acceptance-of-death approach is fully covered by Medicare. The effort is funded by donations—a thrift store at the Willston Shopping Center, a November black-tie auction at the Tyson's Ritz Carlton, a recent gift of $1,000 in taxi coupons from Arlington's Red Top Cab and memorial gifts directed by grateful families.

My family's month-long drama peaked on August 14, when my mother's doctors ended all treatment. The hospice rep arrived to settle a dispute over whether she could be transferred on a weekend. A voice inside me said to accompany her in the transport ambulance to Capital Hospice. Sure enough, the drivers headed erroneously toward its Northwest Washington facility before I redirected them to Arlington.

For twenty-four hours, our family—finally relieved of the hospital's war-zone tension—drank in the hospice's humanistic tranquility. Naturally paced conversation. Few rules. Volunteers serving coffee and tending to our emotions. Visits by a therapy dog, a guitarist, friends, my mother's minister, her church choir mates.

We felt joyfully assured that despite her apparent unconsciousness, my mother heard them all.

In my bed just after midnight on August 16, I was awakened by *the call,* which came from a soothingly competent hospice staffer. I drove to pick up my sister and brother, and the three of us stood under moonlight in the garden of the Halquist building.

Right at this intensified moment, a wild rabbit scampered by. At this most vital institution, the life force goes on, twenty-four hours each day.

Chapter 7

PUBLIC POLICY SPATS

Sounds from Westover Beer Garden
May 18, 2011

As the flakes of Snowmageddon piled high in February 2010, Arlingtonians from the Westover neighborhood quickly got their priorities straight. Some hearty souls traipsed over to the Westover Market's white-blanketed beer garden, where they helped the manager shovel out the place and open the taps.

These suburban adventurers spearheaded a movement from all walks and beer preferences to enjoy the open-air brew, brats and bands that for two years have injected a hip spirit into the Westover shopping strip.

If only life were that easy. In August 2010, the garden's wafting tunes prompted two neighbors to reach out to police. In came the Arlington County zoning authorities. Ever since, Westover Market manager Devin Hicks has been pouring money and anguish into righting the details of his small slice of our area's entertainment offerings.

The regulators are concerned not just with noise but also the aging building's restrooms, which are not handicapped-accessible. They also cite the kitchen as being insufficient for an eat-in venue and seating too close to the grocery aisles.

Some neighbors dreaded the sounds of the Westover Beer Garden, but it endures.
Anne McCall.

"It's outrageous that it takes two and a half years to get a beer garden," complains Hicks. "And they're giving me grief on the music permit," as well as his outdoor TVs, canopies and parking. "But we're making a good-faith effort," Hicks promises, "and in the end, everyone will win."

The sleepy Westover center, which has long seemed frozen in 1963, is lately seeing some action. The renovated Westover Library reopened last year, the adjacent affordable housing project was upgraded, the Lost Dog eatery across the street doubled its size and the long-smoky Forest Inn banned smoking.

The beer garden's homey wood-fence enclosure and funky painted mural have humanized a dull passageway alongside the post office. Its music is "some of the best you can find in Arlington," Hicks says. The sounds flow from 6:00 p.m. to 10:00 p.m. on Fridays and Saturdays, plus an open mic on Tuesdays and Wednesdays from 7:00 p.m. to 9:00 p.m.

This past Saturday, the county board spent three hours preparing for a dramatic, unanimous overruling of its professional staff's recommendation. The board is ready to grant, on an experimental basis, a rare outdoor live music permit to the young Hicks, who by now has become a popular manager of the newly configured restaurant.

Live singers, amplified in ways that county technicians and legal eagles can properly monitor, will be performing in the open air in season on Wednesday, Friday and Saturday nights, no later than 10:00 p.m.

It's good news for Westoverians and visitors who cherish the urban village, community-building aspects of the venue that began amateurishly and became a surprise hit.

It's bad news for the close-by neighbors, four of whom spoke in opposition (one of them lives a mere 110 feet from the garden). They oppose the "unwelcome noise," as Chris Clarkson called it, because it carries into their homes until they must jack up the volume on their own TVs or radios. It allows a grocery store to determine their young children's bedtimes, another complained. Using barriers to muffle the sound doesn't work, another said. Plus, the manager has not acted in good faith, said Tad McCall, when he's been asked to cut off the music on time.

Indeed, the staff's reasons for recommending against a permit included poor compliance with past county directives (on limiting the current number of seats to nine, for example), as well as proximity to single-family housing, the area's low-density zoning and difficulties of enforcement (relying on neighbors' complaints and vague rules).

Staff checks with Falls Church, Alexandria and Fairfax found that only Fairfax permits restaurants to regularly offer live outdoor music, and Arlington in the past has granted only one exception—to Sobe's in Clarendon.

But the beer garden's lawyer, William Lawson, said Hicks shouldn't be blamed for noncompliance when the rules have been utterly confusing. He noted the routine outdoor music at Rosslyn and Crystal City, as well as from high school bands during sporting events.

He and Hicks demonstrated to the meeting a live Internet video stream of the cashier at the Westover market, with a promising decibel monitor visible (barely) on the county's projection screen. This led the discussion deeper into a morass about whether such self-enforcement of the noise ordinance would be admissible in a court challenge and whether the market could pay for extra county inspectors to work evenings.

The views of the majority (thirteen speakers) favoring live music at the beer garden were captured by Dennis Dineen, who said Hicks is a "creative type" who may not be good at following rules, "but let's give him his shot."

Board member Walter Tejada said, "We live in a densely populated area, and noise is part of our lives." When Tejada sits at home and hears a Metro train or kids shouting at a swimming pool, he likes it. Such sounds confirm that "life's out there."

Construction Noise Restrictions

August 2, 2011

Which is the bigger nuisance—a neighbor roaring his lawn mower in the middle of your tranquil dinner or a surprise visit from the local curmudgeon asking you to finish the grass later?

I've played both roles in my checkered history as a homeowner, but I'm appealing here to the better angels of our suburban nature.

Who among us hasn't felt the press of a schedule and revved up the old Lawn-Boy just as the folks next door are settling down to their bowls of summer gazpacho?

But more often, to my wife's mortification, I'm the volunteer enforcer of the rules that, ahem, are spelled out in the "frequently asked questions" on code enforcement on the Arlington County government's website: "Construction activities can begin at any time; however, there are noise limits by time of day for construction. The normal noise decibel level can be exceeded from 7:00 a.m. to 9:00 p.m. Monday through Friday and 10:00 a.m. to 9:00 p.m. on weekends and legal holidays. This would include the use of power equipment and other activities."

In theory, these mandates are designed to allow a gentle dweller such as me to bask in well-earned early morning downtime during weekends and holidays. For me, that means a sweet, four-course breakfast on the back porch; birds chirping; some soft '50s doo-wop on the speaker; and fresh editions of the world's greatest newspapers.

Should I not be a tad miffed if one of my neighbors chooses that moment to fire up his rented power washer or satanic leaf blower?

The problem is that few citizens seem aware of the time restrictions.

So I asked Gary Greene, section chief of Arlington's Code Enforcement Inspection Service Division. He acknowledged that there hasn't been much effort to publicize the decibel level–based rules laid out in code section 15.6. "In this urban environment, you can't totally control it," he says. "My idea of nighttime and daytime may be different from yours."

The nuisance that bugs Arlingtonians most is construction noise. Our affluent community has changed from Mayberry to more like Manhattan, he says, and people spend a lot of dough maintaining their property. Being a good neighbor means telling crews with heavy equipment (and those mobile landscaping SWAT teams) that they must respect the hours, even though, yes, they have a living to make and they, too, want to beat the rush hour home.

Complaints about abusers of small power equipment can be passionate. In the middle of 2010's Snowmageddon, Greene recalls, he heard gripes about people using snow blowers in the middle of the night. (He made an exception and didn't call in the enforcers.)

An astonishing 15 percent of beefs are retaliation complaints against neighbors who complained first. Noise policy in Northern Virginia is ahead of downstate and downtown in that people expect their complaints to be resolved, Greene said. "10 percent of Arlington is lawyers," he says, so the county takes the educational approach, such as speaking to civic associations, which minimizes going to court.

For John Q. Publics who find their tranquility shattered, he recommends first using the soft approach of a civil conversation. (Would I speak any other way?)

Only if that fails should you resort to the police (the non-urgent phone number), Greene says. "This issue will be with us as long as the grass and shrubs are growing."

Fresh Fighting at Fort Ethan Allen

December 28, 2011

Arlington's Fort Ethan Allen has been the scene of conflict in three notable instances.

First there was the Civil War (which prompted its creation in 1861). Second, there was the great dog park fight in 2004 (the upshot being the county's Solomonic decision to move the facility a couple hundred yards from remains of the fort). And now, there's a passionate but civilized dispute about the coming year-round exhibit commemorating it, which got moving with the Civil War sesquicentennial.

Visit the site at Old Glebe and Military Roads—as I have since I attended elementary school at nearby James Madison—and your senses respond to a soothing green space framed by a tidy row of suburban Colonial homes. You get little inkling that those two shrub-covered berms that rise above ground level were once part of a major strategic obstacle preventing Confederate troops from marauding over Chain Bridge into the Union capital.

Venture close and you'll spot some "Please keep off the earthworks" signs and surveyor's pegs in the open space once romped upon by local pets. The county is laying groundwork for what will become an outdoor museum,

Fort Ethan Allen's outdoor Civil War display might bring new visitors to a residential block. *Samantha Hunter.*

with improved signage describing the fort that housed one thousand Union troops and thirty-two cannon.

Consult the text, photos and maps in "Mr. Lincoln's Forts: A Guide to Civil War Defenses of Washington," by Benjamin Franklin Cooling III and Walton H. Owen II, and you see why Ethan Allen was built, as part of a chain around the District by troops from Vermont, who named it after their Revolutionary War hero.

Though garrisoned in succession by units from eight states, the fort was primary home to the Fourth New York Heavy Artillery soldiers. Occupants saw one skirmish with Mosby. A Philadelphia unit watched from its walls as one of history's early military balloon flights monitored Rebel troops four miles distant in Falls Church.

To bring this drama alive, neighbors in the Old Glebe Civic Association led by Burton Bostwick spotted their chance to upgrade the fort using their eligibility for $300,000 in 2010 bond funds under Arlington's Neighborhood Conservation Program. Following completion of an archaeological analysis, the plan is to bring in lighting, pathways and a replica of a cannon.

A three-foot-high brass model evoking the fort's layout is being paid for by neighbor Homer Knudsen, I was told by Rich Samp, neighborhood

coordinator for the project. Also, "the hope is to plant grass or place mulch on the berms to prevent them from becoming poison ivy jungles," Samp said.

One glitch was the county's move—apparently with little notice to neighbors—to chop down trees on the property, drawing fire from some privacy-conscious homeowners on Military Road.

A thumbs-down on the project comes from Judah Best, an attorney who lives across Old Glebe Road. Though he loves history as much as anyone, he told me, he worries about increasing traffic to an area with scant parking. More important, says Best, why spend thousands "in these lean times to commemorate what happened 150 years ago?"

Such austerity is pooh-poohed by Michael Leventhal, Arlington's historic preservation coordinator, who is excited about interpreting for a new influx of visitors the fort's military value from both the offensive and defensive perspectives. "What's public is public," he said. "It is not the private compound of the neighbors."

Editor's note: The outdoor museum at Fort Ethan Allen opened in March 2014.

The $1 Million Bus Stop

July 17, 2013

I finally got a chance to take shelter at Arlington's infamous $1 million bus stop. It's the one that drew international mockery in the spring of 2013 in what might someday make a Jeopardy category of boondoggles.

It feels small for a scandalous object (I'd expected graffiti defacing it). But it is sleek and has nifty maps.

The so-called Super Stop is a planned series of twenty-first-century sidewalk oases along Columbia Pike that planners hope to incorporate into a multi-mode system including the controversial streetcar. The stop offers electronic real-time bus arrival information, ample seating, safe lighting, newspaper boxes and a raised sidewalk to ease bus boarding.

The project was frozen in April 2013 after an outcry when the ARLnow blog attracted twelve thousand readers to its story quoting a county official saying the first copy at Walter Reed Drive cost $575,000 for construction and fabrication and another $440,000 for construction management and inspections.

Critics pounced, lambasting not only the price but also its stingy shield from the elements, as county board member Libby Garvey complained. "If a bunch of public servants run up a bill of $1 million," I was told by Wayne Kubicki, an activist with the Arlington Civic Federation, "an alarm ought to have gone off either at the county or Metro or somewhere in between, particularly in this economic climate."

The project was defended as an investment by some design professionals quoted in *Landscape Architecture Magazine*. Arlington Transportation director Dennis Leach said the community wanted "an open, airy design" that is transparent.

Officials pointed out that Arlington's share of the price tag was only $200,000. (The rest was from the Virginia Transportation Department, which is well aware that Columbia Pike is the commonwealth's busiest bus corridor.)

And the first edition of the Super Stop required extra design and set-up costs that will shrink once builders get the hang of things.

In late June 2013, County Manager Barbara Donnellan announced the launch of an independent, outside review of the design, financials and community consultation process.

"We will move forward with this project only after we are certain that we can produce well-designed stops for significantly less cost in far less time than it took to produce the Walter Reed Super Stop," she said. "Arlington County government takes its responsibility to taxpayers seriously."

With all the ridicule and political brickbats, it seems Donnellan had little choice but to spend more county money farming out the review. That reminded me that a couple years ago, kibitzers like Kubicki proposed that the county create an inspector general's office with a staff of two or so, an approach with which Fairfax County has achieved savings. It's a position for which the Super Stop probe might be tailor-made.

But county spokeswoman Mary Curtius told me the manager insisted on an independent review, and the cost of such a review is not clear since the contract—with completion expected by year's end—has not been awarded. (The *Sun-Gazette* reported that a related contract to survey the Pike's bus users cost $7,500.)

My guess is that the review contractor will bring expertise in transportation and construction perhaps lacking in the in-house staff. But another way to view the situation is that critics who hone in on a boondoggle wouldn't be placated by just another in-house opinion. That's the price we taxpayers pay to restore credibility.

BRAC and Our Office Space

February 15, 2011

February 2011 brought release of an un-humble memoir from former defense secretary Donald Rumsfeld and also brought home one of Rummy's less celebrated legacies: the rubber now meeting the road as local officials carry out the fiats of the 2005 Base Realignment and Closure Commission (BRAC).

I had a hunch Rumsfeld might apologize for the traffic snarls the BRAC will soon visit on Arlington and environs.

But before I could score a copy of his confessions, the National Academy of Sciences on February 7 released a study requested by Senator Mark Warner (D-Virginia). It implored the Pentagon to cough up some semolians to pay for the highway access improvements that must ride sidecar to the pending move of seventeen thousand from Arlington to allegedly safer sites at Fort Belvoir and elsewhere.

Then, on February 9, the Arlington Committee of 100 hosted a talk by three Arlington officials charged with mitigating the BRAC's impact on our economy. They explained how since Arlington's BRAC Task Force was set up in January 2006, the BRAC has been considered an economic emergency.

Arlington is suffering more job losses than any of the other nine localities impacted by the 2005 BRAC. The percentage of office space in transition is 76.8 percent of Crystal City's, 12.8 percent of Rosslyn's, 8.5 percent of Ballston's, 1.8 percent of Pentagon City's and 0.1 percent of those near the courthouse.

The Arlington team has offered job counseling services and has been meeting with defense contractors, small businesses and vendors whose livelihoods are thrown askew by the potential emptying of 4.2 million square feet of office space.

The officials are operating, all three assert, with only minimal data from liaisons at the Defense Department and the General Services Administration. That's one reason, said Arlington BRAC project coordinator Andrea Morris, that for many Arlingtonians, "BRAC is a four-letter word."

The information coveted by the BRAC Transition Center includes the number of employees opting to keep their jobs in the departing U.S. Army, U.S. Air Force and defense intelligence agencies; the timetable for their moves (beyond the official September 15, 2011 deadline); and the fate of leases in the affected Arlington buildings.

The Pentagon's interest, said Sandra Smith, the Arlington BRAC Transition Center's employment specialist, is to have as many employees

as possible make the move, but "our interest is to tell them, 'You have other options.'" The BRAC "happens to the families," Smith said, and many employees consider family first.

Defense contractors and Crystal Underground retailers are facing a "withering exodus of customers," said Adam Beebe, the center's business development manager. Many are facing "tough, bottom-line decisions" on whether they have enough federal work to maintain their Arlington location.

The need to ease the uncertainty vindicates the county's early strategy of taking on the BRAC changes proactively.

The swirl of politics, economics and personalities that informed the BRAC process produced important, if painful, moves to rationalize the nation's obligations in defense spending.

But the leaders seemed tone-deaf to their impact on traffic. How else would they move 6,400 jobs to the Stalin-esque Mark Center on Alexandria's Seminary Road and 1,200 jobs to the National Guard facility at Arlington Hall with nary a public transportation option in sight?

A quick check of the Rumsfeld memoir reveals it addresses the BRAC only in a footnote. Rummy hails it for the money it saves.

Public Lands for Public Good

March 21, 2012

"Public land for public good" is a battle cry making its way up the Arlington agenda. And like many slogans, it has the ring of common sense but encapsulates a mash of forces.

I got a taste of it from Marjorie Hobart, a retired teacher and advocate for the homeless who has worked the issue for nearly a decade with the Arlington New Directions Coalition. The idea is to create affordable housing through better use of land the county already owns. That contrasts with current efforts that rely—nobly—on nonprofit specialty developers and proffers negotiated with for-profit builders.

County-owned land can consist of everything from fire stations to parking lots to schools to slices left over when the feds laid out I-66.

The coalition's percolating proposals got a boost last fall when Arlington's Citizens Advisory Commission on Housing, with backing from other volunteer groups like the Alliance for Housing Solutions, recommended that the county

embrace the concept. Possible projects include the land that is currently the Career Center to the fire station on Wilson Boulevard in Rosslyn.

Housing Commission member Alice Hogan told me "it will be wise, creative and fiscally more feasible" to pursue public land for public good at, say, Arlington's community centers, "where activity space, school needs and housing can all be addressed in a cooperative building structure," she said. Even unused land could be leased to private developers as a revenue stream. Such options could be especially helpful given Arlington's exploding school population.

Also enthusiastic is Nina Janopaul, president of the Arlington Partnership for Affordable Housing (APAH), a nonprofit that acquires and develops properties. She cites a model in Queens, New York, where two hundred units of affordable housing were built upward on what had been an inefficiently used surface parking lot.

Arlington obstacles, she told me, might be "bureaucratic inertia," indecision over questions like who pays for sidewalks and perhaps some resistance from neighbors who prefer tidy single-use development to high density.

The county is warming to the idea. At March 2012 budget hearings, folks discussed a proposal for a multi-year housing needs survey that would officially identify potential parcels among those suggested by the coalition.

On March 10, the board approved $6 million for purchase of land and construction of an 83-unit affordable apartment building on Columbia Pike. And last August, board members broke ground on a diverse complex at Arlington Mill Community Center at Columbia Pike and South Dinwiddie Street. The five-floor facility will include 121 of APAH's affordable housing units, a fitness center, public meeting rooms, a playground, retail and a 140-space underground garage.

Joel Franklin, Arlington's housing planner, told me that "public land for public good" is "one of the tools" the county uses. The next step is to identify which properties merit staff time and resources, he says. Some of the smaller parcels are not zoned appropriately for affordable housing and may have restrictions on right of way or are near trails.

Board member Jay Fisette calls the concept "admirable" but says the county must consider the broad picture. Encourage private projects, by churches, for example. "At the same time there is a growing need for affordable housing, there is also a need for open space," he says.

His colleague Chris Zimmerman is also sympathetic. "The trouble is," he cautions, "the county doesn't own lots of land."

Gulf Branch Nature Center

April 2, 2013

The weeping-and-wailing budget season has enveloped Arlington. And though the Columbia Pike trolley and travails of the Artisphere draw much commentary, smaller line items spark debate that drives home at least three observations: many citizens are suspicious of the county board's agenda, much commentary abounds with misinformation and spending is more fun than cutting.

Take the Gulf Branch Nature Center, near Chain Bridge. The county manager's surprise plans for cutting $9.3 million in social spending include a proposal to cut the center's weekly schedule by six hours. In a letter to the *Sun-Gazette*, Diana Wahl suggested that this "effort is designed to curtail the number of visitors to the center, creating a justification for an attempt in the near future to close the nature center entirely."

The plot to shutter Gulf Branch is part of a larger scheme, according to the blog Arlington Yupette. A contributor wrote that a recent county staff retreat at WETA was a step toward the perdition of selling off "excess" county properties—sports facilities and libraries in addition to two nature centers. The blog published figures on related property values and upkeep expenses from a county summary.

The Gulf Branch Nature Center, former home to Hollywood royalty, has several times dodged the budget knife. *Anne McCall.*

I bow to few in my personal attachment to the Gulf Branch Nature Center. I retreat there for contemplative walks. Before the center opened in 1966, it was a private home to which I delivered the *Washington Post*. As a teen, I passed hours there watching underage classmates smoke. I've written on its link to Polish American Hollywood star Pola Negri, who had affairs with Rudolph Valentino and Charlie Chaplin before retreating there in the 1930s.

A Washington attorney I know, Marshall Meyers, lived in the home that is now Gulf Branch when he was a child, from 1938 to 1942, and has photos to prove it. "The center is such a part of the county…to have it closed or even mothballed, you would lose momentum that would be difficult to bring back," he says.

Susan Kalish, director of marketing and communications for the Parks and Recreation Department, notes that the proposed budget would reduce center operating hours from thirty-nine to thirty-three hours per week, which would curb some programs. "If this is accepted, we will work with the community and schools to see where the hours will be adjusted."

As for the alleged plans for a sell-off, Assistant County Manager Diana Sun exclaimed in an e-mail, "This is how rumors get started!" She said the meeting at WETA was an "opportunity for board members and senior staff to get together to have some high-level, strategic discussions. The point was to get OUT of the day-to-day grind…OUT of the budget cycle, and have some good discussions about how we go about making difficult decisions. NO SPECIFIC BUDGET CUTS were discussed. NO decisions made. NO DISCUSSIONS about FY14 Proposed Budget. NO proposals on cutting anything."

Though the drama is still unfolding, let's not get ahead of ourselves. If cuts materialize in nature center hours and other small Arlington quality-of-life endeavors, I'd say they would be reluctant—and temporary.

Salvaging Reevesland

January 2, 2013

Arlington's budget chieftains take flak for overspending—but also for underspending.

The latter is playing out in the dust-up over Reevesland, the historic but empty farmhouse overlooking the ball fields of Bluemont Park off Wilson Boulevard.

Since 2001, when the county shelled out $1.8 million to purchase the 1899 vintage home—site of the last working dairy farm in Arlington—the plain white structure with its gingerbread trim has sparked clashes among interests representing the old and new.

Should the home on 2.4 acres be a garden farm, an education center, a public-private meeting place or a food service provider? Should it be sold to McMansion makers?

The complicating factor is the need for $944,000 to $1.3 million in refurbishments, according to the Parks and Recreation Department.

If you stroll or bike through Bluemont, it's easy to miss the historic sign harkening back to the dairy farm that, just after the Civil War, covered 171 acres. Nelson Reeves, born there in 1900, milked his herd and grew beets from 1924 to 1955, when profitability gave way to mass-production competitors. (In 1975, he described this life in the *Arlington Historical Magazine*, having become caretaker of Oakwood Cemetery.)

With postwar Arlington hungry for growth, Reeves sold the land to creators of subdivisions, the Ashlawn Elementary School, baseball and football fields, a picnic pavilion, two churches and, later, a Sunrise retirement home.

With Reeves's death in 2000, the county was flush enough for a historic preservation investment. The property was declared a historic district in 2004, but little was done to improve it. Until neighbors got busy in 2010.

The Reevesland Learning Center Steering Committee, a joint project of Bluemont, Boulevard Manor and Dominion Hills residents, petitioned to convert the house to a public facility to "promote positive attitudes among our children, parents and neighbors about growing and eating healthy foods and, equally important, to build new, collaborative relationships among neighbors in our community."

In early 2011, they won approval for a garden cultivated by Ashlawn students during monthly visits, with produce going to the Arlington Food Assistance Center.

Arlington's historic preservation coordinator, Michael Leventhal, recognizes the site's value. "There are few places in the county where you can see a site in a rural setting," he told the AOL Patch.

But the vision of a "symbol of urban agriculture," as project ringleader Joan Horwitt calls it, would require a dollar outlay the county board says is not in the cards.

In September, the county issued a request for proposal for public-private partnerships (though not a sale). The only applicant was the Reevesland Learning Center Steering Committee. So the house sits dark.

I spoke to one soul with a personal stake in Reevesland. Arlington-born Anna Belle Lane, eighty-seven, who married into the Reeves family, spent countless hours as a child on the farm and grape arbor. There she enjoyed Girl Scouts, day camp and roller-skating in the barn. "If you don't go near the barn, you don't have to milk," Mr. Reeves told her. She planned her wedding around his milking schedule.

In recent years, Lane walked an elderly Reeves relative around the old site, and he said, "What's missing here? Cows!"

She thinks the house would make "a lovely place to rent out for meetings, receptions and parties. It's a shame they let it go to rot and ruin."

East Falls Church Metro's Future

April 20, 2011

In April 2011, the Arlington County Board bestowed its final blessing on the recasting of the East Falls Church Metro stop. But relax—there's still no detailed design, no schedule and no developers. Yet.

The long-agonized-over vision to create a "transit town" alongside the coming subway Silver Line would add some retailers, trees, new access paths, improved pedestrian safety, street lane reconfigurations, new housing and new bicycle facilities. It also would scrap the state-owned commuter parking at the intersection of Sycamore Street and Washington Boulevard.

Whether the approved package is too much, too little or just right depends on which of three camps most interested Arlingtonians fall into. All three were represented on a panel convened on April 13 by the Committee of 100 in anticipation of Saturday's board action.

The "just right," or "Goldilocks," camp was represented by activist Mike Nardolilli, chairman of the East Falls Church Planning Task Force. His slide show hearkened back to the small-scale commercial district that was East Falls Church in the early twentieth century.

Given the inevitable change being imposed by the Silver Line, he argued that the task force's plan—modified by county staff—was tiny in comparison with the disruption caused when I-66 was built in the 1970s. Nor would it require tall buildings or removal of single-family homes, as did creation of the Ballston-Rosslyn corridor. He cited neighborhood surveys showing strong majority support.

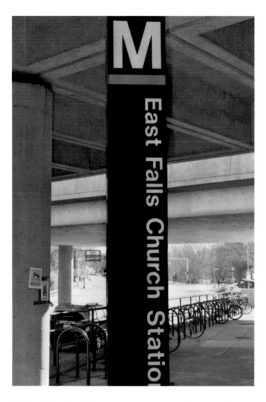

This utilitarian Metro stop may soon be remade as a transit town. *Anne McCall.*

The "too much" camp was given voice by Alan Parker, a retired State Department economics specialist who's had a toehold in the neighborhood since 1975. Like many area homeowners, he backs some changes, like a western Metro entrance and a new public gathering place. But he balks at dismantling the commuter parking lot, calling the plan "frankly auto-unfriendly."

There's not enough room, Parker said. "They're overbuilding" on a small site, which "would create congestion and undermine the neighborhood's suburban character." He cited a petition showing some two hundred protesting the plan for buildings as high as nine stories and says the task force surveys were "fraught" with faulty methodology. He laments that "key characteristics are being made a bargaining chip for real estate developers."

Leading the "too little" camp was Alice Hogan, member of the Arlington County Housing Commission and board member of the Arlington Partnership for Affordable Housing. She criticized planners for neglecting the affordable housing components. She and allies had pushed for higher buildings (the plan's height limits range from three to nine stories, depending on location) and a quantified commitment on the Metro site rather than the plan's "goal" of 100 to 250 units in the general area. She wanted square footage large enough to attract developers, noting that higher buildings are rising just across I-66 in Falls Church.

"It's a missed opportunity for redevelopment," Hogan says. She understands the resistance among residential neighbors, "but we have to give" to get an income-diverse community. "We need a bold and imaginative move rather than letting it happen through fickle market forces."

At Saturday's board meeting, sparks did fly. One speaker heaped contempt on the politicians, demanding they cease using the phrase "it sounds counter-intuitive" while selling the community on the plan's benefits and to stop "planning for property you do not own."

Such is the nature of planning, said board chairman Chris Zimmerman. "Local planning is almost always about land we don't own."

Needed: A Black Heritage Museum

April 17, 2012

Arlington's black history activists know from patience. For a good two decades, they've been waiting out snail's pace progress on two major projects to put their cause on the map. The two are related.

In April 2012, a Virginia Department of Transportation contractor began the demolition of the bridge at Columbia Pike and South Washington Boulevard. It's a scary cement blob built in the 1940s by the War Department that carries eighty-three thousand cars a day.

A spiffier, wider and safer replacement, scheduled for completion in 2015 at a cost of $51.5 million, will be called the Freedman's Village Bridge, in honor of the community of former slaves that the federal government established on the grounds of the nearby Custis-Lee plantation in 1863.

You can learn all about the village on the website of the Black Heritage Museum of Arlington (www.arlingtonblackheritage.org)—the operative word being website, as this local gem is a "museum-without-walls." Online offerings include photos, history narratives, film clips, documents and bibliographies that "celebrate the African American journey to freedom in Arlington County."

But it exists only in cyberspace while the organizers raise money. The plan is to build a physical museum for permanent and temporary exhibits near the site of the now-closed Navy Annex, near the U.S. Air Force Memorial and the Sheraton Hotel. The name would be changed to the Freedmans Village Museum.

"When we heard they were replacing the bridge, we went after the county board to get the name," says Talmadge Williams, a retired college dean who works on the museum out of a Columbia Pike office also devoted to organizations prompting successful parenting and bringing more computers

into schools. "The county board approved it, and the signs are already designed and made."

It took only fourteen years. Such a bridge replacement was first proposed in 1998 but postponed in 2003 while the Arlington County Board honed plans for wider Columbia Pike revitalization. Until VDOT signed the contract last July, it was "dragging its feet," Williams says, a key reason being the need for special sound engineering.

The discussions went on so long that some county officials lost track of it. Michael Leventhal, Arlington historical preservation coordinator, told me he was concerned that the Freedman's Village signs and graphics medallions be well lit enough to be visible to passing autos, bicyclists and pedestrians. The VDOT artists' rendering in the planning documents hints that's not a problem.

Meanwhile, the Black Heritage Museum perseveres. Craig Syphax, a descendant of one of the area's most prominent African American families, keeps up the website. A property manager by profession, Syphax volunteers as a cameraman for Arlington independent media, through which he connected with Marymount University faculty and students to assemble National Archives photos and text for the virtual museum.

You can see him and others at the Arlington County Fair, promoting such projects as the museum's lecture series, an oral history program and a brochure providing a walking tour of the village site.

The bridge and the envisioned museum are a fine example of public-private cooperation and how citizen commitment eventually can win official recognition.

The long wait for the new bridge may prove worth the aggravation. As Williams jokes, he didn't want VDOT to rush and put the Freedman's Village name on the old bridge. "If it fell down," he says, "then I'd be responsible!"

Renaming Places from Old Virginia

October 11, 2011

The Arlington County Board has chosen to mark the 150th anniversary of the Civil War by removing the name of Jefferson Davis from the main drag of Crystal City.

Well, not quite. The September 2011 vote to rename Jeff Davis Highway "Long Bridge Drive" was done partly in anticipation of a revitalized office

conglomerate that the county is striving to reclaim from its four-decades-old glass frigidity. The new name plays off the spanking new Potomac-side green space called Long Bridge Park, which the county built on an industrial site.

"We are about to get some real activity in that area," said board chairman Chris Zimmerman, so "it is important to have a name that… relates to Arlington."

These are tricky issues. Renamers must balance the value of maintaining historic flavor against the value of paying tribute.

Those of us who grew up in Virginia know well how the state that was that tragic war's most fought-over territory continued more than a century later to display its southern sympathies. When it celebrated the Civil War's centennial in the early 1960s—as the civil rights movement was approaching its climax—the tone of the reenactments and ceremonies was one of moral parity between the two sides.

This slant was brought home by Harvard University president Drew Gilpin Faust, a Virginian and a Civil War historian whom I heard this May at the Kennedy Center delivering the National Endowment for the Humanities' Jefferson lecture. She decried the refusal by many southerners to acknowledge slavery as the war's root cause.

In this view, it follows that Jefferson Davis was a defender of an immoral institution and a traitor to his country.

But not everyone is a purist on this—we haven't heard proposals to rename Lee Highway even though Robert E. Lee could be similarly negatively characterized.

Abandoning Davis didn't thrill the Historical Affairs and Landmark Review Board, and Arlington historian Kathryn Holt Springston also opposed it, telling me that Davis was honored simply as a famous Virginian.

On the far side of Crystal City, proposals for a renaming were heard in 2007 when Alexandria was rebuilding T.C. Williams High School. It originally was named in 1965 for a school superintendent who, in the 1950s, had championed Virginia's "massive resistance" to integration. Alexandria mayor William Euille, a T.C. alum, opposed the renaming because the existing name was too much a part of his life and local history. That complex but authentic view prevailed.

But Arlington's different. In the 1990s, it slapped the name Science Focus on a school long named for white supremacist author Thomas Nelson Page.

Arlington officials are clever enough to make their case for the Davis renaming on practical grounds. State ownership of Jefferson Davis Highway transferred to the county in 2010, they note, and the current street "has no

amenities and poor drainage." Upgrades will transform it into "a tree-lined boulevard with sidewalks, bike lanes and transit stops in the next year."

Planners first thought they'd name the road "Long Bridge Park Drive" until board member Walter Tejada suggested shortening it. (I agree. Too many nouns—like Wolf Trap Farm Park.)

So I'm on board for the de-Confederate-izing, an improvement that takes effect next April. Jefferson Davis the man was a mediocrity. And the invocation of Long Bridge, which existed during the Civil War and for decades after, is equally historic.

Preserving the W&OD Bike Path

May 30, 2012

Some nature-boy thoughts percolated as I biked Arlington's slice of the W&OD trail this holiday week, having learned that the Virginia Department of Transportation is again considering widening I-66.

As I steer off the bike lanes of Sycamore Street, I thank the county for completing the newly widened footbridge at East Falls Church Park. It reroutes the path by a few yards but achieves a sturdier passage over the creek alongside the well-maintained basketball court.

I pedal uphill to Brandymore Castle, the mysteriously named, tree-clogged outcrop hill that, as the historical sign explains, shows up on a survey taken in 1724. Nice view of the horizon.

I coast down to the fork in the path (an easy choice—a fresh green glen versus the concrete of the interstate's sound walls).

Here's where you have to begin exercising caution. You see a parade of citizens—all ages, ethnicities and levels of seriousness about bike path enjoyment. Their mixed modes range from pedestrians, to joggers, to cyclists pulling babies in carts, to fanatical mountain bike speedsters stretching their spandex.

Can't say I'm a fan of that last type. Many seem to feel free to take *your* life in *their* hands by barreling down the path head-down with nary a shout-out to the strollers, plenty of whom have their backs turned and are lost in thought.

"Cool your jets, Lance—the Tour de France is over," I'm tempted to yell. But the unwritten rules call for civility.

I notice cracks in the asphalt, a slight safety threat the county hasn't gotten around to fixing that were caused, I suspect, by last August's earthquake.

Crossing Ohio Street, I revert to childhood with the "look, Mom, no hands" stunt. I make my way past a spiffily equipped public playground and stop for coffee with friends fortunate enough to own a home abutting the woodsy path.

Caffeined up, I speed past the informal soccer field, populated most weekends by twentysomething Latino kickers.

Gliding underneath Wilson Boulevard (well labeled to orient non-locals), I weave past the run-for-the-cure tables stocked with water for passing participants. I pass the tiny tots soccer field (though the fancier one is back across Sycamore, by the dog park).

I veer right and stop to watch Little League baseball games on the exact fields I played on fifty years ago (though I deny I was ever that pint-sized). Today's proud parents seem a bit more intense than mine were.

Heading past the Bluemont tennis courts toward home via the path that hugs I-66, I traverse a soothing stream. It's a part of Four Mile Run, where, history buffs know, a police officer in August 1967 waded in and dug out the pistol used to assassinate American Nazi Party leader George Lincoln Rockwell at nearby Dominion Hills shopping center.

I abandon my reverie and ponder the long-standing highway-widening project of Representative Frank Wolf and his merry band of commuters from Fairfax and Prince William Counties.

This month, VDOT released portions of a coming study of options for adding a lane or two, perhaps with high-occupancy tolls, perhaps using existing shoulders, perhaps with plausible funding.

"Widening I-66 inside the Beltway to a cross-section with three lanes in each direction is more physically difficult in certain stretches than others," it says.

All I have to add is, leave those lovely bike paths alone.

Arlington's Desire for a Streetcar

2011–13

Arlington desires a streetcar. Perhaps a fleet of ten to fourteen of them, according to the county board, many real estate folks and scads of residents who favor revitalizing the aged but newly hip Columbia Pike corridor.

Streetcars have loomed in Arlington's vision for a decade. But nowadays, smart-growth enthusiasts believe that by 2016, Arlington can mimic such Shangri-Las as Portland (Oregon), Seattle, Tampa and Little Rock in outfitting thoroughfares with those charming, high-capacity, environmentally clean, convenient and frequent-stopping throwbacks to a quainter transport era.

The planning map shows nearly five miles of electrified streetcar track that would fan out from the Pentagon City Metro, one following the Pike out to Fairfax's Skyline Towers, the other wending through Crystal City to help humanize that sterile but tax-rich office kingdom. The spiffy-looking cars tracked on inlaid rails would stop mostly at right-side curbs, though some would halt on medians. Metro SmartTrip cards would be accepted, and most current bus routes would continue.

But recently, as the age of austerity dawned, Arlington's $140 million-plus plan has come under fire. Some slow-news-day editorialists at the *Examiner* charged planners with withholding secret studies showing that streetcars will snarl traffic. County Transit Bureau chief Stephen Del Giudice issued a rebuttal describing a spate of public meetings and the planned adjustments to the traffic lane widths and left-turn rules.

The county board, in the wee hours of July 24, 2011, with only obsessives and paid officials awake to witness it, voted 4–0 (newcomer Libby Garvey abstained) to green-light the Columbia Pike trolley.

The $110 million investment in economical quaintness to lure commuters from their cars is a gamble. But project boosters are confident in a payoff—for a reason I believe has drawn scant attention.

Critics have voiced multiple worries about the ten-year-old dream of Arlington and Fairfax planners for a revival of the streetcars that last rolled through Northern Virginia in the 1940s. They've cited high investment costs, new congestion, threats to bicycle safety and a developer's gentrification bonanza.

"It's a complicated subject where you have a pro-trolley cult on one side and Tea Party–type opponents on the other," Lew Gulick, a retired newsman who has tracked the issue, told me.

He is puzzled by the county's choice of the pricier streetcar over the cheaper "articulated" bus, noting that while streetcars may hold more passengers (115), they seat only 29, versus 60 seats on the big buses that hold 94. "The official survey shows that either streetcars or modern buses can accommodate projected ridership needs of the Pike," Gulick says. "But riders will prefer to stand in streetcars rather than sit in buses."

The undersung reason for the officials' pro-streetcar proclivities is the uncomfortable fact that buses must battle stigma. Though few admit it, many car-dependent middle- and upper-class citizens look down on bus transit as a less-than-convenient province of the working class.

A June 2012 article by Amanda Hess on the *Atlantic* magazine's "Cities" website is titled "Race, Class, and the Stigma of Riding the Bus in America." It examines cultural tensions over funding public transport in Los Angeles and Atlanta, where the MARTA subway, built in the 1970s, was quietly mocked as "Moving Africans Rapidly Through Atlanta."

In Arlington, the issue comes up obliquely. "Streetcars will attract the widest variety of passengers," Linda Dye, who has lived near Columbia Pike for decades, told the *Sun-Gazette*.

And in January 2013, the chief critic of the now $250 million streetcar plan held his own at the Arlington Committee of 100 debate, dramatizing to the one-hundred-plus in attendance that the trolley is one maddeningly divisive issue.

Moderated civilly by *Sun-Gazette* managing editor Scott McCaffrey, the debate unearthed a hint of a north-south split in the county on top of the ongoing philosophical clash between long-range planners and voters terrified of debt and spending.

All on board for the streetcar was David DeCamp, chairman of the Arlington Chamber of Commerce and supporter of Arlington Streetcar Now. The "time is ripe for a big idea" of replicating, on the aging and gridlocked Pike, "the Arlington Miracle" of the high-functioning Rosslyn-Ballston corridor, he said. Following ten years and fifty meetings, his Plan A of new building requires Plan B of ambitious transport like "a heart needs lungs."

Pike restaurant owners say they're "dying for more wallets." Augmenting existing buses with a trolley that arrives every six minutes, DeCamp said, would help commit developers to preserving an equivalent of the present 6,200 units of nearby affordable housing. As a business owner, he would help pay Arlington's $105 million share of the streetcar through the capital transportation tax.

Pressing the county to "take a pause" was transportation attorney Peter Rousselot, leader of Arlingtonians for Sensible Transit. Its 350 members "have no vested financial interest" in the issue, he said. The streetcar was "conceived in rosier economic times, and its price tag has soared," he said. There's never been an independent cost-benefit analysis, and a better option, at five times less in cost, he added, would be a bus rapid transit system like that in Cleveland.

It is "stylish, sleek and modern and would attract riders," Rousselot said, with greater flexibility for going, for example, to the Pentagon. Transit is not necessary for development, Rousselot added; look at Shirlington.

The streetcar advocate cited their popularity in Portland, Oregon, calling them environmentally clean (endorsed by the Sierra Club) and more apt to lure so-called choice riders out of their cars. Young Millennials, he said, want "a town-sized vision." Riders prefer transit, DeCamp said, saying that the federal General Services Administration when leasing gives points for access to transit but not for having a bus stop.

His opponent challenged the assertion that the commercial tax won't impact the general budget, saying businesses will feel "piled on" and may escape to reconfigured Tysons Corner. Columbia Pike's current renters, Rousselot added, will be driven away during the building phase.

The debaters could not agree on whether the bus approach requires a dedicated lane—for which the Pike has no space.

From the audience, a south Arlington resident said, "Transit dollars should be spread out" because south Arlingtonians for years have paid taxes for Metro, which "disproportionately contributes benefits" for the north.

"I don't think it's constructive to practice the politics of regional resentment," Rousselot replied.

The county board, meanwhile, vows that the streetcar will roll.

O'Connell's Stadium Lights

December 7, 2010

We all want youth in our community to be healthy, athletic and educated. Except, perhaps, if the price is the introduction of a blinding array of new stadium lights shining down on the home into which we've sunk our life savings.

That's the not-in-my-front-yard dilemma facing homeowners in the vicinity of Bishop O'Connell High School.

The fifty-three-year-old pillar of Catholic education this September quietly filed a request with the Arlington County Board that unexpectedly got the goat of onlooking neighbors.

O'Connell's challenge is that its athletic facilities are "incredibly run down," says Katy Prebble, the school's president. "We want to bring it up

to a new level for the kids and give them the same competitive edge and opportunity as their peers in other schools."

The school is seeking a permit for a two-phase plan. The first would redo the main rectangular field currently used for daytime-only football games and track meets. It would enlarge it for regulation soccer games, widen the track from five to six lanes and create space for shot put and discus events. It would install artificial turf, build new bleachers, mount lights to allow night games (back-to-back junior varsity and varsity) and add a twenty-first-century sound system. "The current system is basically a few megaphones tied to poles, and the sound gets projected all over the neighborhood," Prebble says. The new one would better target the ears in the bleachers.

Phase two would reorient the baseball field, which currently faces the "wrong direction" (raining foul balls onto homes along Trinidad Street) and suffers from a right field rendered too shallow by a running track.

Without stadium lights of the caliber enjoyed by competing Catholic schools such as Paul VI and Good Counsel, Prebble adds, O'Connell is unable to give its 1,200-plus students the full offering of sports because the nightly descent of darkness cuts off practice time.

Such noble intentions, however, did not comfort nearby residents, many of whom spent the autumn burning up cyberspace with worries. The renovations would mar the idyllic subdivision with disruptive noise, vandalism, litter and dangerous new traffic, they said. What's worse, the proposal was made, many feel, with insufficient consultation.

John Seymour, a twenty-year resident who lives spitting distance from the school, learned of the plan only through a neighbor who received an official county notice. He penned a detailed protest to the county, which is posted on a local blog. He accused O'Connell of low-balling the expansive nature of the project and heading off informed debate.

The feud is now heading to court. This dust-up pitting youth sports boosters against neighbors treasuring tranquility may escalate to a more philosophic conundrum: the rights of parochial school taxpayers in our public school system.

In December 2010, the Catholic Diocese of Arlington revealed it had filed a complaint in circuit court charging the county board with "discrimination" after its March 15 vote to reject O'Connell's application for a special-use permit to install night equipment to go with upgrades of baseball, track and football fields.

Arlington "had previously approved similar lights at its own public high schools, which, like Bishop O'Connell, are located adjacent to residential neighborhoods," said a statement from the group led by Bishop Paul Loverde. The fields at Washington-Lee, Yorktown and Wakefield "are close to a greater number of homes than those of Bishop O'Connell," it reads. "The board's denial treats Bishop O'Connell and the diocese, religious institutions, on terms that are different from the public high schools." It claims violations of the Fifth and Fourteenth Amendments.

Oddly, the suit was filed in April 2010 but hasn't been served. The diocese filed to preserve appeal rights while it evaluates "next steps." Hence county communications director Diana Sun said, "There's nothing to react to." But once served, the suit gives the board sixty days to change its decision or the court should allow the lights willy-nilly.

This disappoints Seymour, a retired government attorney. His band of neighbors thought they had won when the lights were rejected. Their blog, No Adverse Impact, beat the press in disclosing the litigation, calling the suit "without merit."

"We fought hard and were gratified the board agreed on the quality of life issue," Seymour said. "There is an ineffable pleasure in a quiet fall evening—children playing hide and seek, the sound of crickets and the flickering of fireflies—that we believe will be lost if O'Connell installs field lighting."

The neighbors take comfort that board members agreed that the single-family neighborhood, zoned residential, differs in many ways from the "special districts" surrounding other stadiums. "Yorktown's field is recessed and has landscaping, while O'Connell has nothing to mitigate the glare of lights and noise," Seymour says.

O'Connell, meanwhile, proceeded by right with ground improvements.

Another oddity is that before the board vote, O'Connell had been preparing studies of the lights' impact on traffic, parking and glare but missed deadlines for delivery to county staff. "They have a lot of gall crying discrimination," says Seymour, "when they had seven months and four deferrals" to complete the studies.

O'Connell president Katy Prebble told me her students and staff ran into scheduling problems monitoring traffic on a representative game day. But the studies will be ready for the next round, she said. "Our intent is to retain and strengthen our relationship with neighbors and, at the same time, give our kids the same opportunity as kids in public schools."

The diocese argues that O'Connell and four parochial elementary/middle schools, by enrolling 2,140 students, save county taxpayers more than $41.7 million per year.

But the issue is not the quality of O'Connell and its students, says Seymour. There has been "no anti-Catholic animus" in the debate. "You have to credit O'Connell and the neighbors for steering clear."

Saving the Planetarium

June 21, 2011

"It's not premature to announce that the planetarium has been saved."

So proclaimed Alice Monet, president of the Friends of Arlington's David M. Brown Planetarium, on a Saturday night in June 2011 as she wowed a crowd under the dome on Quincy Street at the umpteenth fundraiser to rescue a local treasure that some dismiss as yesterday's toy.

It has been a remarkable tale of citizens making up shortfalls in the public fisc.

The draw this night was two new-age bands (Cigarette and Grumpy Swamp) composed of laid-back twentysomethings. They showed astronomical appreciation by playing—in the dark—original otherworldly reverbed melodies while the planetarium's projector rolled stars and constellations overhead.

This followed a Wednesday lecture by astronaut and noted physicist John Grunsfeld, which followed sales of T-shirts, bumper stickers and on-campus drives—a poster by kids from McKinley School announces, "We did it!"

The Brown sky theater is the area's only freestanding school planetarium open to the public. It is named for the Arlington native who became a naval flight surgeon and astronaut before perishing in the space shuttle disaster of 2003. Brown is also in the Yorktown High School Hall of Fame.

When this sky-watcher's delight opened in 1969, it was a feather in the cap of an affluent school system. I recall as a high schooler catching its holiday lecture on the celestial origins of Star of Bethlehem, and there I learned to identify Orion's Belt. The planetarium went on to serve twenty-five thousand students a year.

A year ago, the recession-racked Arlington schools had to plan for its closing due to a $400,000 shortfall needed for upgrades and repairs. Superintendent Patrick Murphy agreed to hold off to see whether the new

volunteer nonprofit could raise that sum by June 30, 2011. Monet announced Saturday that Murphy was suitably impressed with the $355,000 pulled in (including a major gift from Arlington builder and former school board chairman Preston Caruthers). She came away with the superintendent's word that he would give the campaign time to finish.

The money will help replace projectors, add new digital programming and supply comfy new seats—a necessity if you want to lean back, cradle your neck and get lost in the overhead vision.

Jonathan Harmon, the planetarium director of twelve years who ran visuals for the musicians Saturday, is keen to modernize the bevy of projectors used to vary his fare of prerecorded shows and interactive lectures.

Slight resistance to the rescue came from educators who argue that today's students can learn more off the Web and through the ease of their mobile phones. Counters Monet, "Who would say there's no need to go scuba diving because we can view the wonders of the ocean on our screens? Under the dome of a planetarium, an audience can be transported in time and space, experience the heavens as they would if actually standing at the South Pole or at the summit of a Hawaiian volcano."

Another dispute caused the parting in January 2010 of the brother of the late David Brown. Doug Brown told me he felt the top priority should have been educating students in science, math, engineering and technology rather than patching ceiling tiles. He didn't want his brother's name used as a "source of perpetual fundraising." But now he's pleased with the group's success.

Friends of the Planetarium will remain just that.

The Homeless Shelter at Courthouse

December 14, 2011

When Arlington officials climbed aboard the campaign to eradicate local homelessness in October 2011, you could sense a cautiousness when discussion turned to the desire long held by activists to create a year-round shelter.

Now it's clear why. A new proposal to buy a building in the Courthouse neighborhood for said shelter and other uses has stirred a hornet's nest of resistance and not-so-gentle rhetoric.

Arlington County manager Barbara Donnellan in late November announced she would recommend to the county board that it acquire the

seven-story Thomas office building east of Courthouse Plaza at 2020 North Fourteenth Street. The move would create overflow space for the nearby government center and advance a "more vibrant mix of public, private and government development that will transform the Courthouse area."

The building's top floors could allow the "board to fulfill a commitment to the community to replace the inadequate Emergency Winter Shelter with a comprehensive, year-round center for accommodating homeless single adults," the statement said. The center is envisioned with a separate entrance, elevator and stairwell.

Residents of the affected Woodbury Heights neighborhood have mobilized in opposition, worried over safety and property values. At least fifty have been writing letters, blitzing Facebook, meeting with officials and distributing fliers at the nearby farmers' market warning, "Keep our block safe."

January Holt, a seven-year Courthouse-area resident, told the *Washington Post* that officials "aren't interested in those of us who pay taxes, only the 100 who are homeless." Local condo resident Kenneth Robinson told AOL's online Patch that "it was all done very secretly and very quickly with every effort to avoid any kind of public scrutiny."

Anonymous patrons of the nearby Ragtime Café spoke of a "death sentence" for local businesses and likened the process to Arlington "declaring war on the community."

Perhaps some should take a deep breath. Deputy County Manager Marsha Allgeier told protesters the plan has long been on the agenda and that when shelters have opened in other residential areas, initial fears arose but then eased.

Still, complaints will be listened to. Kathy Sibert, executive director of the Arlington Street People's Assistance Network, which for twenty years has run the temporary shelter one hundred yards away, told me she assured the protesters the new shelter would have 24-7 staff communicating with neighbors to address any concerns. She added that the Thomas building directly fronts on the entrance to police headquarters and that her group works with police and the sheriff.

The clash seems to pit those who view the neighborhood as primarily residential and those who see it as a multiuse public-private nexus.

Board member Mary Hynes stressed to me that the county is "at the very beginning of a process that may take some time." But acquiring the building "gives us options for the location of a new government center without interrupting operations," she said. "Over the years, the board has a

good track record of listening to those who live close to county facilities and working with them to mitigate concerns of all sorts."

Similar protests took place when Arlington's Human Services Department was consolidated in Clarendon in the '90s, and the neighbors and the civic association were able to work with the county to create successful solutions, Hynes said. "I wholeheartedly support the creation of such a group for the proposed homeless services center."

In March 2012, the county board unanimously approved the long-sought permit to build a homeless services center, despite complaints by some residents of nearby condos. The new seventy-five-bed year-round center will replace the seasonal A-SPAN facility across the square. Typically, Arlington's approach adds up to a comprehensive strategy—to get the homeless into long-term housing.

Raising Hell About Raising Chickens

February 9, 2012

The incredible edible egg debate is now on Arlington's menu of public policy forks in the road.

Culinary gags aside, there exists a suburban urban-farming movement to mimic such towns as Portland (Oregon), Seattle and Baltimore and allow Arlingtonians to raise chickens on egg farms alongside their carports and barbecues.

The bid to loosen an early '60s restriction was hatched last year by some greeny health boosters who formed the Arlington Egg Project. They've gathered more than one thousand signatures in support.

In January 2012, the county board welcomed their idea as one possibility in a larger initiative that might include rooftop gardens and land exchanges. A task force will be named in March, and a full report is expected in a year.

One of the ringleaders is Ed Fendley, the one-time school board chairman who recently took a new job at the Environmental Protection Agency. The idea of backyard chickens, he told me, first attracted him when he saw it while stationed with the Foreign Service in Java, Indonesia.

The advantage is that there is "nothing more fresh than eggs from your own backyard, like growing vegetables," he said. "And the backyard farmer can control what the hen is consuming." He sees "health risks associated

with industrial-scale agriculture and long distribution chains. The greater the distance and time from production to table," Fendley added, the greater the risks. "Industrial agriculture is one of the leading causes of degradation of the Chesapeake Bay."

Foes of homemade eggs worry about sanitation and the scarcity of lots large enough for proper pens. They fear odor and noise (though advocates stress that the real noise comes from roosters, which would be prohibited).

In January 2013, a twenty-one-member Urban Agriculture Task Force delivered its report, and—surprise—the seventy-four-pager with its twenty-seven recommendations is a serious, consensus-seeking compilation. "Issues surrounding healthy and sustainable food production, distribution, consumption and disposal impact the lives and livelihoods of Arlingtonians as never before," said its chairman, my pal John Vihstadt.

Hence the report speaks of "interlinking factors, including the need for locally produced, quality food for a variety of consumers—ranging from the most vulnerable in our community to those who simply wish to embrace a healthier lifestyle."

The three-minute version is that the report recommends allowing backyard hens but caps them at four. It recommends no roosters, a set-back requirement at least twenty feet from property lines, that residents file plans for coop placement, that the majority of adjacent property holders (within fifty feet) consent and that coop inspection be required before hens can set up housekeeping.

Two minority reports were included, one seeking looser requirements and another from a skeptic requiring more study.

The Arlington Egg Project, the movement's ringleader, gave it two wings up. "Keeping small numbers of backyard hens is good for people, good for the natural environment, and good for hens," its statement said. "That's why a large and increasing number of American communities embrace backyard hens. It is unclear whether these recommendations, if adopted, would actually result in more Arlington residents keeping backyard hens."

Less enthused was longtime Arlington Civic Federation activist Jim Pebley, whose new website, Backyards, Not Barnyards, warned of excess animal waste runoff, a need to transport unsustainable amount of chicken feed, increased risk of salmonella exposure and explosion of pest population, including insects and rats. "The smell! Oh, god, the smell!" its statement clucked.

The report impressed me with its in-depth recommendations for an urban agriculture commission, integrating backyard farming into county planning,

promotion of community gardens and yard sharing, a county composting system and helping farmers' markets accept food stamps.

Its nifty history of Arlington farming notes how "the land used now for homes, schools, churches and soccer fields were working farms until the mid-1950s. In the 18th, 19th and into the 20th century, the land now Arlington County was a rural, sparsely populated area. Corn, livestock, dairy, and timber were primary sources of income for farmers."

It was changes in technology—railroad transport of food and preservatives—that produced the numbers that trace the decline. In the 1860s, more than fifteen thousand acres of Arlington (twenty-three out of twenty-six square miles) was farmland. At the dawn of the 1900s, there were 379 farms in Alexandria County (which then included Arlington), decreasing to 96 by 1910. When Arlington became self-governing in 1920, there were just 50 farms. By the mid-twentieth century, that number was down to 24.

Vihstadt told me he was pleased that all five county board members accepted the report and "felt we had a lot of substantive recommendations. It's not another big government tangent but keeping pace with what jurisdictions around the country are already doing. The last thing we want is to have hens overshadow the other priorities. There's a lot more on the menu than chicken dinner."

SUBURBAN LIVING

Cherrydale's Precious Public Library

July 12, 2011

The Internet, say all indicators in Arlington's Cherrydale neighborhood, will not soon replace the public library.

Not with the spirit that abounded in stacks at Cherrydale Library on a Saturday in July 2011 when, amid balloons, an outdoor banner, a history display and a cake, a standing-room crowd of patrons from all generations celebrated the fiftieth anniversary of that cathedral-like temple of knowledge.

To the passel of attendees who spent our childhoods in that neighborhood, it was jarring to ponder the half century of elapsed time. We still think of it as the "new" Cherrydale library on Military Road that in 1961 replaced the ramshackle, poorly lit former clinic that once stood near what is now Essy's restaurant at Quincy Street and Lee Highway.

Broad perspective on the event was provided by Democratic representative Jim Moran, who remarked on how the avant-garde slanted building is "tucked into the physical foundation of the community." He noted how some oppressive governments consider libraries a threat and how early childhood reading habits help break the cycle of poverty. He lamented the thirty-eight thousand public-sector jobs lost around the country last month, some of them librarians. "A place to go read in serenity—it's hard to put a price on it."

The branch's original deputy architect, Judson Gardner, who at age eighty-seven drove up from Orange, Virginia, reminisced about challenges of designing the unique building with its third-floor back entrance on a thirty-foot slope in a residential neighborhood packed with prized trees.

The result—one of 185 community and university libraries his firm built nationwide—on this day was given a green building award from Arlingtonians for a Clean Environment.

The back story was told with a personal touch by accomplished Cherrydale historian Kathryn Holt Springston. As the county's oldest branch, this library goes back to 1922, when an embryonic collection was assembled by the Cherrydale Volunteer Fire Department, League of Women Voters and Patrons League (later the PTA). It was housed at various sites near the community's main intersection, including the old Cherrydale School.

The push to build today's branch began in 1957, when eight civic associations and PTAs banded together (their leader met with the county board fifty times). Ground was broken on September 4, 1960, remarkably just as Arlington's Central Library, less than a mile away, was also under construction. (Its proximity is cited whenever the county considers closing Cherrydale during budget squeezes.)

Springston's exuberance comes through in her recollection of the old library, with its books mounted in seemingly random piles: "I can picture the sunlight streaming through the windows, the dust glimmering in its rays, and still imagine smelling that wonderful old book smell! The fans in summer just seemed to stir the shimmering heat around, and the noisy rumbling and awful smell of the furnace in winter only added to the ambience."

Springston had read every book in that home away from home. So it took her a while to warm to the "new" one's neat stacks, soft carpet, bright lights and coolness, where "I admit I haven't read even a quarter of the books."

Other library fans told of intellectual worlds opened or their first library card. I can recall specific titles on the shelves that caught my young eye.

Arlington has done well with its reconstituted libraries, recently at Shirlington and Westover. The celebration should be duplicated across the country.

Our Hip Urban Residents

January 18, 2011

I have seen Arlington's future, and it's the twenty- and thirty-somethings emerging as our county's hip urban villagers.

At least, that was the takeaway from the generational encounter group staged in January 2011 by the Arlington Committee of 100.

"Go find a young person and make sure they're sitting at your table," came the instructions from the chair of the dining-debating society that since 1954 has attracted a crowd of regulars—myself included—that skews toward fifty- to eighty-somethings.

It was easy to spot members of our hometown's legion of twenty-five- to thirty-four-year-olds—those least likely to wear a coat and tie—who showed up to liven a discussion of housing and transportation.

Chris Zimmerman, the newly installed county board chairman known for championing smart growth, told the audience it's dangerous for politicians to generalize. He then proceeded to express puzzlement over the young generation's proclivities for tattoos, body piercings, iPhones, blogging and Facebook.

While baby boomers saw their suburban culture reflected in 1950s–70s TV shows like *Father Knows Best*, *Leave It to Beaver* and *The Brady Bunch*, Zimmerman pointed to the urban sensibilities in more recent fare like *Seinfeld*, *Friends* and *Sex and the City*.

The young adults' ubiquitousness, not just in the Rosslyn-Ballston corridor but all around bustling Columbia Pike, Zimmerman said, brings a "change in the feel of Arlington." When he was a young adult, he walked often-deserted streets of those areas looking for an open restaurant. Now you've got twenty-four-hour gyms, late-night yoga classes and Wi-Fi cafés some frequent in their pajamas.

As entertainment districts have butted up against residential enclaves, the county has learned to manage it, Zimmerman noted.

The evening show-and-tell was meaty. Lisa Sturtevant, a former county demographer and now assistant research professor at the George Mason University School of Public Policy, laid out data showing how those in the twenty-five- to thirty-four-year-old bracket are one of the county's fastest growing.

They are more apt than other groups to hold professional and technical jobs, more likely to earn over $100,000 a year and more likely to live near their work and use public transit.

Most notably, their homeownership rate (30 percent) is lower than the county average of 50 percent. With the average detached home in Arlington costing $700,000, it's no surprise young adults are more likely to rent.

That's where Arlington housing chief Ken Aughenbaugh came in. He noted that Arlington's young "creative class" boasts the highest percentages of foreign-born, mobile and highly educated citizens. He's been working for decades to create what are now six thousand units of affordable housing—priced at about half the market rate—through public-private partnerships and a revolving loan fund.

The evening's offbeat theme turned out tailor-made for Zimmerman's vision of "walkable urbanity." In making lifestyle and economic decisions, younger folk are less fascinated by cars than their older compatriots, less interested in mowing lawns and less patient sitting in traffic.

Hence they're ripe for Zipcar, Metro, buses, bike paths and the type of "walkability of which Fairfax is devoid," he says. All good for a vision of land use based on sustainability and a mixed-income population.

"Real estate values are rising, and gas prices are going up, so Arlington will become more costly if we don't do anything," Zimmerman said. This modern-day generation gap is "an opportunity to create something in the sweet spot."

Hip Housing

May 22, 2012

In modern-day Clarendon, they thank the lord for the nighttime—nightly. But those scads of young partiers who keep the expanding bars hopping (lord knows how they cover the tab) are also Arlington's future.

County economic planners have their eye on them.

In March 2012, Arlington offered its first "Housing4Hipsters" event. About 175 card-carrying yuppies showed up at the Arlington Rooftop Bar and Grill on Wilson Boulevard to mingle with mortgage officers and boosters of homeownership. They were lured by free refreshments and a raffle giveaway of donated gym memberships and Nats tickets, as well as the "provocative title," says Doug Myrick, coordinator of Arlington's homeownership program.

Most of these under-thirty-five folks "don't classify themselves as poor, and many assume our programs are only for the very low-income," Myrick

told me, "so they wouldn't come to a regional or local housing event because they think they don't deserve help."

Though Arlington has done a good job planning around Metro and attracting a veritable army of young professionals, he says, it remains the most expensive jurisdiction in the state. Hence its low rate of homeownership.

That worries employers and leaders seeking committed residents to assure a stable long-term tax base. "We want people to make roots here, and research shows people who live closer to their job are happier and will vote with their feet," Myrick says.

The county has arrangements with developers to earmark 6,500 apartment units for those with income less than $140,000 so that renting and owning a three-person unit would set them back the same amount they'd pay in rent per month. And they're eligible for special low-interest mortgages, down payment and closing costs. "We want to make sure everyone knows about it because the state, federal and county governments put lots of money in these programs," Myrick adds.

One advantage Arlington offers over neighboring localities is that it does not require that you already live in the county to apply for housing benefits.

Housing4Hipsters attracted employers and people with incomes from $30,000 to $130,000. But the rollout comes at a time when many are feeling burned by the popped mortgage bubble, which makes renting seem hipper. (And that's setting aside those recent grads living in their parents' basements.)

Lydia DePillis, a sassy writer for the *Washington City Paper*, betrayed some regional rivalry when she waxed about Arlington's exploitation of "the cool factor." In a piece subtitled "Arlington Tries to Lure Young Professionals Across the Potomac," she lamented that D.C. lacks an outreach on par with Housing4Hipsters. But she mocked Arlington's "gimmick," "clunky lingo" and use of Jimi Hendrix on the event poster. (Is Hendrix still hip?)

Myrick says the publicity was an experiment in use of social media. Housing4Hipsters was pushed out via Twitter, Facebook and blogs, with fewer than fifty print fliers. The county created a club-like poster for "a sense of young fun, a happy hour, a buzzy event to grab attention," he says.

The county plans others. Myrick has been talking to counterparts in other jurisdictions, including Falls Church.

Once the streetcar project gets underway on Columbia Pike, Myrick says, and property values go up, his agency's services will become even more attractive.

If you're one of those Clarendon bar-hoppers—or if, like me, you're just a passerby they jostle—think of the crowd as another of Arlington's investments.

Counting the Homeless

October 25, 2011

A coalition of the wealthy, the middle class and the poor came together in October 2011 to tackle two societal problems: homelessness and sleeplessness.

"100 Homes for 100 Homeless Arlingtonians," a three-night blitz of well-caffeinated volunteers designed to count and interview the county's street people, came off without a hitch.

At a Friday debriefing/pep rally at the county boardroom, organizers from in and outside government recapped the experience of 152 volunteers who had reported for duty at 3:00 a.m. with flashlights and data recording gear. Twelve teams fanned across Arlington to predetermined locations and spent four hours approaching strangers sleeping outdoors to determine the most vulnerable, who might require immediate aid.

Sample results: out of 185 souls approached, 153 were interviewed. Some 80 percent are male, 70 percent are unsheltered (the rest were from the county shelter, the jail or the hospital) and 15 percent are veterans (most of them honorably discharged).

The 100 Homes effort pools the leadership of Arlington's social service providers and the skilled professionalism of the nonprofit Arlington Street People's Assistance Network (A-SPAN). Its recipe also requires local philanthropies, businesses, faith groups and highly unselfish individuals, who, in turn, coordinate with the larger 1,000 Homes for Virginia effort and another for 100,000 Homes nationwide.

The ambitious night owl census shows Arlington's "willingness to tackle tough social problems," said task force co-chair and county board member Barbara Favola.

"The homeless can't just turn up the heat, wrap a blanket around the kids or toss another log on the fire," said co-chair John Shooshan, a real estate developer. He promised to raise $500,000 toward housing and wraparound services that form part of the county's ten-year plan that already includes 150 supported residential units, with 77 coming next year.

The survey revealed information about causes of homelessness, which—not surprisingly—include alcoholism, drug abuse and mental illness in addition to poverty and unemployment.

The speedily oriented survey teams, each of which included a Spanish speaker, didn't need training to be "patient, respectful, persistent and compassionate," as an A-SPAN staffer put it. Dozens of the time-donors

showed up Friday in red T-shirts reading, "I helped end homelessness." There was lots of joshing about the importance of hot coffee. (Several days' worth of java and pastries were supplied by Starbucks, Bayou Bakery, Harris Teeter, Heidelberg Pastry Shoppe, Pastries by Randolph and the Santa Fe Café.)

The volunteers also were celebrated in a slide show that included photos of their address-less clients (used by permission) who, without this initiative, would likely have stayed "invisible" in the dark folds off the main drags of Shirlington or Rosslyn.

The 100 Homes project is a cross-community symphony of coordination with the police, Department of Parks and Recreation, the sheriff's department and Northern Virginia Hospital Center. Impressively, county board members Mary Hynes and Jay Fisette showed up bleary-eyed to pitch in during the wee hours despite a board meeting that had droned on until 1:00 a.m.

Hynes promised that the county has set aside funds to allow the Arlington shelter to stay open beyond just the cold season, though policy obstacles remain. It's a move that would thrill A-SPAN executive director Kathleen Sibert, who told me that a "low-barrier" year-round shelter open in the daytime is crucial for linking the homeless to vital services that build long-term change.

Certainly the challenge of ending homelessness is a year-round endeavor.

Twelve-Step Celebration

September 26, 2012

A moving act of bravery unfolds when a recovering alcohol or drug addict stands up in public and seeks an encouraging word.

Luckily, Arlington responds. I witnessed it on September 18, 2012, at the annual "Recovery Celebration" staged by the nonprofit Phoenix Houses of the Mid-Atlantic in the banquet room of the Knights of Columbus.

This year's event was special in that it marked the fiftieth anniversary of the Arlington provider of substance abuse treatment that unites, in the phrase of senior vice-president and regional director Deborah Simpson Taylor, a local "human web" of clients, alumni, counselors, administrators, family members and stalwarts from the school and judicial communities.

"People on the other side of the counseling table started where you are," she assured the assembly of some two hundred. She cited her own rewards from "the opportunity to work in a field where people can get better and start loving life again."

What today is Arlington's Phoenix House was born in September 1962 in the basement of Walker Chapel. As recalled by board member Edd Nolen, "At the time, there seemed to be a lot of alcoholism and drinking going on in the community of men." So a group of Arlington Kiwanis, among them dentists Lucas Blevins, Joe Kline and Ken Haggerty, as well as attorneys Ken McFarlane Smith and Thomas Dodge, decided the church could be a place "where men could come and get guidance and help them get on a road to recovery."

After a couple years of organizing, Alcoholics Rehabilitation Incorporated was on its way to eventually treating thirty thousand clients.

In the 1980s, the board renamed it Vanguard Services Unlimited, and in 2010, it affiliated with the national program Phoenix House.

The fully accredited center now helps addicts achieve "new beginnings" via 140 combined full-time and part-time doctors, nurses, psychiatrists and administrators at its Quincy Street headquarters and several satellite facilities. Those include separate centers for new mothers and their children, young men, young women and Latino men, plus a halfway house for those working toward independence.

Though some Phoenix House clients have private insurance, many benefit from the center's contracts with Arlington, Fairfax and Alexandria that refer indigent clients on a fee basis.

"We have a 70 percent or more completion rate, which is 20 percent over the national average," says Taylor, a psychiatric nurse formerly with Virginia Hospital Center. "I like to call us Arlington's best-kept secret, but I'm not sure that's a good thing because some don't know we exist."

At last week's banquet, volunteers and staff served dinner donated by Harris Teeter, Whole Foods and Joe's Pizza and Pasta. Speakers gave intimate testimonials of struggle. Phoenix House "saved my life and made me realize I had a life worth saving," said David Washington, an attorney battling alcoholism. "Recovery is a lifelong process, but you're not in it alone."

To the cheers of a supportive crowd, each group in the program performed skits, recited poetry or sang songs such as "The Storm Is Over Now" and an original with the lyric "I'm a veteran of the war for my soul."

Our Sister Cities

March 8, 2011

A superficial observer might assume it's a boondoggle. Arrogant Arlington elitists gallivanting around the globe on the unknowing taxpayers' dime.

Fortunately, the sister city program is anything but, as I readily deduced when I swung by the fifty-fifth annual Sister City International conference held in March 2011 in Crystal City.

The big news from the three-day confab was the Arlington County Board's announcement that it had cemented ties with a fifth sister city—the surprising choice of Ivano-Frankivsk, Ukraine.

That's a three-and-a-half-centuries-old Carpathian mountain city (population 224,000 versus Arlington's 216,000). It joins the other four towns with which Arlington has conducted similar citizen-to-citizen friendly relations since the nationwide movement went local in 1993: Coyoacán, Mexico; Aachen, Germany; Reims, France; and San Miguel, El Salvador.

Like the six hundred other American jurisdictions that engage sister cities, Arlington embraces it, according to organizers, to foster exchanges in arts and culture partnerships, economic development opportunities, educational and professional exchanges and global tourism and visitation.

The conference, said Sister Cities International organization spokeswoman Kathleen McLaughlin, drew nearly three hundred participants from twenty countries and was highlighted by a Friday night performance of Ukrainian folk dancers. The program "does attract culturally sensitive types of individuals who have a broader worldview," she told me, though they aren't necessarily confined to large urban entities (the sister city–participating town of Gilbert, Arkansas, has a population of thirty-three).

I'd adjudge that the endeavor attracts earnest and cosmopolitan individuals—many retired Arlingtonians and students—who enjoy meeting and staying with not-always-English-speaking strangers and who are comfortable with unlikely juxtapositions such as sister cities Zomba, Malawi, and Urbana, Illinois.

County board members tend to leap at the chance to reap public relations value from sister cities, and the international association does its best to provide a stage for the local hosts.

Arlington leaders justified the program in a fiscal 2004 county board budget proceeding as follows: "Arlington is one of the region's most culturally

diverse communities. The sharing of artistic, educational, recreational, scientific, political and cultural ideas with the citizens of Reims, Aachen and Coyoacán helps keep us so. Citizen diplomacy, as embodied in sister-city partnerships, enlivens Arlington's social, educational and cultural environment, continuing to enrich the lives of Arlingtonians and visitors to our community."

The fiscal impact, the county staff noted, is virtually nothing: half a staff position and a $12,000 budget.

Karl VanNewkirk, the active volunteer who heads the Arlington Sister City Association, told me the county funding was reduced beginning last July, changing over to a $40,000 grant and a $10,000 challenge grant. "The grants are subject to the vagaries of the annual budgeting process," he said.

While he can recall one complaint of the boondoggle variety years ago, most onlookers realize that travel expenses are paid by private individuals and lodging is provided by the host cities, except for occasional excursions by county board members who accept invites from sister city partners. Their trips have been covered by the Arlington association, funded through member dues and individual and corporate sponsorships.

The International Sister City Association, its treasurer told the conference, has seen its assets double in the past two years to $4.5 million for 2010 (unaudited), mostly through foundation grants.

There are no rules limiting the number of sister-city relationships—Chicago has a whopping twenty-eight. The movement in Arlington is apt to expand.

A University Town

May 24, 2011

How does Arlington, land of citizen involvement on steroids, fare as a university town?

Town-gown relations are pretty good if you ask James Bundschuh, the debonair president of Marymount University who was set to retire to St. Louis in June 2011. After ten years of running Virginia's only campus to rate mention on a Metro stop in Arlington (Ballston, but you could count George Mason's satellite campus at the Virginia Square stop), Bundschuh has nothing but appreciation for the nation's smallest county.

"Arlington adopted us during the last ten years," he says, noting that his vice-presidents are active in the Chamber of Commerce's Leadership Arlington, Marymount staff volunteer at the free clinic and its students tutor.

Asked about the biggest change in Arlington, Bundschuh, a chemist, noted that he arrived just two months before the September 11 attacks. "It was a terrible catastrophe, but afterward it brought lots of government agencies and education institutions together, so now we communicate better," he told me. "I can't say enough about Arlington County managers, police and firefighters. We have good relations with them, and we're all now more on alert."

Marymount, which I wager is one of the few college campuses abutting a country club, has been a charming presence on North Glebe Road since its founding in 1950 by the Religious of the Sacred Heart of Mary. I have enjoyed numerous Committee of 100 banquets there (Bundschuh attends faithfully), and I once covered a conference on child labor put on by Marymount's famous fashion department. (TV stars Kathy Lee Gifford and Richard Simmons talked of how their clothing lines address exploitation of overseas workers.)

Plenty of Marymount's growth from a small women's college to a graduate-level university was fulfilled on Bundschuh's watch. The school brings to Arlington 3,600 students from forty states and seventy countries and has branches in Ballston and Reston. In recent years, it added an undergraduate honors program and two clinical doctoral programs—physical therapy and nursing. Undergraduate offerings expanded to include forensic science and computer security.

The boom hasn't been without friction. In 2007, Marymount won county approval for construction of a now-open fifty-two-thousand-square-foot academic hall and six-story residence hall built over underground parking.

But some neighbors objected to the threat of increased traffic and the decline in open space. "Four neighborhood associations were impacted," Bundschuh said, "and we went through a facilitated process, so relations have grown to a pretty good level of understanding. There was some tension and uncertainty, but we were forthright, and they appreciate that. They're an open and positive community."

More recently, Marymount clashed with some neighbors surrounding O'Connell High School. They objected to the high school's proposal to add stadium lights and renovate its baseball, football and track facilities—with Marymount athletes slated to share in their use.

At a March 15, 2011 hearing, after dozens of speakers warned of nightly noise and declining property values, the county board voted 3–1 to reject the

plan. (Board member Barbara Favola recused herself because she works for Marymount.)

"We continue to pursue relations with O'Connell, but the policy is not ready to be announced," says Bundschuh. "We would benefit, and O'Connell students would benefit, too."

Marymount's role in that contretemps will be left to Bundschuh's successor, announced this month as Matthew Shank, the dean of business administration at the University of Dayton.

An Attack That Never Came

November 20, 2012

I spent part of Veterans Day 2012 attempting to witness a dramatic confrontation on the streets of Arlington that never came off. With Thanksgiving upon us, let's be grateful.

Back in October, the ARLnow blog reported that a Kansas-based church famous for its traveling circus of hateful anti-gay protests had targeted Yorktown High School. (The family-run church's name will not be mentioned—my humble bid to foil the online search engines that feed the tiny group's publicity machine.)

On its website, the church—which made national headlines in 2011 when it won a Supreme Court free speech case—vowed to "picket Yorktown High School because we know that Doomed America has turned the school systems into institutions to teach rebellion against God." Also on its protest schedule for the day: the Pentagon and Arlington Cemetery.

My alma mater was not open for classes that day, but that didn't head off the threat. That's because my daughter Elizabeth, as coach of the Yorktown Dance Team, had spent months preparing to use the building for an annual dance camp for elementary and middle school girls. Fear that children would have to run a gamut of placards bedecked with crude slogans prompted hours of anguished contingency planning.

School officials turned the matter over to Arlington police. They had to balance the right of protest (the group had no permit) against others' right to enter a public building safely. It reminded me of the time in 1983 when the then-Arlington-based American Nazi Party used Yorktown to stage a "White Pride Day."

On D-Day at 7:30 a.m., I arrived at the school's main entrance to find three police officers, members of a Unitarian anti-hate group and cameras from local TV stations. Also visible were several dozen student counter-demonstrators and a dozen veterans in their U.S. Army jackets. A truck-based sound system pierced the morning air with repeats of Lee Greenwood's "Proud to Be an American."

The Yorktown students filing by the school's front plaza carried their own placards reading, "Coexist," "How Do You Know What God Hates?" "You're Not in Kansas Anymore" and "Love Conquers Hate."

My friend Ron Watt, a veteran, told me the counter-protest called Standup for Veterans was coordinated by John Murphy (YHS '73). The goal was to let the church "know that this is a patriotic area and that, basically, their hate spew was not welcome here." Watt said the police officers, also Yorktown alums, "appreciated our presence," as did the parents who drove up to drop off kids for other activities.

Dance camp organizers had considered cancelling or relocating their event. But Suzette Timme, a dance team mom, told me they were determined not to let that church "disrupt something we were doing for the good of the community. This way, young girls weren't disappointed, and parents weren't scrambling to find alternate activities for this school holiday."

Numerous volunteers were ready to usher in the 150 campers via a separate entrance. "For the Yorktown community, I thought it was a great showing of respect and patriotism," Timme said, "especially when you consider the majority of those attending to counter-protest were high school students who probably would have enjoyed some extra sleep on an early holiday morning."

In the end, no protesters presuming to know whom God hates showed, and the non-event drew scant notice in the media. A blessing.

Protecting the Historical Society

January 25, 2011

Bear with me while I report that, during the past decade, the price of copper has quadrupled on the New York Mercantile Exchange.

That far-flung fact may have guided the thinking (using the term loosely) of the local thieves who sneaked onto the grounds of the

Arlington Historical Society (AHS) in December 2010 and ripped off three forty-foot copper downspouts.

Given their importance to keeping water out of the historic Hume School—built in 1891 on Arlington's South Ridge Road—such artifacts are hardly frills. "It's a financial hit" to a self-funded organization with an $88,000 treasury, says society president Tom Dickinson. Replacement will cost $2,500 to $3,000 (though the group carries insurance with a $1,000 deductible).

Then there's the problem of whether to order authentic copper or cheaper modern material that, while less tempting to thieves, might be frowned upon by Arlington's Historical Affairs and Landmark Review Board, which has authority over the county-owned property.

Such are the travails of my favorite local membership group, to which I've paid dues for twelve satisfying years. For an annual bargain of twenty-five dollars, the group that has stewarded county heritage since 1954 provides exhibits, a bookstore, a speakers program, a newsletter and an annual magazine whose writers, I can vouch, contribute for love and not lucre.

The society's banquets have featured talks by former NPR host Bob Edwards, *Weekly Standard* editor (and Arlington native) Fred Barnes and *Washington Post* local columnist John Kelly.

Just last week, I caught its terrific lecture documenting the black-owned businesses in Arlington that sprung up during the era of forced segregation, showcasing research by George Mason University geographer Nancy Perry.

The labor to keep AHS headquarters open to visitors (weekends from 1:00 p.m. to 4:00 p.m.) is all volunteer. Unlike counterparts in Alexandria and Fairfax, the Arlington history boosters get no public funding.

So, like many nonprofits in not-quite-post-recession America, the society is scrambling. It copes with the Hume School's rickety HVAC system. Its prized possession, the mid-eighteenth-century home called the Ball-Sellers House (near Route 50 and Carlin Springs Road), Arlington's oldest, suffers from rainwater pooling around its stone-and-mortar foundation. (A $25,000 to $30,000 repair project is out for bids.)

The AHS membership roster of 350 is shrinking, and the search is on for young blood, Dickinson says. Dues, stable for a decade, make for "a diminishing revenue stream and an unsustainable funding model over the long run."

The society needs a Webmaster and a building manager. This year marks the tenth anniversary of the 9/11 attacks, but there's inadequate space to display the Pentagon's artifacts.

Next year will mark the 200th anniversary of the War of 1812, an event, Dickinson reminds me impressively, that caused the original Constitution and Declaration of Independence to be taken by state department employees to Chain Bridge, where, after being suspended in linen sacks from the chain trusses, they were moved safely to a nearby mill.

And like much of the nation, Arlington is just getting started on the 150th anniversary of the Civil War.

Michael Leventhal, Arlington's historic preservation coordinator, predicts that the review board will likely allow the society to order downspouts of a non-precious metal and then paint them the historic color. "We're not colonial Williamsburg; we're a living city," he says.

Memo to thieves: it's a question of values. The custodian of a historic community's heritage, or a few bucks for pilfered copper?

Derecho Power Outages

July 10, 2012

It took ten days—until 10:35 a.m. on Sunday, July 8, 2012—before the county sent e-mails delivering those heatedly awaited words: "All derecho-related power outages restored in Arlington."

Those valiant crews of electricity elves performed phased-in rescues of darkened homes composing two-thirds of Dominion Power's ninety-six thousand Arlington customers. The week in the heat made us appreciate the importance of body temperature, the indispensability of a reading light, the expense of throwing out spoiled food, the value of facial expressions in negotiating at dead traffic signals and our alarming dependency on the Internet.

Damage in Arlington included ninety-six knocked-out traffic lights. Our 911 phone service became spotty as Verizon reported that the storms hit its facilities. Countless events were cancelled at elementary schools with summer camps and at Long Branch Nature Center. The rough weather took out a historic Arlington tree, the Revolutionary War–era Post Oak, in the Westover area.

I personally felt bad that my dry cleaner lost five days' worth of business. Our always-there 7-Eleven carried no ice cream. Safeway ran out of ice, and the parking lot of Lee-Harrison shopping center sat atypically empty. The

During the derecho, tall, beautiful trees became lethal threats. *Arlington County Government.*

suddenly un-air-conditioned Shirlington movie theater was shuttered—we learned after driving hopefully across the county.

On a brighter note, I'm one of those dinosaurs who still subscribe to print newspapers, so I never did without news.

The county made fire stations available for emergencies 24-7 and activated its Emergency Operations Center. Cooling centers were designated at libraries, community centers, senior centers, the Ballston Common and Pentagon City Malls and the three high school swimming pools. Even the Artisphere got in the act, extending its evening hours and drawing an uptick in visitation.

Sixty county parks employees worked twelve-hour shifts to clear trees from seventy-four blocked roads. Refuse teams collected 750 tons of debris. Social workers and nurses from the Human Services Department visited vulnerable residents, focusing on the elderly.

Fourth of July events went off undeterred at Long Bridge Park, the Barcroft neighborhood and Washington Golf and Country Club.

County board chair Mary Hynes sent out a soothing letter reviewing progress. "Arlington is a strong community with a history of pulling together in emergencies," she wrote while asking neighbors to check on neighbors.

On our cul-de-sac, we kept tabs on one another as some fled to out-of-town hotels and cool homes of relatives. Those with generators or smartphones stayed on e-mail as neighbors traded thoughts on how to lobby Dominion Power to quit "neglecting" us.

We kept a sense of humor. The oddity on our block is that there are three families named Clark, two with a Charlie Clark and a third with a son named Chris Clark. One misrouted e-mail reached my college roommate in California, also named Chris Clark, who promptly hit "reply all" and forwarded links for Arlington emergency websites to all my neighbors, etc. Twenty-first-century confusion.

Like you, I'm glad it's over.

Hurricane Sandy Aid

November 9, 2012

Given the urgent superstorm needs of our compatriots in New York, New Jersey and Connecticut, I'd say the proper post-Sandy role for Arlingtonians should be: send money to the Red Cross, count your blessings and evaluate the state of your tall trees.

Though Arlington escaped the brunt of the 2012 hurricane, my neighbor's house was among the twenty-two in the county to be clobbered by a falling thick tree. Sixty-plus-mile-an-hour wind gusts combined with marshy root networks to wrench from the soil a massive aging oak tree from another neighbor's yard and drop it on their roof and side porch. The late-night invader punctured shingles, bent gutters, cracked patio railings and shattered a brick chimney.

Anticipating potential impact from the well-predicted storm on our foresty street, this couple was smart enough to bring their infant son downstairs and sleep in the basement. (My wife had made the same suggestion, pointing to the trees that tower over our house, but a certain unnamed columnist ignored her.)

So, on that Tuesday when the federal government and Metro were closed, the whole gang from our cul-de-sac came out to watch as a handily designed sixty-foot crane promptly positioned itself on my driveway.

A skilled crew labored five hours in the drizzle on my next-door neighbor's property to remove, chop up and haul away five tons from the lethal natural missiles. The professionals from JL Tree Service were most impressive in their ability to climb over splayed branches on the tilted rooftop while operating a gas chainsaw one-handed. They ended by spreading and anchoring enormous blue tarps to leak-proof the pried-open colonial home.

The thousands of dollars in damages are now in the hands of the insurance company and contractors. But a group of us neighbors are teaming up to heed nature's message and invest in some safety treatments to the remaining, still-beautiful trees.

Beyond my block in the days after the storm, the county reported 2,077 homes without power, twenty nonfunctioning traffic signals and eighteen blocked streets.

One private home ended up destroyed, seventeen suffered major damage and twenty-seven suffered minor damage.

The 911 call center received double the usual calls that week. County crews removed more than eighty tons of brush and debris. The free Arlington Alert electronic system grew by two thousand, to fifty thousand subscribers.

Hurricane Sandy destroyed many man-made objects. *Arlington County Government.*

Also noted was the Animal Welfare League's receipt of reports of two sightings of beavers, whose shelters were upended by the storm.

Storm-related costs are estimated at $1.17 million, well over the minimum needed to request federal disaster aid. "Unfortunately, we've gotten quite good at doing this," county board chairman Mary Hynes said on November 1, referring to past responses to rough weather and emergencies. "Everyone knows their jobs."

That Government Shutdown

October 22, 2013

Like last year's derecho and Hurricane Sandy, this month's sixteen-day shuttering of the federal government cut a swath through Arlington life. And like those strange recent storms, its still-sour memories come with an ongoing threat of a repeat.

Washington's closest suburb is home to some 34,000 of the 800,000 federal employees who were furloughed by the new downtown radicals' budget faceoff, many of them my neighbors.

Daily, I watched as dads walked their kids to school (how do you explain furlough to a first-grader?) and puttered in their yards. One devoted the forced downtime to renovating a bathroom; another did volunteer work with youth.

Agencies headquartered in Ballston were hit hard by the "appropriations lapse." The National Science Foundation idled 99 percent of its 2,100 workers, while the Fish and Wildlife Service furloughed 7,300 of its 9,300. One that was spared through the miracle of multiyear funding was the Defense Advanced Research Projects Agency.

Arlington is also terra firma for many government-dependent contractors, among them the skyline logos of CACI at Glebe Road and I-66, Boeing's offices in Crystal City and Northrop Grumman and BAE Systems facilities in Rosslyn. Though the smaller ones faced the most cash-flow problems, they all confronted uncertainty from the shutdown, as did their employees.

Then add in the economic ripple effect when typical spending is suddenly not happening—at hotels, restaurants, bars—by agency and contractor conference planners and by financially spooked individual employees.

Hotels "have had unprecedented cancellations, with revenue losses reported from 15 to 50 percent," said a preliminary compilation by Arlington Economic Development and the county's Department of Management and Finance. Before the shutdown, the hotels were already out 3 percent of usual revenues because of sequestration and the Obama administration's crackdown on federal travel.

"Local service businesses (nail salons, coffee shops, delicatessens, etc.) have reported drastic business drop-offs from regular customers since the shutdown began," the analysts said.

County sales tax receipts are down 3 percent, though that may be related more to earlier fear of the shutdown than the actual event, they added. Revenues from Arlington's Transient Occupancy (hotel) Tax showed a 9 percent decline year over year and a slightly negative twelve-month rolling average compared against 1.3 percent growth a year ago. Meals tax receipts have recently slowed to less than half the growth of the prior year, they said.

As the saying goes, when life hands you lemons…I give kudos to the Z-Burger eatery on the 3300 block of Wilson Boulevard for giving furloughed feds free food. More than one hundred bewildered public servants took advantage on the shutdown's first day, and the managers gave away $60,000 worth before ending the altruism, according to the blog ARLnow.

Taking a lighter approach, the Central United Methodist Church on Fairfax Drive mounted a witty welcoming sign reading, "No Shut-Down Here. God Never Fails Us!"

Central United Methodist Church

NO SHUT-DOWN HERE. GOD NEVER FAILS US!

WORSHIP SERVICE
11:00 AM

ALL ARE WELCOME IN GOD'S CHURCH

For sixteen days in 2013, one church felt God disapproved of the state of government. *Dave Hoard.*

When my federal employee neighbors finally returned to work on October 17, many were forced to spend the day catching up on their 1,001 unread e-mails. I know they'd rather it all never happened. And I suspect most will remain on edge when shutdown season resumes in January and February.

The shutdown's meager good news? Let me think…it *was* easier for me to get a seat on the Metro.

County Bunnies

July 24, 2013

It appears the descendants of Peter Rabbit have taken over Arlington.

Perhaps you've noticed a proliferation of rabbits on our suburban greens in 2013, and maybe you're astonished that these commonly standoffish furry friends are suddenly willing to sit still, stare and quiver just a few feet from imposing humanoids.

During this heat wave, I've witnessed whole warrens of hot, cross bunnies scampering around and laying siege to my wife's strategically

maintained flowerbeds. So I consulted a county authority for the straight dope.

"This is definitely a bunny boom year," said Arlington's natural resources manager, Alonso Abugattas, who reports a dozen or more weekly phone calls and e-mails about sightings to his Shirlington office. "Animal populations go in cycles, and this is the up peak of the cycle as far as rabbits are concerned."

Exactly why is tough to say. It could be that the rabbits' main predator—the citizens of the fox community—have suffered an epidemic of mange that has depleted their ranks. But that doesn't necessarily protect the rascally rabbits because "everything wants to eat them," Abugattas notes, citing crows, possums, raccoons and some bigger birds of prey such as red-tail hawks and great horned owls. "Even large snakes eat the rabbits when they're young," he said, while the older rabbits get dined on by Arlington's own foxes and coyotes.

The rabbit population is probably headed back down once the bunnies' vulpine foes get healthy.

The good news for people who fancy cute visuals is that it doesn't take much for the rabbits' numbers to bounce back. "After all, they do breed like bunnies," the naturalist said, "as many as seven times a year, though three times is more likely. You can see the math."

Monogamy, my research tells me, is not a rabbit's strong suit. The species also displays broad-minded appetites, consuming vegetation from grass to bark to twigs to buds to trophy-winning tulips. Plus they munch on their own droppings, the proverbial second bite at the apple.

Rabbit litters, typically of three to five, grow up and move out of "forms," as nests are called, in about five weeks, at which point the mother is ready for another pregnancy. "A rabbit doesn't live long," Abugattas says. "80 percent don't make it through the first year. Half don't make it the first month." The average lifespan is eighteen months, though a few survive as senior citizens to age three.

Contrary to popular assumptions, cottontails do not live in burrows, he added. Their homes are more out in the open, more like a depression or a divot in the bushes or tall grass, lined with twigs or hair. True, they can dive down a hole dug by, say, a groundhog, but they don't live there. (At least not in North America. The literary bunnies in Peter Rabbit's Europe do live in the ground, Abugattas explained.)

A rabbit's universe is small—less than one hundred yards. That means they know "every hole, gap in the fence and every thorn bush when something's coming after them" to find the best escape route, Abugattas said.

What's fun for humans who wish to befriend old Peter is that eventually he stays calm in your presence. "If they see you a few times and you haven't bothered them," quoth the naturalist, "they start to figure you're not a big deal."

Hall's Hill Gridiron Club

November 30, 2011

Having missed it for fifty years, I finally made it last week to the annual Hall's Hill Turkey Bowl.

The Thanksgiving Day amateur football spectacle has been a staple of Arlington's African American community for half a century (no one seems to recall the exact year it kicked off).

Yet this blast of an event is surprisingly little known among the rest of the county's citizenry—a gap I chalk up as a vestige of the segregation era's separation of cultures.

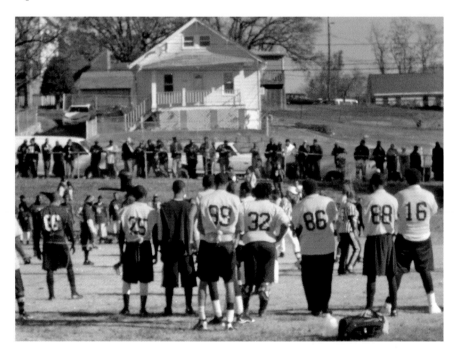

A black community's multigenerational outdoor Thanksgiving tradition. *Photo by Sonya Bailey.*

"It's like a neighborhood homecoming" for people who've known one another since elementary school, Willie Jackson-Baker, president of north Arlington's John M. Langston Citizens Association, told me. As many as one thousand spectators have been known to line the fence on Cameron Street at High View Park to watch a tackle football game that pits the over-thirty men against the under-thirties.

No posters or mail-outs are needed to get the word out, says Alfred Forman, a former player who now referees. "Everybody just comes back home."

Turnout this year was down—I'd guess perhaps three hundred showed, including many who brought antique cars, their Chevy Novas and Camaros—and the ages easily ranged from two to eighty.

That the enthusiasm remains strong was demonstrated by the addition for the past three years of a women's flag football game that begins at 9:30 a.m., an hour before the (mostly) muscle-bound males line up to relive youthful glory in front of their hometown's survivors.

"The women wanted to get in the game," said organizer Brandon Harris, who watched the older females defeat the younger ones 19–16. "It's a homegrown type of deal," he said, open to everyone, but the teams are dominated by reunited pals from the historically African American neighborhoods of Hall's Hill, Green Valley and Johnson's Hill.

The men's game is impressively formal. Players wear numbered nylon jerseys reading, "Hall's Hill Turkey Bowl," the elder guys in burgundy and the younger in gold. The refs dress the part and blow whistles, though they must track progress without a chain crew or a scoreboard.

The regulation-size field is properly lined, though there are no goalposts through which to kick extra points, and some light poles are dangerously close to the action. The teams are composed of twenty players, nine on the field at a time. No one wears cleats, though many use mouthpieces.

The action is fast, and tempers flare, but the contact is mostly of the arm-tackling variety.

Injuries are not unknown. My high school football teammate Paul Terry, whom I chanced upon on the sidelines, assured me that since he began attending in 1968, there has been more than one trip to the hospital. Last year, a fight broke out.

But this year, all seemed sporty after the younger squad was declared the winner, 28–5.

This is one tightknit community—every old classmate I mentioned to onlookers was instantly recalled.

Before the crowd poured on to mingle with the players, the teams gathered round the officials, who gave each player a trophy. A round of applause went up for their funder, neighborhood fixture Ed Hamm, a corporate executive who served as director of minority business enterprise for Virginia governor Mark Warner.

A pep talk was delivered by referee Forman, who quoted a relative in saying, "You don't know what a community football game is until you come to Hall's Hill."

The Real Men's Book Club

March 13, 2013

When the comic video "Arlington: The Rap" conquered YouTube in 2010, one line that got big laughs was the tough guy's reference to "my book club."

In March 2013, I had the privilege (without a lick of preparatory reading) of being a barfly on the wall at one of those rare literary phenomena—an all-male book club.

For thirteen years now, a gang of ten fifty- and-sixty-something professionals in the East Falls Church/Westover neck of Arlington have been escaping wives every six weeks for a rough-and-tumble evening of…non-stereotypical masculine bonding.

Sometime this spring, the club will discuss its 100th book. (The proof? A complete list.) Book clubbers nationwide number some 5 million, according to *Slate* magazine, but this cabal stands out for its focus, chuckles and civility.

At eight o'clock on this Tuesday night, the guys in jeans and sneakers—no careerist wardrobes—assembled in the host's living room after his wife, before departing, exerted quality control on a spread of beer, chips, dip, crudités and beer. (One-upping previous hosts on refreshments is frowned upon.)

Tonight's topic is Richard Russo's rollicking campus satire *Straight Man*. Selection of the book is generally the province of the upcoming host, who shows some mercy by factoring in availability at libraries. Choices rotate between fiction and nonfiction, history and biography, funny and dark.

The conversation gets right down to business. Russo would be thrilled to hear host Tom Dunlap call his novel "a great character study" and Dan Levin note that "he did a fine job capturing a sense of place."

Not all authors fare as well. "If the conversation starts out about sports, you know no one liked the book," says Bob Destro. Members balked at the experimental memoir of Dave Eggers. And the club's unanimously miserable reaction to E. Annie Proulx's *The Shipping News* launched a skepticism toward female authors (though eleven made the list).

Most women would not like *Straight Man*, says Mark Greenwood. He wagers that the percentage of members who show up actually having read the books is higher in this club than in those attended by the wives.

Notes on nifty Russo phrasings were compiled by Nick Acheson, an original member who has also prepared a painstaking analysis of patterns in the group's literary choices. The list includes, for example, two books by brothers, two books by accused plagiarists and two by authors who attended one of the Arlington club's meetings.

Early on, the group learned the hard way that assigning books only by title risked having members read three books by different authors all under the title *Endurance*. Now, more details are specified. Acheson also confesses that his wife once caught him, as he prepared to host, shortcutting cleanup duty by hiding dirty pots and pans in their car.

Time pressures feel minimal. "We all look forward to it, and attendance is usually high," says Levin. (Failure to show might mean you're the next host.) "The nucleus has been together since our kids were in elementary school," he adds. "We've been together through things other than book club," such as PTA and youth basketball.

"Despite a wide spectrum of interests and life experiences, the atmosphere is respectful and genuinely joyful," says Mike Violette. "The club mostly reflects the left-leaning sensibilities of Arlington demographics. I've come to appreciate the sincerity and personal sharing. It's all about the camaraderie."

Advanced Towing

February 6, 2013

As parking grows scarcer in Arlington, normally angelic citizens get tempted to be scofflaws. The price, however, can be more than just a ticket—try a major hassle with a towing company that some call predatory.

Leave it to Arlington to try to make this mess a bit more civilized.

Hundreds of visitors to the Department of Motor Vehicles have been ensnared over the years when they parked, either in ignorance or desperation, off Four Mile Run behind a private market. Big boo-boo. Within seconds, you get pounced on by the truck from Advanced Towing.

My own mea culpa came when my wife and I were late to dinner at a Thai restaurant on packed Columbia Pike. The only spot we could find belonged to the fine residents of Fillmore Gardens, whose sign we ignored. Until we came back to an empty space and assumed narcissistically we were victims of car theft.

Most recently, my friend Art's daughter was on a yogurt run in Clarendon when she fed a meter that expired at 11:00 p.m. She returned at 11:02 p.m. to join other drivers in discovering their cars were gone. "What the signs do not tell you is that the meters are not those of Arlington County," says Art, "and therefore no tickets are written but that you are subject to towing by a private company at any time of day or night."

If this befalls you, you will likely make a panicky call to the police and rush—by taxi or Metro—to the fenced-in Advanced Towing in Ballston behind Mercedes Benz of Arlington. It's a lonely place, especially late at night. The women inside the trailer "are rude and have rehearsed their lines—'It only takes thirty seconds to set up a tow,'" Art says. As he paid his daughter's $125 bill, another tow truck arrived and blocked the egress, almost sparking fisticuffs.

My calls to Advanced Towing went unreturned.

To apply reason to the issue, I consulted Brian Stout, the county's federal liaison, who assured me the county and police are sensitive to consumer complaints. "Folks who have vehicles towed are pretty hot when they get over there," he said. "The goal is to hold them accountable but to provide information so the towing is done legally and properly."

A 2007 ordinance, since updated and reviewed annually, regulates towing from private property. It requires minimum-sized signs, caps fees at $125 and mandates safe storage and a "drop" fee of $25 if the car owner returns while towing is underway. The tower must keep records and report to police. Car owners may inspect their vehicles for damage.

The county works with property owners to go beyond the requirements, such as posting a complaint procedure. "It speaks to the issue's importance," Stout says, "that it's handled from the county manager's office."

The Busty Mermaid

July 26, 2011

Arlington's best-built mermaid is seeking a safe harbor.

For seven years, passersby in my neck of Lee Highway—the conventionally proper 6200 block—have grown accustomed to the eighteen-foot varnished tree carved into the form of a sailor's topless fantasy figure, her long arms reaching to the sky.

In July 2011, an ad on Craigslist noted by the ARLnow blog revealed that her owner, Paul Jackson, a retired D.C. Fire Department captain, wants to sell his unique aesthetic statement.

The mermaid's grandiose style and ample appendages—which face away from the highway—have won over the vast majority of local onlookers, Jackson says. "I know all my neighbors because of her."

She attracts tour buses and has been featured in a national architectural magazine and tourist publications such as RoadsideAmerica.com. So he'll be sad to see her go.

"Her roots are giving out, so it's time to move her on," Jackson told me, explaining that despite his twice-yearly climb up a ladder to revarnish her, the 130-year-old dead white ash tree was invaded by carpenter ants. Three years ago, one of the mermaid's arms fell to her side and was propped up (though her bustline, as Jackson puts it, "never sags").

The Craigslist ad, which gives her the name of "D.G.," for damaged goods, reads: "Standing a prodigious 18' tall, she is a buxom mermaid, popular in her neighborhood and has also earned notoriety in newspapers, WETA, and worldwide publications such as *Weird Virginia*. She is now on sale for $3,000 firm as her roots are weakening. Buyer is responsible for 'slicing her off' and transporting her to her new home. The price is $3,000 or higher offer!"

The wooden siren first drew attention in a 2004 story by *Washington Post* reporter Laura Sessions Stepp (she also lives in our neighborhood). Jackson recalls how an unsatisfactory tree-care company had over-trimmed the treetop, leaving limbs dying. So rather than sue the company, Jackson said, he and his wife called carvers they'd heard of in Lancaster, Pensylvania. But none would make the trip.

So he found Scott Dustin of Frederick, Maryland, just starting out with experience carving bears, eagles and totem poles. It was Jackson's wife, Nancy, and their daughter who suggested a mermaid. Jackson then took over "the details" and ordered up a Dolly Parton shape "bigger than DDs,

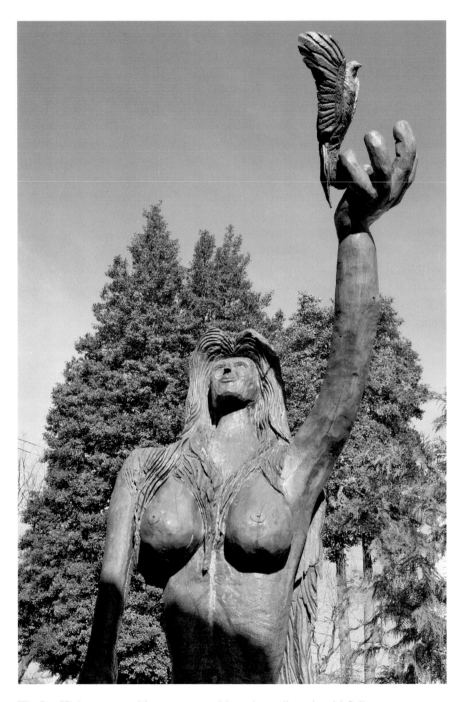

The Lee Highway mermaid attracts more drivers than sailors. *Anne McCall.*

with a small waist." Out of courtesy, he ran the plan by a neighbor whose view would be affected and who had a young daughter. All was a go.

Jackson's one regret is the supernatural lady's man-hands, unavoidable, he says, because more-feminine hands would too easily rot.

The Craigslist notice has drawn nibbles, one from the entrepreneur for a coming seafood restaurant in Clarendon, which is considering transporting her to a courtyard to protect her and accommodate public viewers. "It would be great because I could visit her," Jackson says. "After all, she's kind of special."

When the mermaid first appeared, an Arlington code enforcement official researched her legality and concluded the sculpture was art. That view is now accepted by neighbors who at first were turned off. Says Tom Wolfe, who lives two doors down, "Those in the neighborhood more or less got used to it. But now I'll no longer be able to say, when guiding friends to our homes, 'Just look for the mermaid.'"

Editor's note: As of press time, the mermaid is still there.

Ghost Story at Overlee

April 4, 2012

I couldn't resist weighing in on the ghost story floating around Arlington in the spring of 2012. That's because I'm a sensationalistic journalist and a member of the Overlee Community Association, the Lee Highway swim club where the incident (alleged, putative, supposed) occurred.

Credit ARLnow.com with the scoop.

In January, a construction worker was preparing to help dismantle Overlee's 120-year-old historic Febrey-Kincheloe house to create a modern clubhouse. He told his bosses of a strange sight in the fenced-off construction zone—a young girl in Victorian dress, peering from the house's window and, later, sitting on the basement stairs. When the worker approached to investigate, she had vanished.

The guy, name not published, got so scared he went to his boss the next day and asked to transfer.

The plot thickened. Local press revealed that the Harry Braswell construction company had been alerted by Overlee to keep an eye out for the apparition that neighbors had spoken of for decades.

The contractors were e-mailed an ancient photo of fourteen-year-old Margaret Febrey, a former occupant of the home who died in 1913 and is buried at Oakwood Cemetery in Falls Church. The photo was broadcast by WJLA-TV. The National Paranormal Association got wind.

Overlee board member Mike Maleski told a reporter that sightings and strange noises and music had long emanated from the house, which became a sanitarium after the Febreys departed. Overlee managers who occupied the house beginning in the late 1950s had often spoken of such phenomena. Neighbors claim the ghost is friendly and pals around with children.

Permit me some non-supernatural observations. Ghost stories are irresistible, around the campfire, across the picket fence and in publications facing slow news days.

As I write, the Overlee ghost tale has been ignored by the *Washington Post*, the *Sun-Gazette* and the *Connection* newspapers (the exception to this print blackout is the *Washington Examiner*). As a reporter, I find it weird a publication would credulously present claims that violate known laws of science without an iota of skepticism. (The *Post* eventually succumbed.)

Note that all interviews are with people who heard the story secondhand. A ghost at Overlee is "certainly possible. The house has been there a long time," north Arlington resident Liza Marshall told the blog Dateline Zero. The local ABC affiliate somberly explained that neighbors for years have talked up the ghost. But then the producers show a young man who used to mow the Overlee lawn but who admits he never saw anything odder than a house that's "creepy."

It is possible the construction worker wanted out of his job for other reasons and that this was a pretext. A therapist I consulted who has interviewed people on their ghost sightings says they are earnest and come in all psychological profiles.

Ghosts, of course, are a venerable literary device. The vision of the disrupted Febrey girl rising up a century after death gives solace to critics who opposed the swim club's decision to tear down the handsome building that had become too expensive to keep code-compliant.

Overlee officials treat the story as fun, hedging their bets on its veracity—why risk alienating the entire ghost community?

None would discuss it with me. Their February 2012 newsletter says, "It is in all of our interests that the workers be allowed to work unimpeded and undistracted."

I'll believe in the ghost when I see it. Perhaps while swimming laps this summer.

That Elusive Neighborhood Sign

May 22, 2013

The great neighborhood sign caper came into my view by happenstance.

As I drove by the entrance to my boyhood Arlington neighborhood in April 2013, I was stunned to behold a key ingredient gone missing: the white three-dimensional letters spelling "Rivercrest" had been removed from the two curved brick walls at North Thirty-eighth Street and Military Road, where they had labeled the subdivision since 1960.

I raced home and e-mailed a bulletin to a dozen former Rivercrestians with whom I maintain diplomatic relations. From Arizona, Jim demanded an investigation. From Rochester, New York, Jennifer wrote, "Yikes, keep us posted." From Charlottesville, Jonathan wrote, "Maybe wild kid vandals swiped them." From Arlington, Alan moaned, "I am just crushed by this. What can I do from a political or PR end?"

Subdivision signs erected by home builders—presumably to confer a touch of cachet on their carved-out rows of new homes—are not uncommon in Arlington. Within blocks of Rivercrest you can find fancy signs reading "Chain Bridge Forest" and "The Glebe."

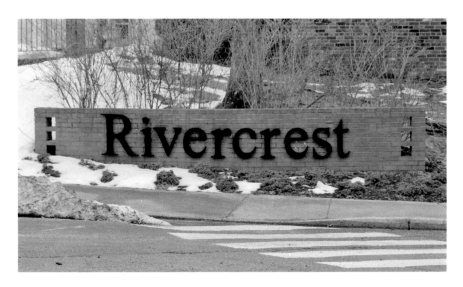

When the decades-old prestige sign vanished, the homeboys were outraged. *Samantha Hunter.*

On Yorktown Boulevard stands a pair of curved "Crescent Hills" signs erected six decades ago by the Broyhill builders. (They look a little worse for wear, but no one I consulted on the block knows who's in charge of them.) And fronting a cluster of modern houses on Lee Highway, opposite Overlee pool, stands a chiseled sign reading "Stonehurst."

Our Rivercrest sign, I'm reminded by realtor and local boy Dean Yeonas, was created by the Dittmar builder in a style used on several 1950s-era projects. "The entrance signs add an identity and helps frame the community," he says.

Ross Richmond, a realtor and developer who sold the Stonehurst houses, says signs "provide an important sense of community and belonging." Richmond lives in the Franklin Park subdivision at the Arlington edge of McLean, where he and an informal group of neighbors erected a sign because they "all care about Franklin Park."

Not surprisingly, the county has addressed the identity sign issue on a more official—and egalitarian—basis for Arlington's larger jurisdictions. As part of the Neighborhood Conservation Program, it funded forty-four sets of signs (photos are on the county website) "to better identify the neighborhood and help to foster an increased sense of community and pride among residents," says the Community Planning, Housing and Development Department.

County landscape architect Jill Yutan walked me through the process of how citizens request eligibility for funding and work with her on choosing a unique design. County engineers install the signs. "Almost the whole county has been done," she says, noting that small signs in the sets cost $1,200 to $1,500 and the larger ones $3,500.

Because Arlington has little open land left for building, new subdivision signs are rarer, Yutan notes, "but you see them farther out in Fairfax."

In a community like Rivercrest, says Yeonas, "the signage is maintained by whatever association or loose group of homeowners decides to take charge."

Calls to current residents solved the mystery. The white wooden cursive letters—which were refurbished twelve years ago by two Rivercrestians—were cracking, the civic association president told me. So the board collected money from "everyone in Rivercrest," and a neighbor is making long-lasting black letters for mounting after the wall gets power-washed and landscaped.

Black letters will require getting used to, old-timers agree. But now we don't have to organize a protest.

So-Called 22rd Street

August 30, 2011

Ancient rug weavers purposefully included a flawed stitch in their work to symbolize life's imperfections.

A tip from my observant pal Todd tells me our hometown of Arlington, which usually runs like clockwork, has committed a small public error.

I assumed it was done for similarly philosophical reasons. The truth is more quotidian.

Look at the street sign at the corner of Sycamore Street and North 22nd Road. The sharp-eyed will spot how instead of reading 22nd, the official black-on-white metallic sign reads nonsensically as 22rd.

Look carefully and spot the typo. *Todd Lewis.*

Okay, no one will get lost because of this misprinted street name. But in Arlingsville, we take pride in literacy. Turns out county officials do, too.

"We try to keep all our signs neat, clear and straight, and we patrol amply," Wayne Wentz, chief of Arlington's Transportation Engineering and Operations Bureau, told me. "But our guys do make mistakes." During his thirty-three years working at it, Wentz has seen examples of 22st instead of 22nd. He's seen street names misspelled, and he's seen the word "school" mis-stenciled on a parking lot.

"Good citizens call us" to report errors, Wentz said. "Others try to embarrass us by taking a picture and sending it to four hundred people."

Wentz walked me through the county's in-house sign creation process—the computer software with standardized type for vinyl lettering and the large printer that rolls out ready-to-trim sheets of aluminum. "Every sign has its own lifetime, on average ten or sometimes fifteen years," he said.

So replacement demand is steady, and the crew also does traffic signs, which might explain the occasional typo.

New street names in Arlington are rare. The signs communicate a systematic grid of street names that has been run by the county board since 1934. Except for the state roads, Arlington owns all its streets. Hence it can enforce the regime of numbered streets that cross over named streets arrayed alphabetically in groups of one-syllable, two-syllable and three-syllable names.

Unlike neighboring jurisdictions, Arlington doesn't let developers choose names for streets they build on, says Luis Araya, chief of Arlington's Development Services Bureau. "Some of them would want flavor-of-the-month superstar names or themes like trees or water." Arlington keeps it simple.

The only exception is when the county board agrees to commemorate an individual, who must be deceased for five years, Araya says. The most recent example was in 2006, when the board renamed South Twenty-eighth Street in Shirlington for Elizabeth Campbell, civil rights activist and founder of WETA, and her husband.

The name on that sign was spelled correctly.

Though it's trendy to bash government, I'm a fan of Arlington services. Last week's earthquake caught me in the midst of shuttling between two county agencies, the Commissioner of Accounts and the vehicle registration desk. As hundreds evacuated and gathered at the courthouse parking lot, I was able to stroll over and track down the right employees from both departments. They seemed as stunned and out-of-context as I felt, but both were happy to help move forward with my transactions.

Chief Wentz tells me the county can fix a street sign mistake in two or three hours. Okay, the clock is ticking.

Meanwhile, here's one that's easier to fix. Todd sent me a photo of an electronic sign Friday at North Glebe Road and Williamsburg Boulevard. It reads: "Chian Br. Road Closed."

Editor's note: Arlington County crews had fixed the misspelled sign by 9:15 a.m. the day this column appeared.

Keep Arlington Weird

August 22, 2012

Keep Arlington (a little) weird.

So goes the plea on the bumper sticker for sale at Westover Market. It's a charming local adaptation of Texas's famous slogan "Keep Austin Weird." But it made me wonder precisely how our notably utilitarian county could even begin to associate itself with serious weirdness.

Herewith weird, Arlington-style:

Arlington is the smallest self-governing county in the country, but its population of 216,000 is nearly half that of Wyoming.

Arlington's otherwise logical street grid, dating from 1934, allows North Twenty-sixth Street to suddenly become Thirty-first Street at Taylor Street, North Sycamore Street at Seventeenth Street North to morph into Roosevelt Street and North Quincy Street at Glebe Road to transmogrify into Henderson Road.

Arlington has no central square; instead, it spokes out from a central corridor with Metro stop nodes, surrounded by residential neighborhoods with names—now on lovely signs—that few other than the locals use in conversation.

The intersection of I-66 and Lee Highway occurs three times, several miles apart. Speaking of Lee Highway, it changes—by state law—temporarily into Old Dominion Drive at Lorcom Lane (off to one side, the official Lee Highway continues on a parallel track that used to be Old Lee Highway).

Arlington boasts a neighborhood called East Falls Church that has not been in Falls Church since 1936, when the Virginia Supreme Court ruled in favor of some secessionist petitioners.

Arlington certainly looks weird to the rest of the state. In 1954, it jumped out ahead of other counties to desegregate following the U.S. Supreme Court's landmark ruling in *Brown v. Board of Education*. Hence in 1956, the gang in Richmond took away our elected school board, which wasn't restored until 1992.

Today, Arlington appears to be the only community in Northern Virginia resisting the widening of I-66.

From the late 1950s to the early 1980s, Arlington tolerated the presence of the American Nazi Party, which set up shop here a mere fifteen years after we fought the real Nazis in World War II.

In July 2012, Arlington became the only site in the United States to serve as a polling site for expatriates voting in Libya's first election in four decades.

Democratic-dominated Arlington is home to a statue of President Reagan, installed last year to bid you goodbye at what for decades was called National Airport.

Arlington is the only jurisdiction in the solar system to host both the Pentagon and the Metaphysical Chapel.

In Arlington's famous street-naming scheme—which groups streets with one-, two- and three-syllable names—the only four-syllable exception is Arizona Street.

When an Arlington swim club (Overlee) set out to build a new pool and clubhouse last winter, it ended up resurrecting a century-old ghost story.

Arlington's housing stock is rich and diverse, but I'd single out two for mild weirdness. The nice but unusually colored home at Washington Boulevard and Frederick Street is known to my daughters as the Pepto Bismol house. And the home I suspect is Arlington's tiniest—less than ten feet wide—is a cutie at 1802 North Monroe Street.

When the Westover Beer Garden applied for a permit to offer live evening music, the Arlington County Board required it to submit to randomly scheduled electronic decibel checks in case of neighbor complaints.

And Arlington's Iota Club recently staged a troupe of opera singers belting out arias with lyrics drawn from Craigslist ads.

Feel free, fellow weirdos, to send me your own.

ABOUT THE AUTHOR

Charlie Clark, for three decades a Washington-area journalist, has written the weekly "Our Man in Arlington" column since 2010. By day, he is a senior correspondent for Government Executive Media Group. He has been a writer and editor for the *Washington Post*, *National Journal*, Congressional Quarterly, Time-Life Books, Tax Analysts and education groups. He has spent two-thirds of his life in Arlington (with a hiatus for college and a taste of Alexandria). He lives in the East Falls Church neighborhood with his wife, Ellen, who's in charge of quality control. They have two grown daughters, Elizabeth and Susannah.

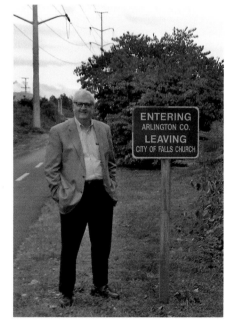

Photo by Elizabeth McKenzie.

Visit us at
www.historypress.net
..

This title is also available as an e-book